Architecture and Meaning in the Athenian Acropolis focuses on the architectural complex generally considered to be one of the outstanding achievements of Western civilization. Though the buildings and sculpture of the Acropolis have been scrutinized by scholars for more than a century, Robin Rhodes's sensitive analysis is unique in its consideration of the ensemble as a whole and its explanation of how the monuments communicate meaningfully with one another to form an iconographic narrative.

Architecture and Meaning on the
Athenian Acropolis

Architecture and Meaning on the Athenian Acropolis

ROBIN FRANCIS RHODES

Corinth Excavations
American School of Classical Studies at Athens

CAMBRIDGE
UNIVERSITY PRESS

Published by the Press Syndicate of the University of Cambridge
The Pitt Building, Trumpington Street, Cambridge CB2 1RP
40 West 20th Street, New York, NY 10011-4211, USA
10 Stamford Road, Oakleigh, Melbourne 3166, Australia

© Cambridge University Press 1995

First published 1995

Printed in the United States of America

Library of Congress Cataloging-in-Publication Data
Rhodes, Robin Francis.
 Architecture and meaning on the Athenian Acropolis / Robin Francis Rhodes.
 p. cm.
 ISBN 0-521-47024-2 (hardback). – ISBN 0-521-46981-3 (paperback)
 1. Acropolis (Athens, Greece) 2. Athens (Greece) – Buildings, structures, etc.
 I. Title.
 NA283.A25R48 1995
 726´.1208´09385 – dc20

 94–38706
 CIP

A catalog record for this book is available from the British Library

ISBN 0-521-47024-2 hardback
ISBN 0-521-46981-3 paperback

*For my former colleagues and students at Yale
and
in fond memory of Charles Malcolm Edwards*

Contents

List of Illustrations

Preface

THIS BOOK IS an interpretive essay. Its purpose is to present an accessible, synthetic view of the architecture of the Periclean Acropolis in Athens. In it the forms of buildings are carefully examined, but not for the sake of descriptive catalogue; instead, I have tried to keep the problem of meaning foremost in my mind and writing. Each chapter represents an attempt to articulate and examine a significant aspect or aspects of the Acropolis and to relate it to the larger themes of Greek architecture as a whole. As presented here, the Periclean Acropolis stands on a religious and architectural cusp and can be best understood not simply in its contemporary context, but in detailed relation to its Archaic, pre-Persian predecessors and in the light of its immediate architectural and spiritual legacy. Among the themes treated in this book are the relationship between landscape and religious architecture, the humanization of temple divinities, the architectural expression of religious tradition and even specific history, architectural procession and hieratic direction, emblem and narration in architectural sculpture, symbolism and allusion through architectural order, religious revival and archaism, the breaking of architectural and religious canon. Taken together, they constitute the specific architectural narrative of the Periclean Acropolis.

The Periclean Acropolis is uniquely valuable in any discussion of meaning in Greek art and architecture, for its immediate historical and cultural context is known in remarkable detail. J. J. Pollitt's invaluable contribution in his *Art and Experience in Classical Greece* (Cambridge University Press, 1972) is the articulation and synthesis

of that rich context and the analysis of Classical art within it. In fact, *Architecture and Meaning on the Athenian Acropolis* has grown directly from a series of lectures I gave at Yale as part of the team-taught "Periclean Athens," a course devised and normally taught by Professor Pollitt. As a result, the book's organization and general conception owes much to him, as both the founder of the course and as author of its text for Classical art. It does not, however, make any attempt to re-create the cultural context of Athens; it directly concerns itself with a single aspect of it, the architecture, and selectively treats other facets of art and culture as they clarify that specific focus.

Since architectural meaning is the primary concern here, each temple or building is considered as a whole, that is, its sculptural decoration is not treated as somehow separately conceived and separate in meaning from its more abstract architectural features. Both contribute significantly to an understanding of the meaning of Greek architecture, and as they are integrated parts of single buildings, they must also be integrated in our interpretations of them. Similarly, in the Introduction and in the final chapter of the book – discussions of the spiritual roots and legacy of Classical temple architecture and the Acropolis – the focus moves beyond specific buildings to general considerations of the Greek landscape and its relationship to myth and ritual on the one hand, and to the changing conception of man and his relationship to the gods on the other. In the latter case, much of the most illustrative material is sculptural, and a survey of Greek sculpture in the round is central to the book's final chapter.

This book is envisioned as useful on several different levels: as accessible reading for the layperson; as a general introduction to Greek architecture and the character of Classical Greece for survey courses on the history of art and architecture; and as a complementary text to *Art and Experience* in Classical art and culture courses. For more experienced readers, it will serve as an interpretive analysis of the Acropolis and a statement of significant themes in Greek architecture. For those who require more extensive treatment of those themes, most can be followed throughout Greek antiquity in this author's forthcoming study, *A Story of Monumental Architecture in Greece* (Cambridge University Press).

Acknowledgments

I WOULD LIKE TO THANK the 1984 Foundation for a grant that made the writing of this book possible.

I would also like to express my thanks to the students, friends, and colleagues who have contributed to this book through their reactions to written or spoken text. I am particularly grateful to my editor, Beatrice Rehl, for her constant encouragement and her quick and thorough work, and to my father, Daniel D. Rhodes, for his careful reading and fresh perspective. I am also grateful to Nancy Bookides for the generous loan of her apartment while I was gathering illustrations in Athens.

Finally, I extend my thanks to the various publishers that have allowed me to reproduce copyrighted drawings, and to all the foreign schools of archaeology that have provided me with photographs from their archives and granted me permission to reproduce them in this book. Special thanks are due to Klaus-Valtin von Eickstedt and Nellie Lazaridou of the Deutsches Archäologisches Institut in Athens, and to Marie Mauzy, Leontina Klopp, and Carol Zerner of the American School of Classical Studies at Athens.

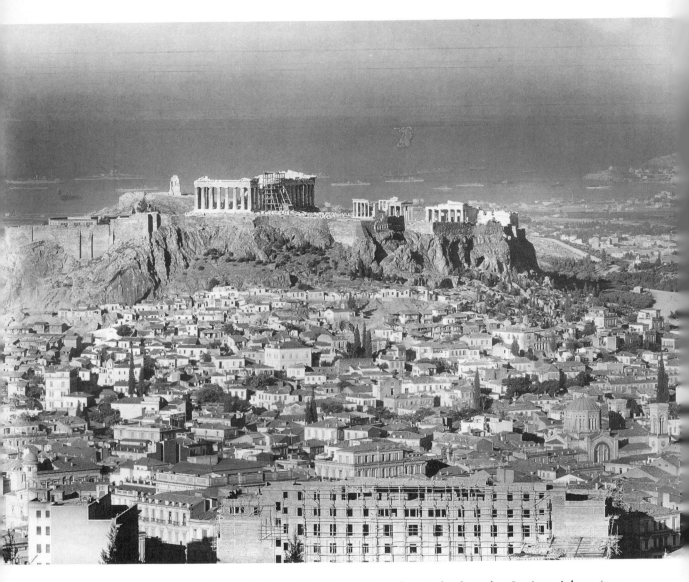

1. Acropolis from NE. [Photo: Deutsches Archäologisches Institut, Athens (neg. no. Hege 1598).]

Introduction

A Sense of Place and the Seeds of Monumentality

THE PERICLEAN ACROPOLIS is one of the most elaborate *Fig. 1* examples and perhaps the purest expression of classical form ever created, and the primary goal of this book is to speak of the meaning of its individual buildings and of the program as a whole, within the immediate context of Classical Greece. At the beginning, however, it may be useful to step back and muse on more general contexts, in fact on the polar extremes of context. Essential to any general understanding of the Periclean Acropolis is, on the one hand, some consideration of the religious traditions and instincts from which classical form ultimately sprang. On the other, no judgment of antiquity can be completely divorced from the context of the judge, and rather than stifling meaningful inquiry, a certain amount of scholarly inspiration and insight into ancient meaning can be found in the consideration of why classical architectural form still touches us so deeply today. The classical orders, Doric and Ionic, were developed to answer specific problems and meet specific needs in the world of ancient Greece, but because of the universal nature of their forms and the needs they fulfill they have spanned centuries and cultures as the universal architectural palette of the Western world.

Why our attraction to classical architectural form? Is it an antiquarian, amuletic desire to associate ourselves with the semimythological Golden Age of Pericles and Athens, Socrates and the Parthenon? The Parthenon still stands as the most eloquent statement of that brief cultural nova, a marble beacon from the past, the monument of all monuments. The Parthenon, in its historical context, its

1

mathematical refinement, its sculptural narrative, its international style, is a celebration of victory, a celebration of culture, a celebration of Athens as cosmopolis; it speaks to us in intentional, unambiguous terms of the value of humanity in this world, of its perceptions, of its infinite potential. Humanity, safe on a mountaintop, surveying its past and future: Is it this distant gaze we meet with our own classical forms today?

Is this the power of classical architecture? Or is its power derived from a less historically specific source? Is there something in its appeal more basic, less intellectual – even, the gods forbid, primally religious?

Ruins

Fig. 2

In part, the attraction of the classical orders is their association with ruins. Ruins embody the mystery of antiquity; they have inspired the imagination for centuries. From ancient Greece to twentieth-century America, tourists (not to mention poets) have preferred ghost towns to living towns, sunken ships to seaworthy ships, Atlantis to Buffalo. Broken columns on an isolated mountaintop, the battered and crumbling walls of a Civil War fort are fascinating because in them every layperson recognizes a direct link with the distant past. In the presence of ruins everyone becomes an active participant in the reconstruction of history: We reconstruct the lines of the building, the lives of its inhabitants, the history of its decay. Nor is prior knowledge of the distant past prerequisite, for before us is gripping testimony to the ravages of time, the depredations of humanity and nature. Before us is a living bridge between the past and present, a building whose character has changed dramatically, but whose vitality and significance have not been diminished by tarnished surface or abandoned function; rather, they have steadily evolved, from proud, unbowed youth to decayed splendor, touching each successive generation in a different way. Decayed splendor is a source of curiosity and inspiration because it forces us into a realm of timelessness: Here lies the tangible argument for the existence of another time that, like the future, cannot be fully accepted purely on the basis of

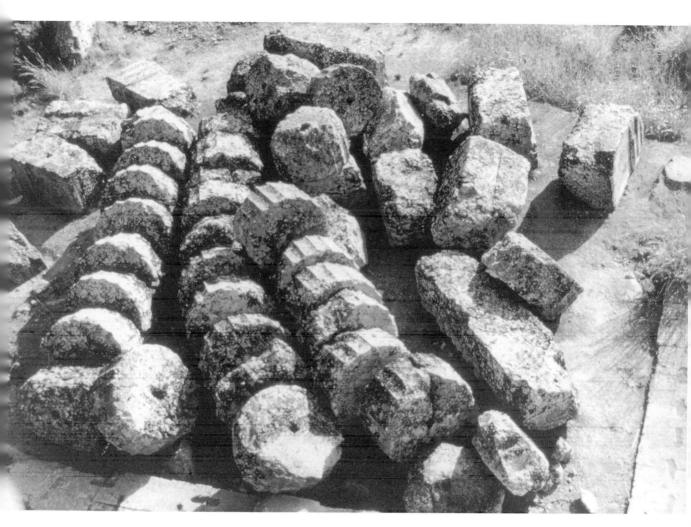

2. Fallen columns from the Temple of Zeus at Nemea. [Photo: R. F. Rhodes (neg. no. 94-S-1).]

intellect; both can be experienced only indirectly; both require of us faith and imagination; both are akin to myth.

When we approach the Lion's Gate at Mycenae, set in a wall of cy- *Fig. 3*
clopean masonry, stones so huge, so beautifully joined that the Classical Greeks attributed their construction to the one-eyed giants of myth, the bastard sons of Poseidon; and when we pass through that gate into the palace where Clytemnestra awaited her returning husband, great Agamemnon, king of the Greeks, still bloody and stinking

3

from the conquest of Troy – Agamemnon, led by a scarlet carpet, unmoved by the oracular shrieks of Cassandra, up to the royal megaron to be butchered in his bath by his own wife in atonement for the murder of their daughter; when we gaze into the grave circle, whose excavation a hundred years ago by Schliemann granted, for the first time since antiquity, flesh and bones to the Mycenaean heroes of Homer, we know we stand in a spot where myth and history mingle. Ruins give us the tangible reality of history; Homer and the poets and the painters give us the myth; and the myth elevates the ruins – and, by association, humanity – to the realm of the imagination, the universal. Ruins give us the tangible reality of history, but are in reality nearly indistinguishable from myth in their effect upon us. In this, and in the ambiguous nature of the semimythological, semihistorical cultures they reflect, the kinship of myth and history is inescapable, of memory and inspiration. For us today, experiencing antiquity from a distance, they are inseparable. Both elicit a strong sense of continuity, of kinship, of the profundity of ancient sites and their inhabitants.

From Greek times to the present, Western humanity has felt a deep, intuitive connection with classical antiquity. It has something to do with the romance of ruins. It has something to do with the fact that the history and in some cases even the existence of ancient cultures are inextricably intertwined with myth and legend and metaphor, and that their contemplation invariably removes us from the everyday into the more universal, mythical realm of Minos and Homer, Oedipus and Pericles, Alexander the Great and Julius Caesar.

Indeed, this is not the stuff of standard scholarship, but the heart of poetry and music and paeans of praise. It seduced the Romantic poets, and has served as artistic inspiration throughout the history of Western culture. Its definitive texts are eloquent proofs of the power of antiquity: from Homer to Byron and Keats, from Sigmund Freud to Henry Miller, from Hadrian's villa to the fantasy architecture of Charles Moore, death masks, classical composers, Alma-Tadema and the Victorian classicists, Kazantzakis, Schliemann, Auden, and the modern Greek poets.

The classical orders possess the aesthetic attraction of recognizable, satisfying proportional relationships, the academic, intellectual

4

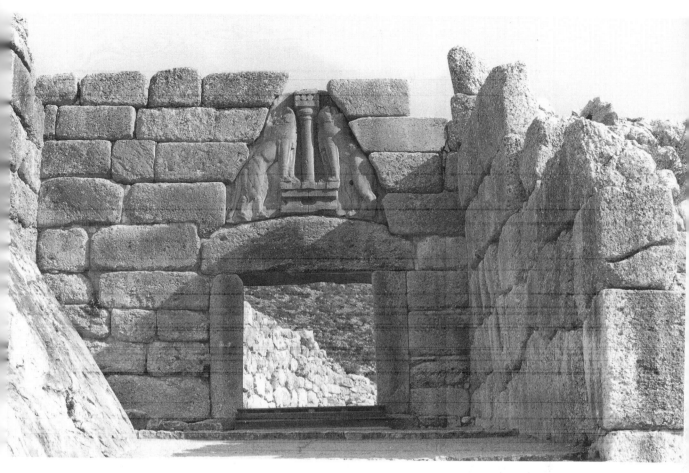

3. Lion's Gate, Mycenae. [Photo: R. F. Rhodes (neg. no. 94-9-6a).]

attraction of orderly, adaptable precision, and the romantic attraction of decayed splendor; but on a more essential level, they are cultural reactions to profound questions about the position of humans in the universe and their relationship to the gods. The "perfection" of these architectural orders reflects the uncanny ability of the Greeks to express these universal human concerns in a universally meaningful fashion. This is at the heart of Greek "monumentality": More than the

5

specific details of the orders or the specific theories of proportional relationship embodied in them, Greek architecture's legacy to us is a universally meaningful conception of monumental architectural form.

Monumentality

Monumental architecture, monumental art: What is "monu-mental"? Is it essential to the problem at hand, to the meaning and attraction of classical architecture? Almost coincidental with the first serious stirrings of Greek culture after the three hundred murky years following the collapse of the Mycenaean world is the second stirring of a genetic Greek drive, a fixation, a compulsive desire for grandeur and permanence of creation: grandeur and permanence of human creation through inhuman scale and material, permanence through balance, through theme; theme beyond the everyday, extraordinary, transcendent, permanent in its universal appeal to the human condition. Monumentality: agent of commemoration, of sacred human memory, of approach to the gods; myth, spiritual metaphor in stone; ritual in three dimensions.

Rituals develop at points of transition between people, between places, between spiritual conditions. They ease the unpredictability of practical transitions through formula, and make the spiritually un-speakable speakable through metaphor and incantation:

"Hello, how are you?"
"Fine, thank you."
"Congratulations."
"Knock on wood."
"Gesundheit."
"Do you take this man . . . ?"
"Dust to dust, ashes to ashes."

Ritual acknowledges, commemorates, celebrates, orders significant moments in life and significant human instincts. It makes the unfamil-iar, the irrational, the unpredictable, the unknowable accessible, less terrifying, through familiar, predictable, patterned incantation. There are two sides to ritual, however: On the reverse, as these incantations

arise in direct response to the irrational, the unknown, so can their simple recitation remove us from the everyday, transport us again into that mythical realm that first inspired the ritual. Ritual is cultural memory. It gives life texture, aesthetic order, consistent access to the spiritual. Ritual is the poetry of everyday life.

The earliest preserved monumental art in post-Mycenaean Greece *Fig. 4* takes the form of grave markers, six-foot terra-cotta amphoras and craters, household pots blown colossally out of scale with their natural function – indeed, blown completely out of the realm of kitchen pottery and into the realm of architecture – appropriately massive, appropriately inhuman, appropriately extraordinary through their transformation, appropriately transcendent for their new, superhuman duty of carrying the memory of the deceased beyond the grave, as well as of providing a vehicle for recontacting the dead. These pots carry the memory of the deceased beyond the grave, but in the monumentality of their transformation, their superhuman scale, their permanence, they also sing of the final *human* transformation, and mark the ultimate, monumental point of transition for mortals: from life to death. The earliest monumental art in Greece was created for the express purpose of bridging the terrible gap between the transience of mortal existence and the permanent, never-ending, immortal realm of the dead. It *is* ritual in three dimensions.

The representations of humans on these gigantic pots – the first such representations since the close of the Mycenaean Age three hundred years before – invests the monumental with a peculiarly Greek stamp of humanity. Furthermore, through their monumental medium and memories of Mycenaean war chariots and figure-of-eight shields, through allusion to a golden age, they elevate the deceased to the realm of the heroic, the mythic, the divine. This transition between the temporal and the immortal, the tension between life and death, human and god, permanence and flight, can be traced in all Greek monumental art, from the great Dipylon cemetery vases with their uniform, unchanging, abstracted figures to the theoretical geometry of Polykleitos' Spear Bearer. Indeed, the transition itself, the electricity behind the monumental instinct, becomes an almost literal component of monumentality, as the individual is transformed to the generic, the generic to the ideal, the ideal to the divine.

7

Fig. 5

Perhaps the most profound transition represented in Greek art is that celebrated by the Greek temple and chronicled metaphorically (if unconsciously) in its gradual transformation from a thatched and mud hut to a solid stone colossus, as well as in the formal elaboration of "transition" through the introduction of procession into its architecture.

Temples were not originally vehicles for the expression of aesthetic theory or for the aggrandizement of individual people or nations. They protected the image of the god and, more important, like the simple altars that preceded them, they marked points in this world where humans were convinced, for whatever reason, that their prayers might be heard, their sacrifices received, suppliants protected. They marked points where divinity alit, where the divine might be approached by the mortal. As grave monuments acknowledged the point of transition between life and death, as well as facilitated communication with the dead, so the earliest altars and temples were human responses to the sensed presence of divinity, the vehicles by which communication with the gods was possible. Grave markers bridged the gap between the mortal and the immortal for individual men and women; temples bridged the gap for humankind.

Figs. 6, 7

A ruined temple may be a bridge for us from the past to the present, but *the* temple was the ultimate bridge between the Greeks and their gods, and its invention and development the monumental expression of spiritual transition. The Parthenon speaks to us of universal Western ideals and the fantastic apotheosis of humanity, and it is in this human-centered context that Doric and Ionic truly commingle for the first time. These orders were not invented for the Parthenon, however. Their birth floats in the hazy realm of the post-Mycenaean Dark Age, in the age of tyrants and infant city-states, of barely remembered wars and Eastern strangers. It floats in the semimythological past, and represents not the genesis of an aesthetic canon, but the three-dimensional expression of mythology: a home for the cult image, a home for the god; a place where immortal and mortal mingle. Appropriately enough, and as suitable materials and techniques were

4. *(facing)* Krater from the Dipylon Cemetery in Athens; eighth century B.C. National Archaeological Museum, Athens. [Photo: Deutsches Archäologisches Institut, Athens (neg. no. 75/664).]

8

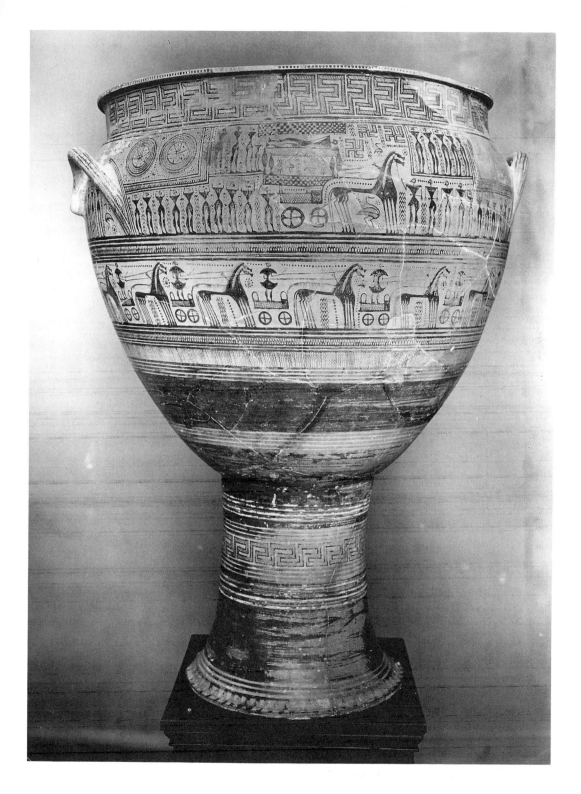

9

(a)

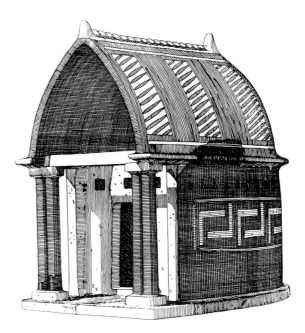

5. (a) Reconstructed temple model from Perachora; eighth century B.C. [From H. Payne, *Perachora* I (Oxford, 1940), pl. 96. By permission of Oxford University Press.] (b) *(facing)* Parthenon, W facade. [Photo: Deutsches Archäologisches Institut, Athens (neg. no. Hege 1035).]

discovered, temples evolved from their thatched origins toward grandeur and permanence. They were not born full-blown in stone with fluted shafts, domed stylobates, contracted corners, aligned triglyphs. However, as all these canonical features of later Greek architecture are organically related to that original temple, to that original ritual response, perhaps their meaning should ultimately be read in the half light of origins rather than in their most illustrious expression, or in the treatises of Hellenistic and Roman architects and architectural historians.

Landscape and Myth

The Greeks approached their gods through temple-bridges that spanned a clearly perilous gap, and eventually eased the transition, perhaps even tamed it, by insulating themselves ever more securely from that first, profound response. They accomplished this through repetition of form, architectural incantation – triglyph metope, triglyph metope – through reason, the great comforter; but what *specifically* compelled them to build those first altars and temples? What convinced them of the presence of divinity? What were they

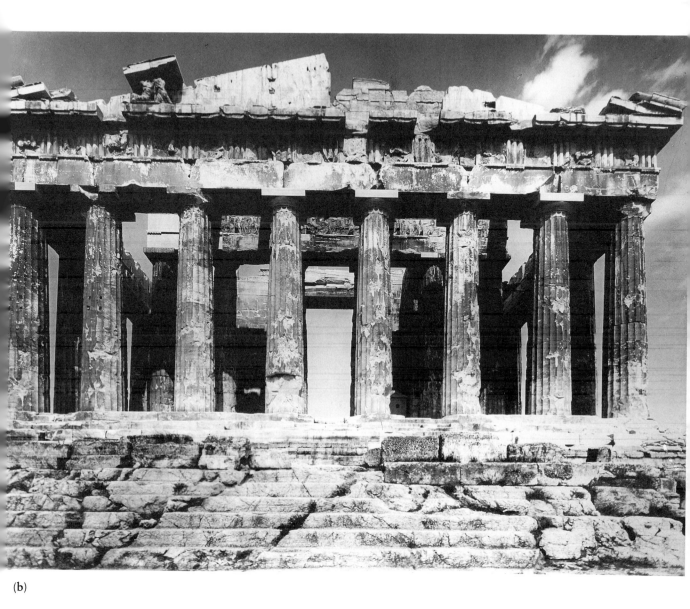

(b)

taming? What were the transition points like before the bridges? The appearance of temples and the development of their architecture reflect the reaction of the Greeks to profound questions about the position of humankind in the universe. How, though, do we get at those questions? Moreover, are these questions what we actually respond to on the deepest level when in the presence of the Parthenon or the Propylaia, or even of neoclassicism?

11

DORIC ORDER

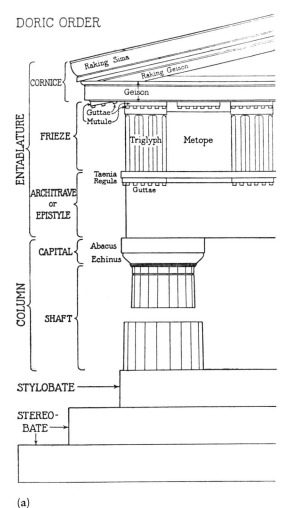

(a)

6. Typical Doric: (a) elevation and (b) plan. [From I. H. Grinnel, *Greek Temples* (New York, 1943), pp. xviii, xv. (By permission of the Metropolitan Museum of Art.)]

(b)

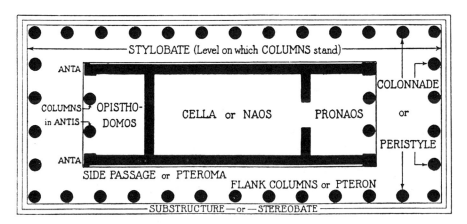

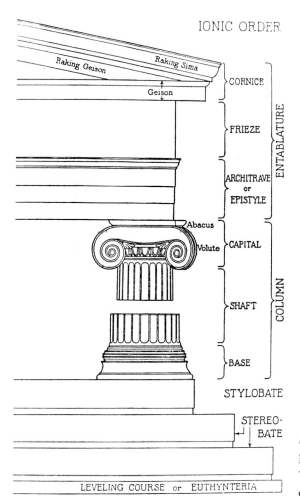

IONIC ORDER

7. Typical Ionic: elevation. [From I. H. Grinnel, *Greek Temples* (New York, 1943), p. xix. (By permission of the Metropolitan Museum of Art.)]

Our deep reaction in the presence of antiquity has to do with academic memory and with myth. It also has to do with the collective memory of Western culture, a memory perhaps best expressed subconsciously through the abstract geometry of classical temple architecture, the memory of a time so remote, the memory of instincts so uninsulated by the ever-successive layers of ritual and objective intellect, that our only meaningful access to it is through myth and instinct – and through the land itself.

Nearly every traveler to the ancient world is touched on one level or another by the sometimes overwhelming, sometimes brutally crys-

talline sense of place experienced at ancient holy spots. It is more than just beautiful vistas and lovely settings; perhaps it comes from the rich historical and mythological associations that pack a given site. It is true that we as visitors are moved by the almost palpable reality of the myths and history that tradition places there. Certainly this contributes to our sense of continuity, of place in the ancient world. Myth and history, however, were essential elements in the character of classical sites not just now but also in antiquity: the one as the memory of witnessed events, the other as memory of deepest human nature. It is thus perhaps unreasonable to suggest that either type of memory can be separated, even hypothetically, from the actual character of their site. In light of the nature of myth, the most ancient kind of memory – the kind of memory that precedes the foundation of settlements – the more essential questions would seem to be, "Why did these myths become associated with these specific spots? Is myth inherent in the site?"[1]

Myths, like temples and grave monuments, are responses to divinity and the problem of humanity's relationship to it. The inspiration for myth is closely related to the inspiration for temple building, and as Greek temples preserve the memory of their original inspiration, so myths preserve the memory of an original confrontation with divinity, with the gap between human and god. Just as local myths are almost always associated with specific, natural features of the landscape, it is reasonable to think that temples, whose nature is not unlike that of myth, were not scattered haphazardly through the landscape, but sited in direct response to it.

Figs. 8, 9

Ancient tradition and modern archaeology indicate Corinth as an originator of monumental temple architecture in Greece, and it is worthwhile asking why it began there. Can it be accidental that Corinth is also a site packed with uncommon riches of vista and myth? The earliest habitation in Corinth centers on the sacred Spring of Peirene, in whose shade the old men of Euripides' *Medea* lolled away the daylight hours – Peirene, the unfortunate mother who dissolved into a spring of tears when her son was killed by Artemis. A second spring, now a bedrock cube before the Doric monoliths of Corinth's central temple, records the misery of another woman – Glauke, fickle Jason's fiancée – who hurled herself into the spring, robed in Medea's fiery

14

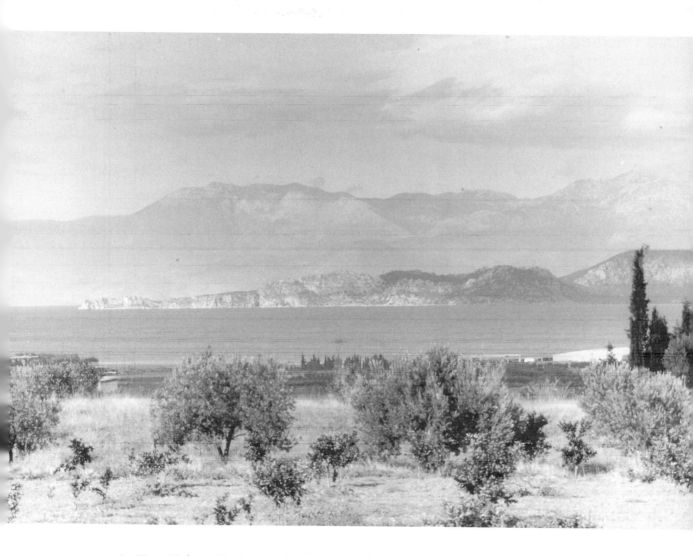

8. View N from Corinth: peninsula of Perachora in middle ground, Mt. Helicon behind. [Photo: R. F. Rhodes (neg. no. 94-S-2).]

wedding gift, only to be consumed in witch's flames beneath its surface.

Beside the Spring of Glauke, as late as the second century of our era, stood monuments to terror and to the children of Medea and Jason, butchered on the spot by Medea in final vengeance upon her faithless husband, or by the Corinthians themselves in vengeance upon Medea. There, too, beside Glauke was perhaps the earliest sanctuary in Corinth, a sanctuary of Hera, whose Dark Age cults are often wed to heroes, myth, and memory of Agamemnon and the warriors of the Trojan War; Hera whose Corinthian epithet derives from the landscape, Hera Akraia, Hera of Heights, Hera of the highest spot in Corinth; Hera who gazed at her reflection in the gulf, another Hera Akraia who from time immemorial also inhabited the point of Geranion's peninsula, Perachora, Corinth's northern flourish, "the land

Fig. 8 beyond." There on the ridge beside Hera were Apollo and Zeus and Athena. Corinthian Zeus and Hera and Athena – a tripartite divinity, derived at least in part from the landscape, lost none of its power outside its local context, for the heights of Corinth were transported to the Etruscans in Italy, and the first Tarquin king of Rome, half Corinthian, brought them to another peak, the peak of the Capitoline, as Jupiter, Juno, and Minerva, the Roman Triad of the Republic and

Fig. 9 Empire. Moreover, on Corinth's mountain, Acrocorinth, is a second Peirene, an endless supply of clear, cool water, so refreshing that it lured Pegasos the flying horse – Pegasos of Corinthian coins, born of the severed head of the monstrous Gorgon Medusa – into the waiting bridle of Bellerophon. The scent of Peirene enticed this creature to leave his home, Helicon, the mountain against which Perachora silhouettes itself, home of the Muses, inspirers of myth, of art, of monumental instinct – Helicon, neighbor and kin of Parnassos, home of Delphi, mouthpiece of the great god Apollo, towering white-capped above the shores of the Corinthian Gulf.

Fig. 10 Corinth is a site that inspired limitless layers of mythology, and a sense of the mythical still filters to the surface through the dusty strata of the gritty little modern village. Even today a strong impression of timeless place is experienced there, through the counterpoint of rock and water and heat, a sense of the impassivity of nature toward humankind. Greece does not have a monopoly on "place," but its peculiar physical character, with the immediate and nearly universal

16

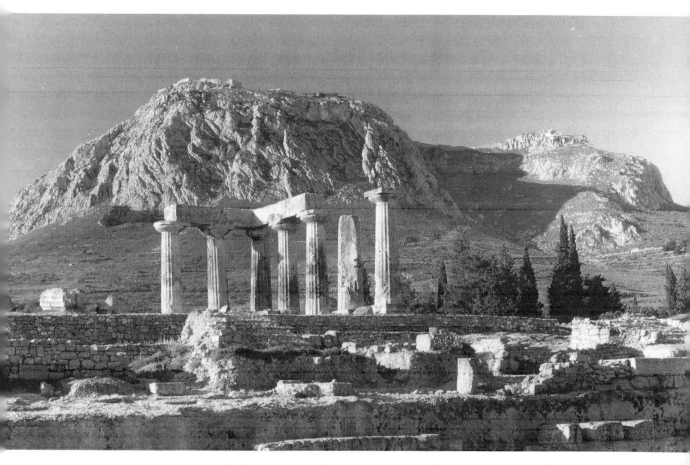

9. Corinth, looking S: Temple of Apollo and Acrocorinth. [Photo: R. F. Rhodes (neg. no. 94-8-21).]

juxtaposition of sea and plain and mountain, compels acute aware-ness of nature, and compelled the ancient Greeks to seek their gods in the landscape.

The human need for physical and spiritual orientation is universal, and the clear, hard edge of the Greek landscape and its crystal-dry air magnify both that need and the sense of place. The mountains, their relationships to one another and to the sea, are so clear and unique that even brief familiarity with two or three can serve as a firm if daunting anchor in the physical world. It is more than a matter of be-longing to a specific family or village; it is standing in a specific spot

17

that has been recognizable since the beginning of time by the same unchanging spatial markers, a spot whose location has been precisely and unconsciously triangulated with those very same markers a million times by a million farmers and shepherds and soldiers. It is the sense that on some level each of those millions was compelled to calculate his or her place in the universe – physical, temporal, spiritual – in relation to those markers; the sense that firsthand knowledge of the eternal is *compelled* through the experience of their permanence.

It is the magnitude and permanence of the markers that anchor and are humbling, and their particular configuration that fixes a pilgrim more firmly in one spot than another. Truly, the power of the landscape – the mountains, the empty sky, the sea and its wine-dark blueness – is felt nearly everywhere in Greece, but in certain spots the triangulation is crisper, purer, and the lines of sight seem to rivet the beholder as if in stone. Such a perception, as an endless line of poets and painters over the centuries attests, is not ephemeral: These spots are forever fixed, infusing this pilgrim and the next, and the next and the next, to the next millennium, with a sense of adamantine permanence, a sense of the unchanging, never-ending continuity of the power and texture of nature. Surely these spots inspire human beings to acknowledge permanence, to dread it, to wonder at it, to placate it, to embrace it, to worship it – to build temples to it.

Maybe it was in response to this that the Dorians chose their temple sites and invented their immobile, indestructible architectural order, carved from the very rock of the landscape, weathered like the face of a mountain. Maybe it was the overwhelming sense of permanence felt by some Dark Age vintner that made a specific spot in the landscape holy and that drove him on that impossible quest after permanence in architecture. Maybe this is why "the earth, the temple, and the gods" are impossible to separate in Greece, and why in Nashville the Parthenon looks like just another bank building.[2]

The Temple

As we have observed, rituals originate at points of transition and can perform a spiritual function. The site of a temple is a monu-

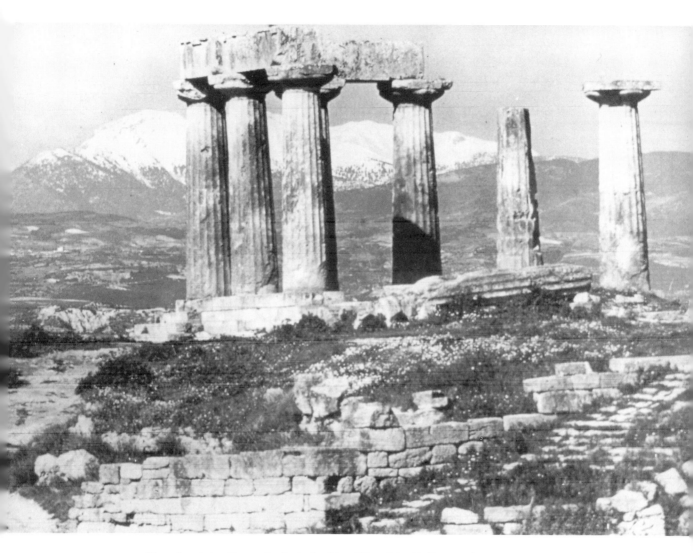

10. Temple of Apollo at Corinth, looking W to Mt. Kyllene. [Photo: G. Sweet. By permission of the Yale University Slide and Photograph Collection.]

mental point of transition, a transition between god and human, and the temple is the appropriately monumental ritual, the bridge, that makes the meeting possible. On these sites humankind comes face to face with permanence, a confrontation that is not a comforting one. These points of spiritual transition smell not of cool rationality, but of emotion and dread. In art emotion is traditionally expressed through distortion, through the transformation of the familiar into the unfamiliar, and the magnitude of the original Greek emotional response to spiritual transition is evident in the magnitude of the transformation of common kitchen crockery into the earliest monumental architecture of Greece. However, the points at which human beings pass from life to death are trivial in comparison to the sites the gods themselves inhabit! Those sites require burnt offerings, blood sacrifice, and entire buildings, not pots. The dread and awe originally ex-

11. Temple of Artemis at Corfu, reconstructed W facade; first half of the sixth century B.C. [From R. Lullies and M. Hirmer, *Greek Sculpture* (London, 1960), p. 57, fig. 1, after G. Rodenwaldt, *Altdorische Bildwerke in Korfu* (Berlin, 1938), fig. 37. By permission of Hirmer Verlag and Gebr. Mann Verlag.]

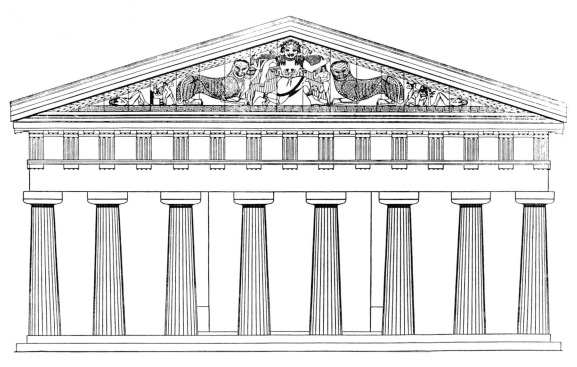

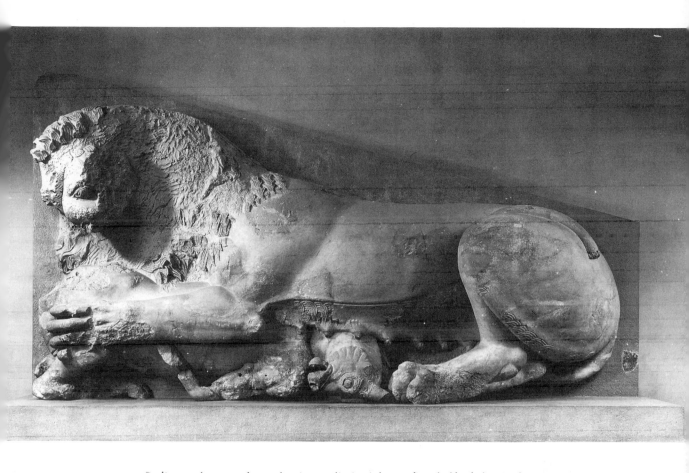

12. Pedimental group from the Acropolis in Athens; first half of the sixth century B.C. [Photo: Deutsches Archäologisches Institut, Athens (neg. no. 72/2962).]

perienced in these places still resonates in the sculptural represen-
tations on the earliest stone temples in Greece, in their emblematic
monsters, viper-haired Gorgons whose glance terrifies man to stone,
colossal leopards, lions ripping oxen limb from limb – monsters still
untamed by human intellect, not yet banished from religious expres-
sion in favor of carefully sanitized, neatly contrived, consistently
scaled, eminently controllable human stories. The purpose of these
monsters is not decoration: They are not confined to the random lim-
its of their architectural space, they simply rest there. Nor do they
protect the god: Gods don't live in garrisons. Their purpose is the di-

Figs. 11, 12

21

rect confrontation of any pilgrims who dare to approach, to confront them abruptly with that same unwavering, awesome, dreadful gaze that originally inspired the creation of the temple. Their purpose is one of ritual.

The sense inspired by these temple sites is not what emanates from the Parthenon; indeed, it is the antithesis of the Parthenon's order, its neatly rational form; the antithesis of god-in-the-service-of-humanity; the antithesis of a human-controlled universe. These sites do not inspire pride or ambition; they do not inspire the Olympian comfort we feel in the presence of the minutely controlled geometry of Classical Greek art. They inspire the awe and dread of the irrational, of a monstrous underworld, of Near Eastern gods, sky gods, Hittite Teshub of the devastating thunder: a sense of the monumental, beyond the ordinary; a sense of the immortal; a sense that recalls primal memories of more immediate gods, memories that can be expressed only as myth. In these places, these early temple sites, we have the unique opportunity to experience and remember something of that original religious reflex, stripped of its ritual insulation and sheltering intellect.

Fig. 13 Perhaps, then, the entire temple, as it develops over the centuries and in all its details, should be read as conscious and, later, subconscious, expression and elaboration of that ritual.[3] Eventually, that first temple builder's reaction to the permanence of the landscape approached permanence itself, through strict canon and the intricate regularity and ever-returning pattern of his massive stone architecture. Now, twenty-five hundred years later, we respond to the beauty and proportion of the classical orders, to the sense of the continuity of time and humanity implicit in them and in their ruins; but under-
Fig. 14 lying it all, in causal relationship, is the Gorgon Medusa.

The successors of that first temple, with their richly carved moldings forming well-modulated, organic transitions from one part of the building to the next, ultimately constitute an infinitely orderly and precisely constructed bridge from the daily life of the fields of a Dark Age farmer to the permanence of the unknown. Perhaps it is for this that we grope, in our spiritually destitute culture, when we reach out to the classical orders; perhaps a deeply subconscious cultural mem-

13. *(facing)* Parthenon, W end. [Photo: Deutsches Archäologisches Institut, Athens (neg. no. Hege 1039).]

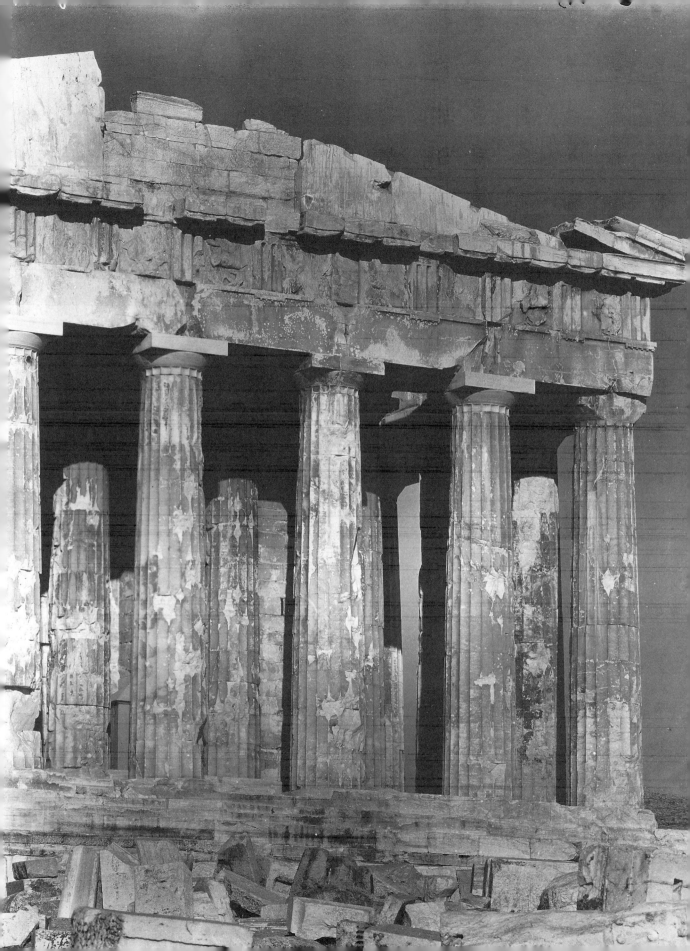

ory whets our thirst for the three-dimensional texture and spirit imparted to stone by the carved symbols of Greek architecture – triglyphs and metopes, scotias and apophyges, mutules and regulae, cavettos and reversas. Texture and spirit, ritual – the fruit of a living mythology – has now been sacrificed to practical theory, for the shallow aridity of slick glass and plastic.

As Vincent Scully has written:

> . . . all Greek art, with its usual sculptural concentration upon active life and geometry, may be properly understood and adequately valued only when the Greek's counter-experience of his earth is kept in mind. In this way the forms he made can be seen in their uncompromised logic and true dimension: as compact images of act and will . . . nakedly separate from the natural environment but to be understood in balance with it. The landscape should therefore be regarded as the complement for all Greek life and art and the special component of the art of Greek temples, where the shape of human conception could be made at the landscape's scale.
>
> . . . [T]emples . . . were so formed in themselves and so placed in relation to the landscape and to each other as to enhance, develop, complement, and sometimes even to contradict, the basic meaning that was felt in the land . . . the temple itself developed its strict general form as the one best suited to acting in that kind of relationship.[4]

Fig. 15

The Parthenon, with its crisply ordered Doric, speaks to us of confidence, of safety, of predictability and understanding – of Periclean Athens; but its glossy surface is ultimately fed by the roots of monumental tradition, a tradition whose earliest examples were not expressions primarily of intellect. When the Greeks first laid an altar or built a temple, when they drained their artistic and spiritual psyche into the creation of monumental form, they were not responding to a comfortable or comforting or safe universe. Comfort inspires complacency, not images of Gorgon's blood and child murder. In a sense, developed Doric inspires the antithesis of the feeling inspired by the original site; in other words, in the end – in its crystallized, canonical form – Greek temple architecture does not recreate the emotional impact of nature, of basic religious experience on humans, but is a cumulative reaction to it, a human counterbalance, the other side of rit-

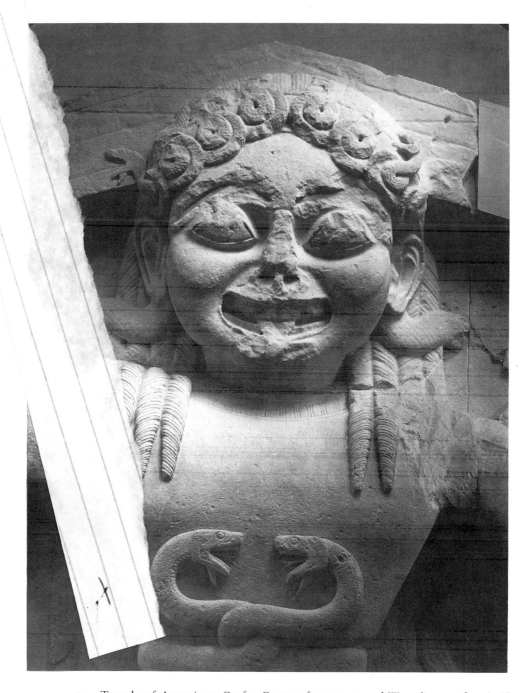

14. Temple of Artemis at Corfu: Gorgon from center of W pediment; first half of the sixth century B.C. [Photo: Deutsches Archäologisches Institut, Athens (neg. no. Hege 2213).]

ual. Perhaps the infinite care and detail with which the Greeks ordered their art and architecture is a direct correlation of their original spiritual distress, their original sense of awe and dread in the face of a colossal universe completely unfazed by and even unaware of the existence of humanity. The ever-increasing, ever-more-detailed elaborations of the classical orders are the successive layers of religious and cultural patina that grew from, but also separate us from, that original core of question and ritual response. When those layers are cleaned away, we are left with something completely unsanitized, un-insulated, as yet untamed: Western humanity's original and most basic response to its transience and utter weakness in the landscape, in the universe of power and permanence that surrounds it. When humankind first sought some understanding of its place in it all and, perhaps, a sense of personal substance, where did it look? To those specific spots in the landscape that exuded a godlike sense of permanence – spots fixed by the numinous landscape, not simply in three dimensions, but for all time, past and future, by the unchanging, un-affected, unconcerned reality of rock, immensely and immortally anchored between the ever-shifting, infinitely unpredictable sea and the endless sky. In these locations human beings were compelled to react to permanence, to acknowledge it, to mark it, lest they be swallowed up by it. These are the holy places, where gods alight. These are the homes of temples.[5]

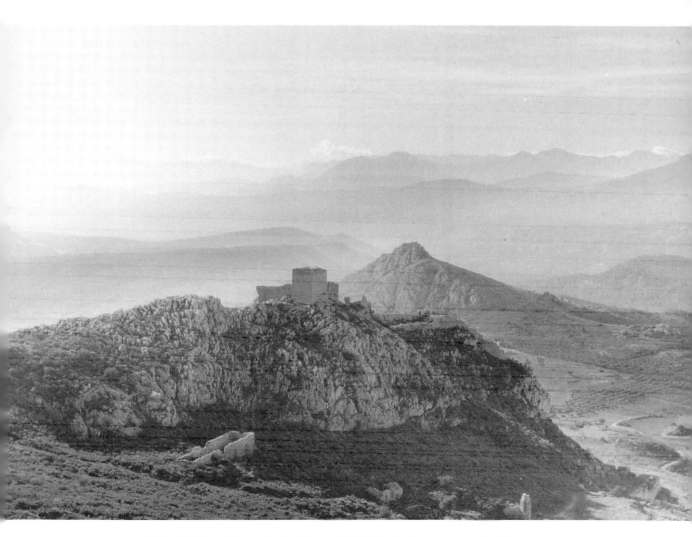

15. View W from Acrocorinth. [Photo: R. F. Rhodes (neg. no. 94-S-3).]

1 History in the Design of the Acropolis

Figs. 16, 17

IT WAS NOT UNDER PERICLES and Athenian democracy that the Acropolis was first transformed into the monumental religious and artistic center of the city: That was accomplished a century earlier, at least in part under the tyrant Peisistratos and his two sons. The organization and traditions of the Archaic Acropolis are at the heart of both the form and the meaning of the shining fifth-century Acropolis of Periclean Athens.

At the dawn of Athenian democracy in the late sixth century, the Acropolis was entered through a monumental stone gateway, perhaps still the original Mycenaean one and on the site of the later Classical entrance, the Propylaia of Periclean times. Cults of Athena were housed in two large temples, the Hekatompedon (on the site of the

16. *(above, facing)* Plan of the Archaic Acropolis according to W. B. Dinsmoor (pre-530 B.C. buildings black, those between 530 and 480 B.C. hatched, later structures outlined): 1, propylon and Propylaia; 2, Temple of Athena Polias and probable predecessor (Erechtheion immediately to the N); 3, Kekropion; 4, altar; 5, oikemata; 6, Hekatompedon, Older Parthenon, and Parthenon. [From W. B. Dinsmoor, "The Hekatompedon on the Athenian Acropolis," *AJA* 51 (1947), 109–51, fig. 3. By permission of the *American Journal of Archaeology*.]

17. *(below, facing)* Plan of the Classical Acropolis: 1, Propylaia; 2, Temple of Athena Nike; 3, Mycenaean wall; 4, Sanctuary of Artemis Brauronia; 5, Chalkotheke; 6, Parthenon; 7, Temple of Athena Polias; 8, Erechtheion. [From G. P. Stevens, "The Periclean Entrance Court of the Acropolis of Athens," *Hesperia* 5 (1936), 443–520, fig. 66. By permission of the American School of Classical Studies at Athens.]

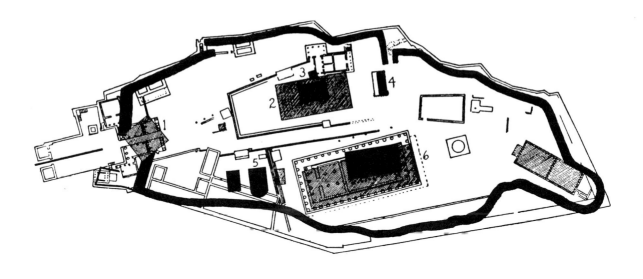

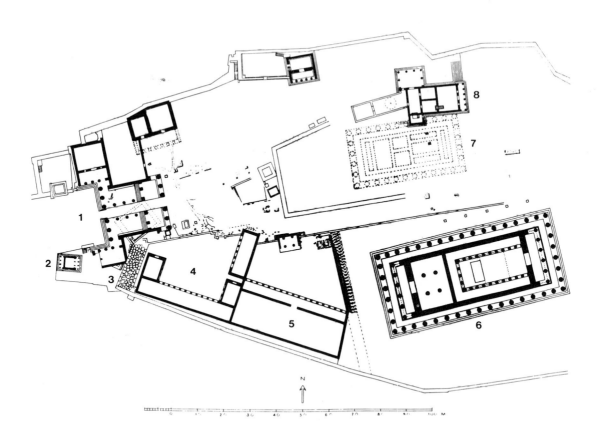

Periclean Parthenon) and the Temple of Athena Polias (just to the south of the late-fifth-century Erechtheion). To the west of the Hekatompedon were a series of *oikemata* (probably treasuries), built in the form of miniature temples.[1] All these buildings were executed as parts of an extensive Athenian building program whose overall layout, at least in the case of the major buildings, is preserved in the Classical Acropolis. Yet what of the young democracy? Was there a building program associated with it?

For political reasons, Kleisthenes, eventually "the father of Athenian democracy," and his family of Alkmaionidai were expelled from Athens by the tyrants, and after their attempted return was thwarted in 513, they undertook to complete the great Temple of Apollo at Delphi. In fact, in an intentional political statement to Apollo and to the Athenian people and to the rest of the Greek world, they finished the temple more magnificently than it had been begun, in fine marble. In a sense, the east end of the Temple of Apollo at Delphi, the Alkmaionid end, is the first monument of the new Athenian democracy.

The Older Parthenon

Fig. 18

In the earliest years of the democracy, shortly after the expulsion of the last of the Peisistratid tyrants, two major constructions were undertaken on the Acropolis: a new *propylon* (gateway) and a new temple to Athena. The propylon was the immediate predecessor of the Periclean Propylaia; the new temple of Athena replaced the Hekatompedon, and in site and form closely foreshadowed its successor, the Parthenon of Pericles.[2] This "Older Parthenon," the most elaborate construction of its time, appears to have been built in the wake of the greatest military victory in Greek history – that of the Athenians over the Persians at Marathon in 490 B.C. – and was probably intended, at least in part, as a monument to and a monumental thank-offering for the miraculous survival of their tiny democracy in the face of an immense and aggressive Persian tyranny. The threat of tyranny was all the more immediate and bitter for the traitorous alliance between former Athenian tyrant Hippias and the Persians; the implications of his presence on board one of the enemy ships must

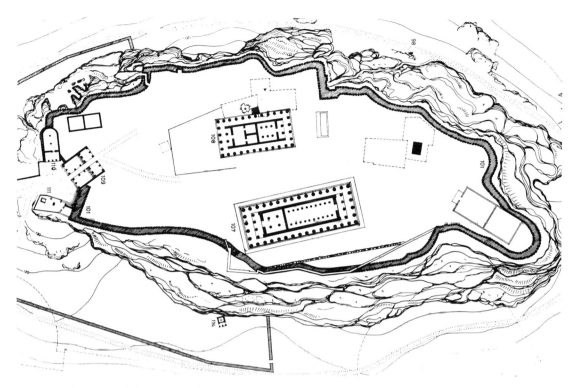

18. Plan of the late Archaic Acropolis; oikemata not included: 101, Mycenaean fortification wall; 107, Older Parthenon; 108, Temple of Athena Polias; 109, propylon; 111, Sanctuary of Athena Nike. [From J. Travlos, *Pictorial Dictionary of Ancient Athens* (London, 1971), p. 61, fig. 71. By permission of Ernst Wasmuth Verlag.]

have further enhanced the Athenian perception of Marathon and the Older Parthenon as symbols of the remarkable early success and power of the young democracy. The magnitude of the victory at Marathon cannot be overestimated. It quickly reached mythical dimensions; indeed, its dimensions were mythical at the time it occurred. Athens was singled out as the quarry of a vast, numberless horde of semihumans who fought not of their own free will but had to be whipped into battle, whose lives were so cheap that they wore armor not of metal but of wicker, if any at all. The Persian attack on Athens

31

was something out of a childhood fairy tale or nightmare: the Near Eastern monsters of myth and art come to life.

When the Persians attacked again ten years later, the Older Parthenon was still under construction. It and the Temple of Athena Polias and the treasuries and everything else on the Acropolis were destroyed when the Athenians retreated en masse to the nearby island of Salamis and surrendered their city to barbarian vengeance. A year later, after the Persians had been soundly defeated on sea and just before they were effectively driven from the mainland, the Greek allies swore a battlefield oath, the Oath of Plataia, not to rebuild their newly demolished sanctuaries, but to leave them in ruins as a constant reminder of the Persian threat and, perhaps, to remind them of the revenge still owed their Eastern foes.

The Acropolis North Wall

In those years following the Oath of Plataia no significant rebuilding was carried out in the ruined sanctuaries of the Acropolis, but under their general, Themistokles or Kimon, they did reconstruct the Acropolis fortifications.[3] Its north wall, that facing the agora, was reconstructed in part from fragments of the Older Parthenon and the Temple of Athena Polias, neatly ordered by type that they might be immediately read from afar as column drums and frieze blocks and cornices ripped from the religious heart of Athens by marauding Persians.

The construction of the Older Parthenon, the most important temple of the early Athenian democracy, had been rooted in Archaic religious tradition, but its significance was also closely tied to a specific historical event, the Battle of Marathon, and to the historical development of a specific Athenian institution, democracy. Still less ambiguously, the ruined sanctuaries of Greece, left unrepaired by the Oath of Plataia, created a widespread, general monument to a specific historical circumstance. The rebuilt north wall of the Athenian Acropolis, however, represented a specific monument consciously *constructed* from the ruins of the Persian sack to commemorate that specific event, to warn of the general Persian threat, to kindle the anger of the Athenians against them, and, probably, to symbolize the

Fig. 19

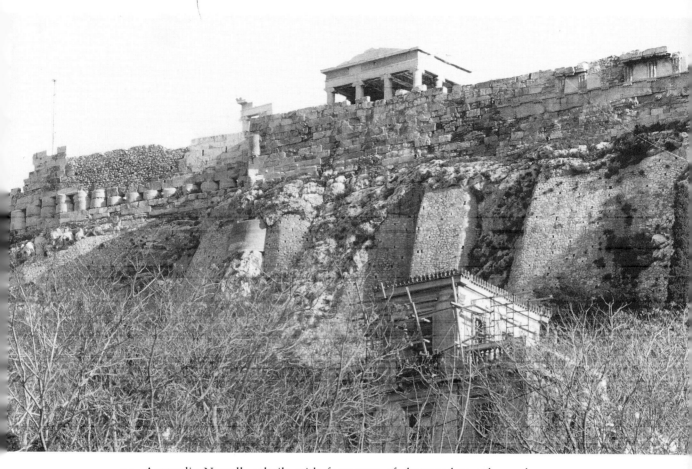

19. Acropolis N wall, rebuilt with fragments of destroyed temples: column drums to the left, frieze and cornice blocks to the right; Erechtheion in background. [Photo: R. F. Rhodes (neg. no. 94-7-37).]

Athenians' selfless sacrifice of their city to the general defense of the Greek mainland. The rebuilt north wall of the Acropolis is a unique monument in the history of Greece, and is truly remarkable in its understanding of the potential power of ruins upon the emotions and imagination of people.

Aeschylus' *Persians,* a play about the destruction in 480 of the Persian fleet by the Greek allies off the island of Salamis, can be read as a contemporary historical monument, a monument to Athens and the

33

new democracy; and the Painted Stoa in the Athenian agora included a monumental painting of the glorious victory of the Athenians at Marathon. We do not normally associate the art of Classical Greek religion with the representation of specific, literal history; yet here in Athens, in the Older Parthenon and the north Acropolis wall, as well as in the unrepaired, ruined sanctuaries of Early Classical Greece, are monuments created in response and reference to specific historical events. In fact, a sense of specific history is not limited to Early Classical Greece; it is also crucial to the conception and form of the Periclean Acropolis in Athens.

The North Foundation Wall of the Temple of Athena Polias

A third historical monument on the Acropolis, another monumental ruin, is the north foundation wall of the Temple of Athena Polias, destroyed, as was mentioned, in the Persian sack of 480. This *Figs. 20,* north wall was intentionally incorporated into the fabric of its suc-*68, 73* cessor, but not for purely structural reasons; it was overlapped by the Erechtheion south porch, the Porch of the Maidens, but did not serve as the foundation for it. Instead, its purpose was at least in part symbolic, to serve as a link between the Erechtheion and its religious and architectural predecessor, between the Periclean Acropolis and the one destroyed by the Persians; it is even probable that the ruined north wall of the Athena temple was intended to be seen when passing beneath the Porch of the Maidens, and that its north face was left at least partly visible as a retaining wall for the cult area to the west of the Erechtheion.[4] The juxtaposition of its rough and irregular limestone blocks with the elegantly smoothed marble of the Erechtheion would have strikingly emphasized the contrasting age and circumstances of the two buildings. It would have been a simple matter to refinish the Athena temple's north foundation and revet it with marble, but the architects of the Erechtheion seem to have chosen to leave it in its original state, as an intentional visual connection between their new building and the pre-Persian Acropolis, through the preservation and incorporation of a recognizable fragment of the old, destroyed cult house of Athena Polias.

34

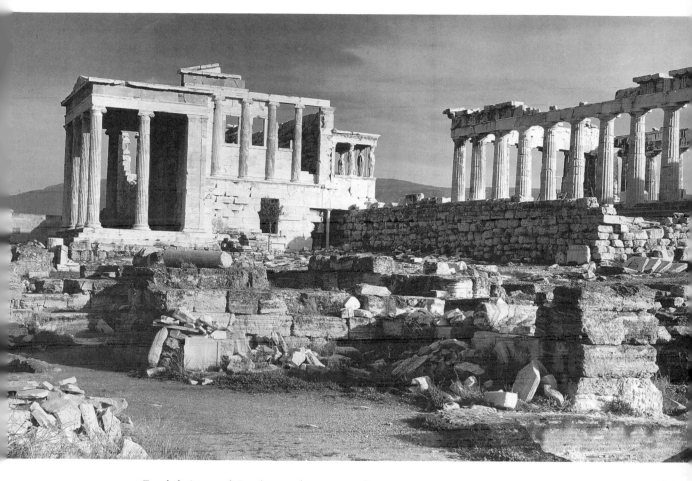

20. Erechtheion and Parthenon from NW, showing N foundation wall of the Temple of Athena Polias passing under the Porch of the Maidens. [Photo: Deutsches Archäologisches Institut, Athens (neg. no. 75/534).]

The Caryatid Porch

Closely related to the north foundation wall of Athena Polias, *Fig. 21* physically and symbolically, is the Porch of the Maidens, the caryatid porch of the Erechtheion. Not only does it overlap and incorporate that wall into the fabric and meaning of the Erechtheion, but its maidens, through specific historical reference, may have been intended as a kind of symbolic explanation for the Erechtheion and for the Periclean building program in general. This certainly seems to have

35

been the view of Vitruvius, a Roman architect and architectural historian of the first century B.C. In describing the origins of caryatids in Greek architecture he says:

Caryae, a state in Peloponnesus, sided with the Persian enemies against Greece; later the Greeks, having gloriously won their freedom by victory in the war, made common cause and declared war against the people of Caryae. They took the town, killed the men, abandoned the State to desolation, and carried off their wives into slavery, without permitting them, however, to lay aside the long robes and other marks of their rank as married women, so that they might be obliged not only to march in the triumph but to appear forever after as a type of slavery, burdened with the weight of their shame and so making atonement for their State. Hence, the architects of the time designed for public buildings statues of these women, placed so as to carry a load, in order that the sin and the punishment of the people of Caryae might be known and handed down even to posterity.[5]

It is generally agreed that caryatids were invented long before the Persian Wars with Greece, but on the basis of Vitruvius it is possible that they, like the battles of the gods and Giants, or the Centaurs and the Greeks, took on new symbolic significance in the context of those wars. In this event, the reference made by the caryatids of the Erechtheion was all the more powerful for the fact that they were forced to stand above and survey forever the site and remains of Athena's old temple, laid waste by the Persians ten years after Marathon.[6]

The Mycenaean Wall

Figs. 17, 22

There are still other architectural monuments on the Periclean Acropolis that are at least partly historical in intent, designed to recall and to document Athens' past visually. The old Mycenaean fortification wall still stands high in the unfinished southeast wing of the Periclean gateway to the Acropolis, the Propylaia. Rather than removing it where it impinged upon the projected lines of his building, the architect Mnesikles incorporated the Mycenaean wall into its fabric. From bottom to top he trimmed the angle of the Propylaia corner blocks to accommodate the wall. In other words, no economy of labor was accomplished by leaving the Mycenaean wall intact, nor does there seem to have been any intent to remove it at a later date.[7] From the beginning Mnesikles seems to have intended the Mycenaean wall

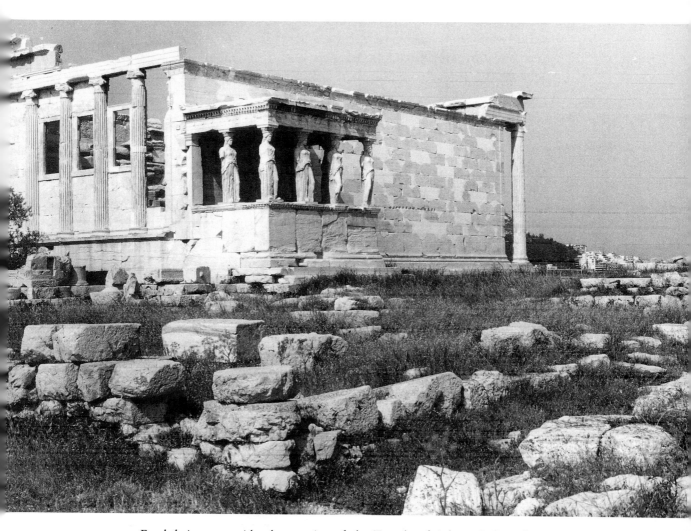

21. Erechtheion caryatids above ruins of the Temple of Athena Polias, from SW. [Photo: R. F. Rhodes (neg. no. 94-5-23).]

as a visible and meaningful part of his Propylaia. He and the Athenians were well aware of the great antiquity of their Acropolis, and here they memorialized its earliest architectural phase, as well as the debt of the new Propylaia to the original, Mycenaean entrance.

The Nike Bastion

Fig. 23 The last of the historical monuments in the architecture of the Athenian Acropolis are the hollows built into the base of the Athena Nike bastion. What remained of the original Mycenaean bastion was

22. Mycenaean fortification wall at SE corner of Propylaia, from SE; Temple of Athena Nike in background. [Photo: R. F. Rhodes (neg. no. 95-3-10a).]

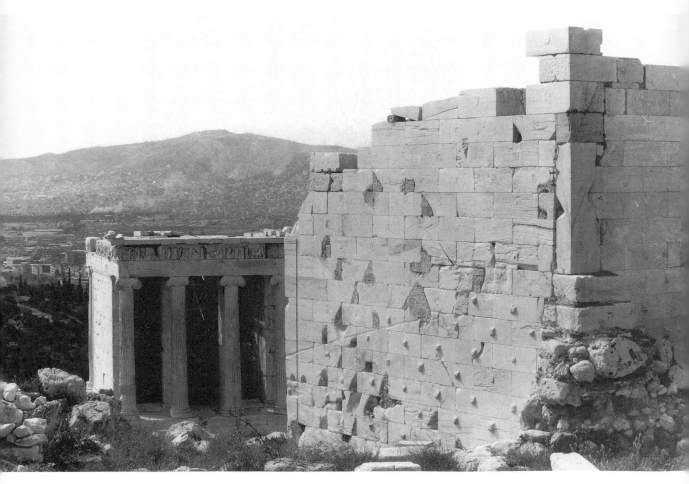

38

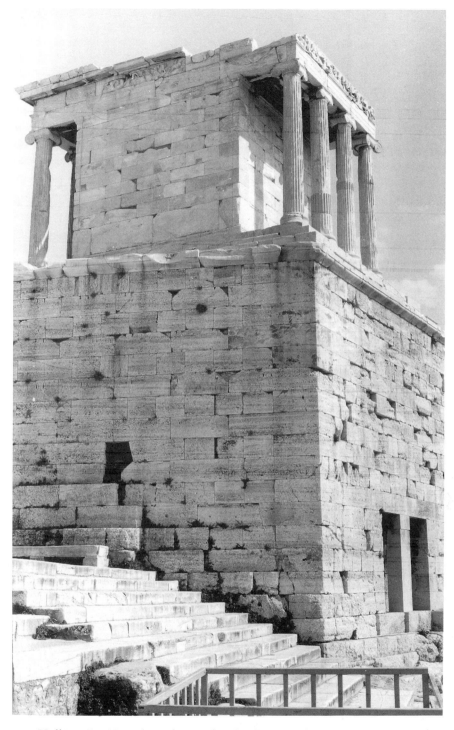

23. Hollows in N and W faces of Nike bastion, from NW. [Photo: R. F. Rhodes (neg. no. 94-12-11).]

finally faced with *ashlar masonry* (regularly coursed, squared blocks) in the fifth century, and a double-niched shrine in the west face of the old bastion was transferred directly into the masonry of the Classical sheathing.[8] The window left in the north face of the Classical bastion, however, indicates more than the simple continuity of ancient religious tradition. It accommodates the corner of one of the great rocks on which the ancient bastion was founded, and its sole purpose seems to have been to provide an immediate visual (and tactile?) connection with antiquity. Here smooth Classical veneer is peeled back to reveal the rugged cyclopean core of the Periclean Acropolis.[9]

The Parthenon

With the Battle of Marathon a new perspective, a new historical emphasis, and an almost religious sense of specific history begin to color the entire architectural fabric of the Acropolis. This is perhaps most immediately obvious in the monuments just discussed, and, to a lesser extent, in the original construction of the Older Parthenon, but it also permeates the rest of the Periclean building program. The interweaving of history in its post-Marathonian monuments is a crucial uniting element of the entire Classical Acropolis, and the whole fifth-century building program can be read on one level as a historical monument, most specifically as a monument built to the memory and results of the Persian threat.

Even the form of the Parthenon, the centerpiece of Pericles' vision of the Acropolis, was determined to a significant degree by a respect for history and a desire to incorporate it symbolically and literally into the crowning feature of the new Acropolis. Its location and much of its plan were determined by its predecessor; it even used columns and perhaps metopes originally prepared for the Older Parthenon. This was not done purely out of a sense of thrift: Pericles had control of the treasury of the allied league, the Delian League. Nor was it unintentional or without meaning: His building program was the symbolic manifestation of his vision for Athens, and the Parthenon was its jewel. When fantasizing and spending on such a scale, the salvage and reuse of architectural material is not necessarily to be expected,

particularly in light of the potential complication of integrating dimensions and proportions of preexisting members into a much larger structure than the original.

The Parthenon was the first building constructed on the Acropolis following Athenian release from the Persian threat, the first building constructed out of the rubble left untouched for all those years as a reminder of that threat. As such, it must certainly be associated with the intention to present Athens as final victor over the Persians, as the new leader of Greece, the mistress of an empire formed to defend Greece against barbarian destruction. Moreover, by building his new temple out of the ashes of the Older Parthenon, itself conceived in the euphoria of the Athenian victory over the Persians at Marathon, Pericles reminded the world that Athens had also been the initial defender of the Greeks against the Persians, the founder of the Greek resistance, the miraculous hero of the most magnificent Greek military victory of all history.

The post-Persian Acropolis[10] is unified on its most basic level by two closely related concepts, a sense of history and a sense of religious tradition. Not only are cult sites and religious traditions reestablished and reinvigorated, but specific historical events and circumstances are commemorated. The history involved might be ancestral Mycenaean or contemporary Athenian, but in any case its new monumental references evoke images of mythic proportion. Here is a specifically Athenian understanding of history (which must certainly have been encouraged by the fairy-tale magnitude of their recent victory over the Persians) not simply as a chronology of events, but as a vehicle for the monumental, as metaphor for the further elevation of themselves and their offerings into appropriate monumental concert with their gods.

This is not to say that the Athenian drive to associate themselves with the continuity of history and culture arose purely out of a desire for self-aggrandizement. It can also be traced to the very real threat presented by the Persians that all continuity in Athens – with the past and with the future – would be broken, and that Athens would cease to exist.

2 The Acropolis as Processional Architecture

THE PERICLEAN BUILDING PROGRAM represents the first significant construction within the walls of the Acropolis after the Persian sack of 480 B.C. It represents the resurrection of Athens' religious heart from the ashes of war, and for that very reason its meaning and form are deeply rooted in the history of the Athenians. As we might expect under these circumstances, the Periclean building program represents on the simplest level the rebuilding of the pre-Persian Acropolis. The Parthenon replaced the Older Parthenon as a home for the image of Athena Parthenos, just as the Older Parthenon had replaced the Hekatompedon.[1] The Propylaia replaced the early-fifth-century gateway on the same spot; the Nike Temple replaced the destroyed shrine to Athena Nike atop the old bastion;[2] and the Erechtheion was built to house those cults left homeless by the destruction of the Temple of Athena Polias. The oikemata seem never to have been rebuilt.

Pericles' building program was more than a simple rebuilding: It represented an integrated architectural concept and, unlike the pre-Persian buildings of the Acropolis, which had gradually appeared over the course of the sixth and early fifth centuries B.C., it seems to have been conceived as a unit. This does not mean that all the architectural details and the relationships among the various buildings had been determined when the program was begun; more likely, the details of each successive building were designed to fit both into the general context of Pericles' original concept and into the increasingly complex context of the existing buildings. The normally cited indica-

42

tions of the Periclean Acropolis as a unified concept are specific, for-
mal elements of design:

1. the parallel east–west axes of the Propylaia and the Parthenon;
2. the correspondence in proportional height between the columns of the
Parthenon's peristyle and those of the Propylaia's east facade;
3. the nearly identical echinus profiles of the Parthenon and the Propylaia;
4. the 2 : 1 relationship between the height of the Ionic orders in the Propylaia
and the Temple of Athena Nike;
5. the 2 : 1 relationship between the axial spacing of the Erechtheion north
porch columns and that of the Athena Nike columns;
6. the inward inclination of the Ionic columns of the Temple of Athena Nike
and of the Erechtheion north porch, a regular feature of Doric colonnades but
extremely rare in Ionic; and
7. the identical solution to the problem of the corner capitals in the Nike
temple and the north porch of the Erechtheion.

That a general, unified concept existed from the inception of the
building program is further suggested by inscriptional evidence that a
Nike temple had been planned before any construction had begun on
the Acropolis, and perhaps as many as twenty-five years before it was
finally built.[3]

In the Periclean Acropolis we see a religious center conceived and
built as an architectural unit, with kinds of formalized relationships
between the components that, in general, are unheard of before the
great building programs of the Hellenistic Age. Yet perhaps the Peri-
clean Acropolis is united on a more profound level than that of sym-
metrical geometry: Perhaps it is also consistent with the traditional
character of the Athenians' religious center; it may even reflect some-
thing of the overall effect of the organically grown Archaic Acropolis.
Indeed, given the historical sensibilities of the Athenians and the con-
tinuity of specific cult and site in the Periclean building program, as
well as the natural conservatism of religion, we might well expect
to find a partial key to the meaning of the Periclean Acropolis in
the meaning of the Archaic temenos it replaced. Pericles' Acropolis
might, in fact, represent more than a formal aesthetic treatise on the
new cultural center of the world, more than an immediate vision of
Athens as hero of Greece and victor over the Persians. Perhaps, like
a new colony, it also represents a formalization and unification of
those elements deemed essential to the spirit and traditions of its
mother.

The Archaic Acropolis

Fig. 24

What *was* the overall sense of the Acropolis in pre-Periclean, pre-Persian times? What was its function? In its most general and most traditional sense, it was the home of Athena and the other gods and heroes of Athens; but the Acropolis was also where the most important festival in Athens, the Grand Panathenaia, culminated. Furthermore, since the Acropolis was probably first elaborated monumentally in conjunction with the reorganization of that festival in the mid-sixth century, we might expect its architecture to reflect, to one degree or another, its function as the festival's monumental end point – more specifically, the culmination of the festival's final procession from the Dipylon Gate at the edge of town through the Potters' Quarter, through the agora and onto the Acropolis, and ending at the altar of Athena near the east end of the temples.[4] It may be that it was for the reinitiation of this grand celebration that the Hekatompedon, the first temple of Athena Parthenos, the ancestor of the Periclean Parthenon, was constructed, that treasuries were built, and that a ramp was added up the west side of the Acropolis. It might also be that the concept of procession, the element of the Panathenaia most pertinent to the Acropolis, was an essential influence in the early architectural elaboration of Athens' religious center. In fact, there are indications that distinct qualities of procession were transferred directly to the architecture of the Archaic Acropolis, and that they eventually comprised one of the guiding principles of the unified, formalized building program of Pericles.

At least as early as the late Archaic Period the Panathenaic procession was guided up onto the Acropolis via a massive masonry ramp, clearly constructed to accommodate large numbers of people. At its head a propylon formed a monumental transition from the secular world to the holy temenos of Athena. The propylon led from the profane to the sacred, but it channeled the procession onto the west side of the Acropolis, the *back* side of the temenos, the back of the temples. As a rule, the east is the holiest direction in Greek temple architecture – the temple entrance faces the rising sun – so the entrance to the Acropolis brought the procession from the outside world into the least sacred area of the holy temenos.

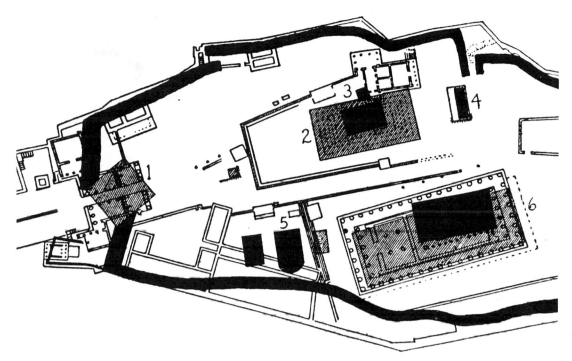

24. Detail of plan of the Archaic Acropolis according to W. B. Dinsmoor (pre-530 B.C. buildings black, those between 530 and 480 B.C. hatched, later structures outlined): 1, propylon and Propylaia; 2, Temple of Athena Polias and probable predecessor (Erechtheion immediately to the N); 3, Kekropion; 4, altar; 5, oikemata; 6, Hekatompedon, Older Parthenon, and Parthenon. [From W. B. Dinsmoor, "The Hekatompedon on the Athenian Acropolis," *AJA* 51 (1947), 109–51, fig. 3. By permission of the *American Journal of Archaeology*.]

This side of the Acropolis, the west, the back, is where the least holy buildings in the temenos were located: Their form was that of miniature temples, but their function seems to have been much different. Like the treasuries at Delphi and Olympia, they were probably *Fig. 25* not intended as places of worship or as shelters for cult images; instead, they likely served as repositories for votives, a place, perhaps, for public display of the generosity shown by the Athenians to their gods and heroes.

Like temples, these oikemata carried pedimental sculpture, but their subjects and design are distinct from those appropriate to tem-

Figs. 26, 27

ples and consistent with a step-by-step progression from the world outside through gradually more sacred grounds to, finally, the holiest place of all, the temple front. All the stories depicted on the oikemata pediments appear to be stories of *heroes:* Herakles fighting the Hydra, Herakles fighting Triton, the introduction of Herakles to Mt. Olympos, the death of Troilos at the hands of Achilles. Gods do appear in some, but the primary subject of each appears to be mortal man. Similarly, the primary purpose of these sculpted pediments is narrative, that is, they tell a story. Each is a self-contained, logical tableau. As human beings conduct themselves within the world of mortals, so these sculpted figures think their thoughts, live their lives, interact only within their own world, the world of the pediment. Not only does their action take place completely within their architectural frame, but even their glance is confined to the pediment: They move parallel to the tympanum wall, their faces in profile, never looking out from their own little world, never infringing upon the realm of the viewer. In the oikemata of the Athenian Acropolis, there is no confrontation between worlds.[5]

Figs. 11, 28

This is in striking contrast to the earliest sculpted pediments of Greek temples. Roughly contemporary with the oikemata are the pediments from the Temple of Artemis at Corfu. The purpose of their great central groups is not to tell stories of heroes, or even to tell stories. Their figures do not move or interact with each other, nor do they employ the conventional profile composition of narrative. Instead, they are staring emblems, clearly outlined and easily readable, formally immobile monsters from the darker side of creation: Gorgons and immense flesh-eating leopards, representatives of the older, pre-Olympian, inhuman side of the universe. They are the forces of nature, of Mother Earth, of the underworld. They do not confine their gaze to a neatly framed narrative space, nor direct their gaze at each other; rather, they stare directly into the eyes of the viewer and invade our space. Their strict frontal gaze forces us to interact with them. If there is any relationship between the intent of the creators of the Corfu sculptures and their actual effect, one purpose, if not the only one, was direct confrontational engagement with the viewer.

Storytelling is a basic human device for putting things beyond human grasp within the reach of reason; in general, stories follow logical rules and can make the unspeakable understandable, or at least de-

46

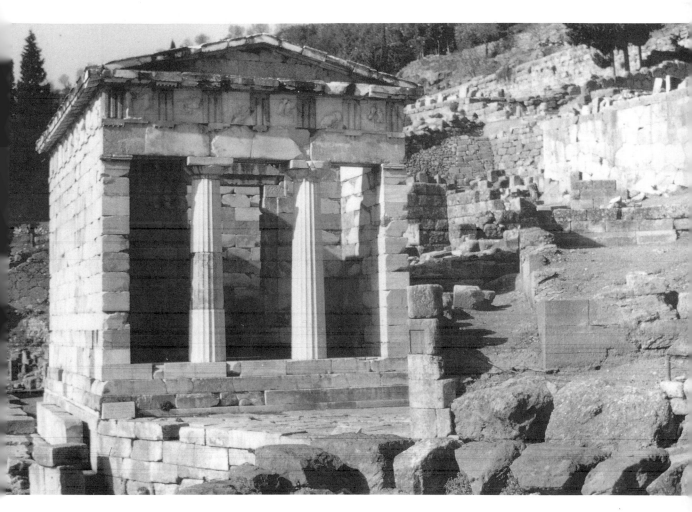

25. Treasury of the Athenians at Delphi, early fifth century B.C. [Photo: R. F. Rhodes (neg no. 94-S-4).]

scribable in human terms. The emblems at Corfu are not inappropriate to Artemis as mistress of animals, but they make no attempt at humanization; they tell no story. Instead, they invade our space and stir inarticulate, irrational, darkly emotional instincts about the universe and our place in it; their primary purpose is not to express the specifics of the goddess whose temple they adorn, but to inspire a general, abstract sense of divinity. The jarring contrast between the central group of the west pediment and the little human-shaped figures

47

(a)

(b)

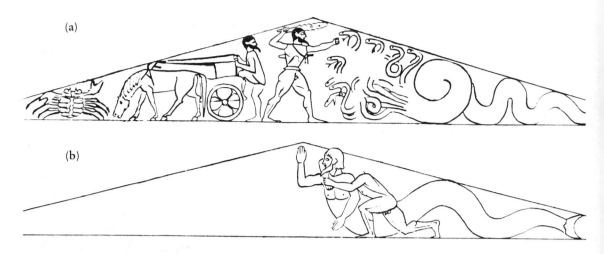

26. Acropolis oikemata pediments: (a) Herakles and Hydra; (b) Red Triton. [From E. Buschor, *Größenverhältnisse attischer Porosgiebel* (Athens: 1924), figs. 8, 9. By permission of the Deutsches Archäologisches Institut, Athens.]

27. *(facing)* Acropolis oikema pediment depicting the introduction of Herakles to Mt. Olympos. [Photo: Deutsches Archäologisches Institut, Athens (neg. no. Hege 1416).]

28. Temple of Artemis at Corfu, reconstructed W pediment; first half of the sixth century B.C. [From G. Rodenwaldt, *Korkyra*, vol. II, *Die Bildwerke des Artemistempels* (Berlin, 1939), pl. 2a. By permission of Gebr. Mann Verlag.]

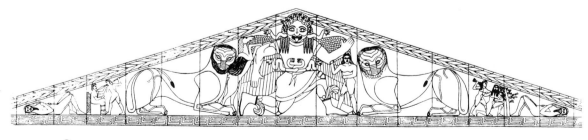

to either side (existing, it should be noted, in an appropriately narrative microcosm, completely oblivious to their larger context) imparts a pointed sense of human insignificance in the face of undiluted divinity.[6]

In contrast, the oikemata of the Athenian Acropolis are appropriately human in scale (miniature versions of temples) and their pedimental sculpture appropriately human in theme and narrative technique for their function as the most secular buildings in the temenos of Athena.

Fig. 29

Fig. 30a

The most sacred buildings on the Acropolis are the temples. Their relationship to the oikemata, together with their own decorative organization, reflect a sense of hieratic direction, of sacred procession. In the Hekatompedon, the first monumental temple constructed on the Acropolis, the two ends are emphasized by *in-antis* colonnades (i.e., those with columns framed between wall ends) and pediments. The colonnades equally emphasize the front and the back as the primary focuses of the temple, but the pedimental decoration clearly distinguishes between the two.[7] The pediment visible to the procession as it passed through the propylon into the back side of the temenos was the west, rear pediment, and it is indeed consistent in spirit with the other pediments of that sector of the Acropolis, those of the oikemata. The scale of the Hekatompedon sculpture, as of the architecture, is of course much larger than that of the oikemata, and the central group of the west pediment is emblematic and confrontational: two lions, frontally gazing, ripping a young bull to shreds. The purpose of the flanking groups is narrative, however, and unlike the minuscule flanking figures of Corfu, those of the Hekatompedon west pediment are consistent in scale with the central group. The resulting effect is very different from Corfu: The realm of narrative, of human

29. Plan of Hekatompedon. [From W. B. Dinsmoor, "The Hekatompedon on the Athenian Acropolis," *AJA* 51 (1947), 109–51, fig. 7. By permission of the *American Journal of Archaeology*.]

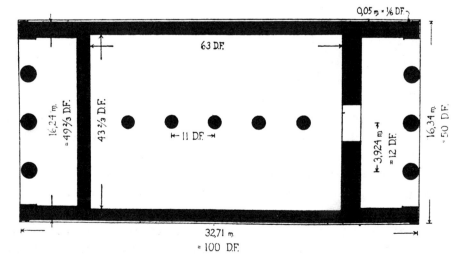

(a)

(b)

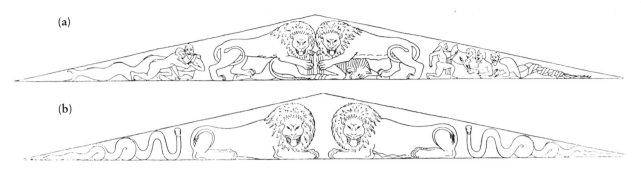

30. Reconstructed Hekatompedon pediments: (a) W pediment; (b) E pediment. [From W.-H. Schuchhardt, "Die Sima des alten Athenatempels der Akropolis," *AM* 60/61 (1935/36), 1–111, figs. 14, 15. By permission of the Deutsches Archäologisches Institut, Athens.]

action, is not dwarfed by the spirit of abstract confrontation. Confrontation is central, but the viewer's eye is equally drawn by the adventure of Herakles wrestling Triton (not to be confused with the "Red Triton" pediment mentioned above among the oikemata sculptures) and by the remarkably three-dimensional, triple-bodied "Bluebeard," who looks on but seems nearly as interested in the viewer as in Herakles, and whose effect, therefore, is partly narrative, partly emblematic. As would seem to be appropriate for a temple, the focus of this pediment is less strictly human, and its narrative less strictly unified, than the oikemata pediments. On the other hand, the relatively equal balance of narrative and emblem ties this end of the temple in spirit to the oikemata, as well as forming a bridge, a smooth transition, between the more secular aspects of the Acropolis and the most sacred area of all, the east front of the temple.[8]

The east end of the Hekatompedon, the front, the direction from which the temple was entered and the cult image approached, carried a sculptured pediment whose theme, like that of the rear, has no apparent direct connection with Athena. It consists of a symmetrical central group of two lions, one or both shredding a bullock (not shown in Fig. 30b; see Fig. 12), flanked by a pair of symmetrical, wavy-bodied snakes. With the exception of the beleaguered bullocks, each of the principals turns its head directly to the viewer. This purely emblematic, confrontational, completely nonnarrative pedimental

Fig. 30b

51

composition distinguishes this end of the temple from the back and articulates a third and final step of sacred procession on the Archaic Acropolis. In turn, the character of the hieratic distinction made between the sculpture of the oikemata and the Hekatompedon west pediment, and between the Hekatompedon west and east pediments, suggests that, as at Corfu, the most significant and most profound aspect of the Athenian conception of divinity at that time was general and abstract, as opposed to the specifics of narrative mythology.[9]

The second of the great sixth-century temples on the Athenian Acropolis, the Temple of Athena Polias, was built forty or fifty years after the Hekatompedon. Fragments of both pedimental groups are preserved, and although the specifics of representation differ from those of the Hekatompedon, the same distinction between east and west, between front and back of the temple, appears to be made. Unlike the Hekatompedon, however, whose west pediment is emphasized as belonging to a more human realm than the east by the employment of both narrative technique and mortal hero, the west pediment of Athena Polias tells a story of the gods, the battle of the gods and Giants (Gigantomachy).[10] Nonetheless, all its figures are human in form,[11] and it does comprise a story, not an emblem. Its violence is graphically related according to pure narrative tradition: The battle rages back and forth across the length of the pediment, movement and gaze parallel to the pediment wall, never overstepping the architectural boundary, never directly engaging the viewer. The one element of confrontation that perhaps belongs to this pediment is a *quadriga,* a chariot drawn by four horses abreast, set frontally in the very center of the pediment and probably carrying a frontal god. So here in the west pediment of Athena Polias divinity is rendered, but it is rendered in purely human terms; perhaps even the central figure of divine confrontation is no longer monstrous, but Olympian.

The temple's most purely emblematic, confrontational epiphany of divinity is reserved for the center of the east pediment, where another ferocious pair of lions stare out from over a downed bull.[12] The rest of the composition is unknown, but it does appear that here in the Temple of Athena Polias the traditional distinction between the narrative realm of humans and the nonnarrative, emblematic realm of abstract divinity is preserved in the thematic and compositional distinction between west and east pediments.

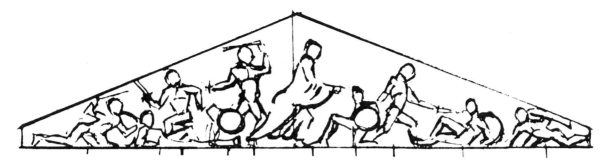

31. Sketch reconstruction of W pediment of the Temple of Athena Polias, by C. Seymour, Jr. [By permission of the Yale University Slide and Photograph Collection.]

A sense of architectural direction enhanced the atmosphere of procession inherent in the function of the Archaic Acropolis: Its architecture, in concert with the Panathenaic procession, progressed step by step from the west, from the realm of the secular, the human, the realm of stories, of human explanation, to the elemental religious experience of divine epiphany at the east side of the temenos, at the front of the two major temples to Athena.[13]

The Classical Acropolis

The emphasis in most discussions of the Periclean Acropolis is on innovation; but in the years following the Persian Wars, Athens and the Acropolis were not reinvented out of whole cloth. Many of the most ingenious and innovative features of the Periclean building program are directly, if somewhat paradoxically, inspired by assiduous respect for tradition on the parts of Pericles, his architects, and the Athenians. Sacred procession, at the heart of the Archaic Acropolis, is also basic to the design and spirit of its Periclean successor.

The Propylaia

The Periclean Propylaia, designed and built by the architect Mnesikles in the decade of the 430s, is a huge Doric gateway constructed on two levels. Its wings reach out from the Acropolis toward

Fig. 32

53

the west to embrace the Panathenaic procession, to gather it to itself, and through its split-level construction it ushers the procession from the lower ground outside up onto the sacred rock itself. This is the monumental articulation of the most profound point of transition in the procession: passage from the secular world to the temenos of the patron deity of Athens. The transitional purpose of the building – the procession from low ground to high, from outside in, from profane to holy – is elegantly expressed in the west elevation of the building, in its broken roof line and double pediments, which step up like the procession from west to east; these represent not the inevitable solution to structural requirements, but the unique choice of an architect concerned with incorporating a strong visual impression of procession into his gateway. Mnesikles could have leveled the bedrock; he could have built a roof of continuous line. Instead, he chose to reflect the changing ground level below in the changing levels of his roof, to emphasize the physical nature of the passage onto the Acropolis and, coincidentally, to create a monument uniquely appropriate to the celebration of spiritual transition.[14]

Mnesikles also chose to use the Ionic order on the interior of the Propylaia west porch. He did this for more than practical or even aesthetic reasons. Symbolically, the Ionic order was brilliantly appropriate for an architecture of procession: Together with colossal scale, the most salient feature of traditional Ionic temple architecture is the strong processional quality it derived from its religious requirements and Egyptian roots.[15]

Doric and Ionic both developed in the context of Archaic Greek temple architecture, Ionic in the colossal temples of sixth-century Asia Minor, Doric in the temple architecture of the Greek mainland, and in many ways the two temple types are very similar.[16] Yet at the time of the Periclean building program they were still essentially distinct regional styles, and their traditional differences in form and meaning would have been understood and exploited by Mnesikles and the architects of Pericles as they combined them in new and unique ways on the Acropolis in Athens.

In general terms, traditional Doric temple architecture is a symmetrical architecture of the exterior, meant to be experienced from a distance. The two ends of the temple are presented as virtually identical entranceways, with virtually identical arrangements of colonnade

Fig. 6

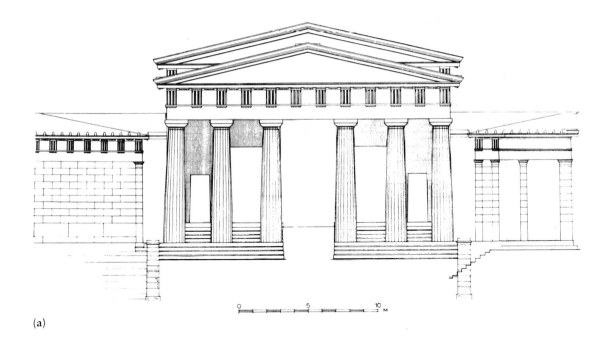

(a)

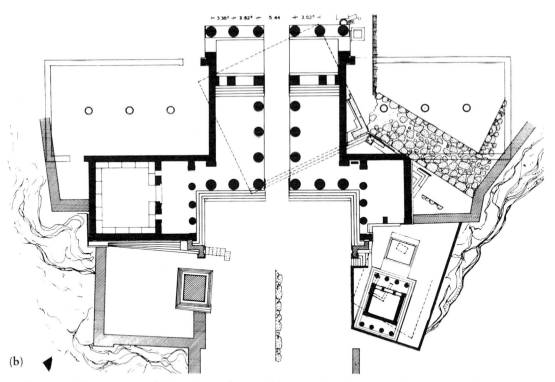

(b)

32. Reconstructed Propylaia of Mnesikles: (a) W elevation; (b) plan. [From J. Travlos, *Pictorial Dictionary of Ancient Athens* (London, 1971), p. 487, figs. 613, 614. By permission of Ernst Wasmuth Verlag.]

(peristyle) and open porch (pronaos at the front, opisthodomos at the back). As a result, there is no strong sense of direction inherent in Doric temple plan, no sense of procession, no compulsion to enter. Further, the temple proper is set on a platform with its columns at the very edge of the *stylobate* (top step). The height of the platform (three steps, and proportionately very high in comparison with Ionic), together with the emphatic delineation of the temple boundaries through coincidence of the columns and the edge of the top step, distinguish the temple from its immediate surroundings, isolate it as an independent entity. Its formal qualities set the Doric temple apart and impart to it that distinctly sculptural character so often attributed to Doric architecture.

Fig. 33a The interruption of horizontal continuity with the surrounding landscape also helps create a characteristically vertical emphasis. In addition to its platform, the Doric temple is traditionally sited on a natural eminence. Further, Doric is graduated in elevation, by means of the progressive multiplication of ornamental forms, from a rock-like, unadorned platform and baseless column shafts, through simple but decorative capitals, to the complex repetition of intricate geometric forms and colors in the entablature, to the temple's crowning glory and emblem of its spirit, separated from the sky only by the peak of the roof itself: the decorated pediment.

Everything about traditional Doric temple architecture separates it from the horizontal, isolates it from the pedestrian. It is this that most clearly distinguishes it from Ionic and defines it as an architecture meant to be experienced from without, whose significant space is that which surrounds it, a space excluded entirely from within the lines of the building.

Figs. 33b, 34 Traditional Ionic, on the other hand, is a strongly directional architecture in which the divisions between landscape and temple, exterior and interior, are consciously and effectively blurred. The temple floor is raised above the surrounding ground by the measure of two or three steps, but visually – that is, in proportion to its immense width (around three times greater than its contemporary Doric counterpart) – the difference in elevation between the floor of the temple and the surrounding ground is virtually indistinguishable. The boundary between temple and surroundings is at times further confused by the positioning of the peristyle columns well in from the edge of the

stylobate. This effect is enhanced by the tremendous number of columns in the *dipteral* (doubled) peristyle, a metaphorical if not, in some cases, literal reflection of a surrounding sacred grove. Finally, the colossal width of the temple results in an immense pedimental space pressing down weightily on the slender-proportioned columns below. All these features emphasize the horizontal, not the vertical, aspect of the temple. Nor is there the vertical graduation of ornament seen in Doric: The columns have elaborate decorative bases, and the pediments carry no sculpture. Everything about Archaic Ionic, including its normal siting in flat coastal plains, emphasizes the horizontal continuity of temple and surrounding landscape.

This ambiguity of borders in Ionic is carried one step further by the continuation in scale and line of the columns from the outermost colonnade directly into the interior of the cella building. This is again in contrast to the nature of Doric, where colonnade and cella are as clearly differentiated as landscape and colonnade: There is almost no structural relationship between them; indeed, the Doric peristyle seems regularly to have been completed as an independent unit before the cella was begun. Even the columns of the Doric peristyle and cella are clearly differentiated: The porch columns, that is, those of the pronaos and opisthodomos, are smaller in scale than the columns of the peristyle and, set as they are between the *antae* (wall ends of the cella), are visually and structurally incorporated into the cella building, not the colonnade.

In a general way, the ambiguous boundaries in Ionic invite the mingling of things outside with those within; and the strong frontal emphasis of Ionic, effected through the closed back wall of the cella building (as opposed to the open opisthodomos of Doric) and the noticeably wider intercolumnar spaces on the front than sides or back, encourages that mingling to take place specifically at the front of the temple. Further, the progression of intercolumnar spaces on the front, from narrowest at the corners to widest in the center, leads to the very axis of the temple; but again, this widest, central intercolumniation exists in more than two dimensions, that is, in more than the elevation experienced from without the temple. It extends into the third dimension, has a third axis: an axis that coincides with and *opens* the major longitudinal axis of the temple, and that extends, unbroken, through the double colonnade of the peristyle, through the

(a)

33. (a) Temple of Hephaistos, Athens, from SE; mid-fifth century B.C. [Photo: R. F. Rhodes (neg. no. 94-5-10).] (b) *(facing)* Reconstructed view of the Temple of Artemis at Ephesos; mid-sixth century B.C. [From A. E. Henderson, "The Croesus (VIth Century B.C.) Temple of Artemis (Diana) at Ephesus," *Journal R.I.B.A.* 16, no. 3 (1909), 77–96, fig. on p. 77. By permission of the *Journal of the Royal Institute of British Architects*.]

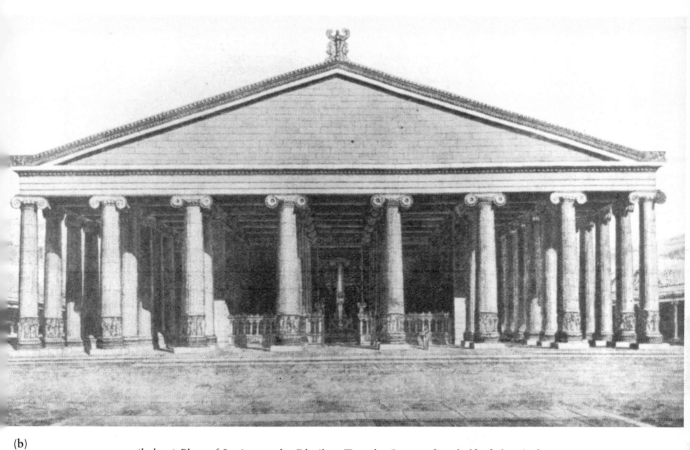

(b)

34. *(below)* Plan of Ionic temple: Rhoikos Temple, Samos; first half of the sixth century B.C. [From E. Buschor, "Heraion von Samos: Frühe Bauten," *AM* 55 (1930), 1–99, illus. XIII. By permission of the Deutsches Archäologisches Institut, Athens.]

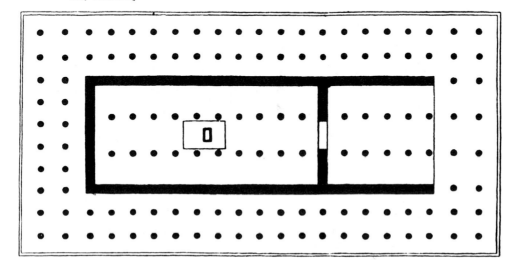

depth of the pronaos, to the cella door. Ionic temple architecture channels its visitors first to the front, then to the axis, then inside.

In other words, Ionic is an architecture of procession. Even its sculptural decoration is processional in nature: continuous horizontal friezes carrying unbroken, nonnarrative, single-file processions of people, animals, monsters. Ionic is an architecture of direction that leads us along formal, processional lines, passing fluidly and almost imperceptibly from landscape to colonnade, from colonnade to interior. What better choice for the interior of that very building whose purpose was to guide the most sacred Athenian religious procession onto the Acropolis, to serve as the monumental vehicle of transition for the procession, to ease the passage from the secular world outside into the sacred temenos of Olympian Athena?[17]

The Ionic spirit of the Propylaia is even evident in its Doric facade. Like the colossal facades of Ionic temples, its intercolumnar spacings widen incrementally from the sides and channel the procession to the widest spacing of all, the central intercolumniation, on the axis of the building. The continuation in depth of that intercolumniation by the two rows of interior Ionic columns then draws the procession within.[18] It may also be more than pure coincidence that the colonnades of the great Ionic temples of Asia Minor at least sometimes led, like the Ionic colonnades of the Propylaia, not to a dark, closed cella, but to a huge, unroofed sanctuary. Coincidence or not, an Ionic temple procession from landscape to colonnade to colonnaded interior to immense unroofed cella is not unlike the passage of the Panathenaic procession through the templelike *hexastyle* (six-columned) facade and the lofty hall of the Propylaia into the walled, open-air temenos
Fig. 35 of Athena.[19]

The Parthenon (and the Other Temples)

The other great Doric building of the Periclean Acropolis, the Parthenon, also incorporates a strong sense of Ionic procession into
Fig. 36 its ostensibly mainland fabric. Most obviously, its pronaos and opisthodomos columns are no longer set in antis (between wall ends) but *prostyle* (before them), and thus, visually, become more a part of the peristyle than of the cella building. They are also six in number, as opposed to the canonically Doric two, which enhances the distinctively

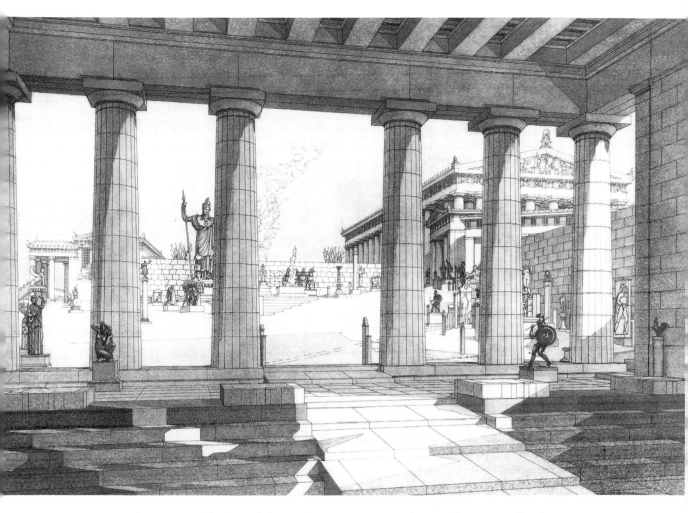

35. Reconstructed view of Acropolis entrance court from within E porch of Propylaia, according to G. P. Stevens. [Photo: American School of Classical Studies (no neg. no.).]

Ionic impression of a dipteral colonnade on either end of the building. Similarly, the eight columns across each end of the Parthenon peristyle reflect the traditional column count for the front of the colossal temples of Ionia. In addition, the characteristically Ionic architectural channeling to the axis of the temple is accomplished through greatly reduced intercolumnar spacings at each end of the facade and the resulting illusion of intercolumnar expansion toward the center.[20] This illusion is itself augmented by the graduated widths of the metopes, from narrowest in the corners to widest at the center. As we would expect, this occurs only on the facades.[21]

Fig. 37 Finally, the six columns of the porches and the flank cella walls of the Parthenon carry an Ionic frieze, an element borrowed directly from the traditional, processional architecture of Ionia. The frieze, in turn, carries the sculpted representation of a procession that, in the spirit of Ionic temple plan, moves clearly and unambiguously from the back of the temple, up the flanks, to its conclusion on the axis of the front peristyle.

36. Plan of Parthenon. [From H. Berve, G. Gruben, and M. Hirmer, *Greek Temples, Theatres and Shrines* (London, 1963), p. 375, fig. 61. By permission of Hirmer Verlag.]

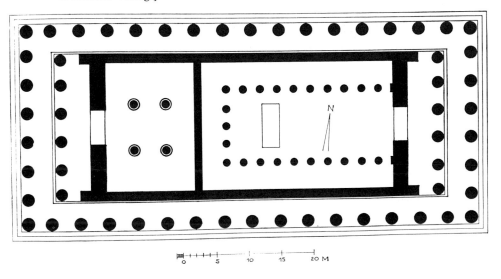

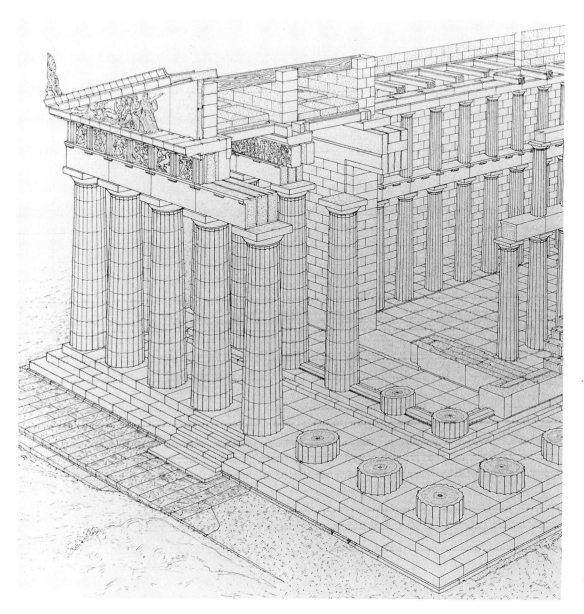

37. Parthenon: cutaway perspective. [From A. Orlandos, Ἡ Ἀρχιτεκτονικὴ
τοῦ Παρθενῶνος (Athens, 1986), pl. 15. By permission of the Ἀρχαιολογικὴ
Ἑταιρεία, Athens.]

Closely related to the subject of procession is the question of hieratic direction in the Acropolis building program of Pericles. There seem to have been no new treasuries or sculpted buildings of more secular nature on the Periclean Acropolis, but the concentration of dedications to the west of the Parthenon, as well as the practical function of the Chalkotheke (a storehouse for various bronze objects) and the nontemple form of the Sanctuary of Brauronian Artemis (both on the west side of the Acropolis) fit the hieratic conception of the pre-Persian Acropolis, with its west-to-east progression from most secular to most holy. The sculptural decoration of the new temples also seems to be thematically organized according to the general directional sense of the Archaic Acropolis. The pedimental compositions of the little Ionic temple of Athena Nike, the westernmost of the Periclean buildings on the Acropolis, are extremely fragmentary, but they seem to have been representations of the battle of the Greeks and Amazons (Amazonomachy) on the west and the battle of the gods and Giants (Gigantomachy) on the east. A sculpted frieze also runs around all four sides of the building. Only one side, the eastern one, carries a scene of divinity: an assembly of Olympian gods. The other three, those facing out over the Acropolis wall, carry scenes of battle, and their figures are rendered in traditional heroic garb and pose. Although these figures are heroic, the scenes lack the iconographical keys necessary for tying them to specific mythological events. In fact, one side of the frieze (the south side) almost certainly represents a heroic rendition of the historical battle of the Athenians and Persians at Marathon; the others likely represent critical moments in contemporary Athenian history, or at least generic battles between the Athenians and their enemies, rather than scenes from mythology.[22] Thus, in both the pedimental and the frieze sculpture of Athena Nike, the more human-centered themes face out toward the city of Athens, whereas the divine subjects are oriented toward the sanctuary of Athena;[23] and here in the frieze of the westernmost temple on the Acropolis are the most human, the most historically specific, the least divine subjects of the whole building program.

Perhaps closely related to the battle scenes on the Nike temple and intermediate in the procession along the Sacred Way from the Propylaia to the east side of the Acropolis are the caryatids of the Erechtheion, possible symbols of the Persian War. The Erechtheion is also

Ionic and carries an Ionic frieze on which a procession of divinities is apparently represented.

Finally, the entire elaborate sculptural program of the Parthenon seems to be graduated thematically from west to east, from most human to most divine. Its west, south, and north metopes carry representations of heroic battles from mythology or ancient history (respectively, the Greeks versus the Amazons, the Centaurs, and the Trojans); only in the east metopes, at the front of the temple, are the gods represented, in the battle of the gods and the Giants. The subject of the west pediment, the contest of Athena and Poseidon, is divine, but that contest takes place in Athens, among Athenians, and is part of the early foundation myths of Athens, part of its most ancient history; that of the east pediment is the birth of Athena, a purely Olympian event set exclusively among the gods. Lastly, the procession represented on the Parthenon's Ionic frieze is a human one but, lacking specific indicators of standard myth, is probably a procession of Athenians, either contemporary or legendary.[24] It mirrored another procession, a flesh-and-blood one: that of the Grand Panathenaia, which literally paralleled it, accompanying it along the Sacred Way toward their common destination, the east side of the Acropolis.[25] The living procession culminated at the great altar of Athena, the stone one over the entranceway to her greatest temple. There, directly above the front door of the Parthenon's cella, the scene in the frieze is no longer mortal, no longer Athenian, but Olympian: an assembly of the gods.[26]

In spite of the fact that the characteristically Archaic contrast between narrative and emblem, between specific and abstract, is not as explicit in the sculptural program of the Periclean Acropolis (a subject to which we return in detail in Chapter 4), the traditional processional flavor of the Archaic Acropolis seems to have been revived and even enhanced in the Periclean rebuilding, through not only its general organization and the architectural specifics of its great Doric gateway and temple, but also the choice and organization of the themes represented in the sculptural decoration of the new buildings. In some cases it was as specific as representing a procession on the building; taken as a whole, however, procession was expressed more allusively through a general thematic progression from west to east, from themes of humanity, of mythic heroes, or even of specific history, to themes of the Olympian gods.[27]

3 Religious Tradition and Broken Canon
The Doric Architecture

THE IMPORTANCE OF TRADITION in the Periclean building program cannot be overstated. Yet the means by which it was incorporated and the self-consciousness with which it was accomplished was not at all traditional: It was *brand new*. In many other ways as well, the buildings of the Periclean Acropolis were unprecedented, even revolutionary. The Propylaia was perhaps the most successfully innovative building ever constructed in the Greek world and fulfilled a multitude of requirements of function, tradition, topography, and religion. Moreover, it accomplished them within the general outlines of the Doric order.

The Athenians' desire to emphasize the continuity of their ancestors' religious traditions down to the present, to associate themselves with their forebears, to bask in their heroic aura and, thus, to suggest their own heroic potential, is most formally and assiduously symbolized in the conservative, consistent, in many ways unchanging stone order of mainland temple architecture, Doric. To deviate sharply from its canon was to deviate from religious tradition, to break a tie with antiquity, to break a connection with ancestors, with the heroic past, with man as myth and, therefore, with humanity in its closest proximity to the gods. Paradoxically, Mnesikles, the architect of the Propylaia, bent and stretched and distorted traditional Doric in order to accommodate religious tradition and to create, at least on the surface, the *impression* of Doric regularity, of order, of symmetry, in a remarkably irregular building.

66

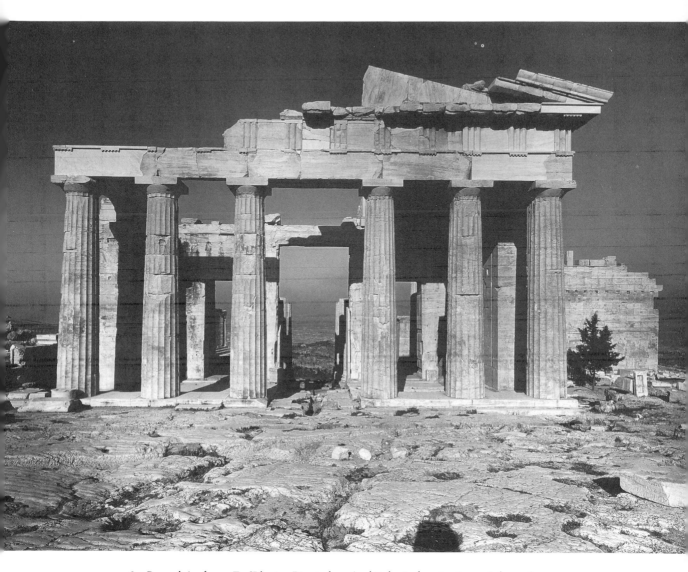

38. Propylaia from E. [Photo: Deutsches Archäologisches Institut, Athens (neg. no. Hege 1461).]

The Propylaia

Figs. 32, 38

The Propylaia came directly out of a long tradition of Greek gateways, whose closest relations in form and scale were the little *distyle-in-antis* (facades with two columns between wall ends) treasuries found on the Acropolis and in other sanctuaries. However, the Propylaia was the grandest gateway ever created in Greece, the most complex in conception, the most monumental in scale, and it presented itself as kin not so directly to the Archaic oikemata as to the Parthenon, and as integral to the most important religious tradition of the Acropolis: The main facades of the Propylaia took the form and scale of a hexastyle Doric temple.[1]

As we have seen, in order to accommodate the Panathenaic procession and to underscore visually the processional function of his gateway and the traditional processional nature of the Acropolis' architecture in general, Mnesikles incorporated the graduated columnar spacings of Ionic temple architecture into the main Doric facades of the Propylaia. His ultimate inspiration for this, of course, was the religious tradition of the Acropolis, but such an arrangement of columns was completely uncanonical for Doric architecture of the mainland, and resulted in unique problems in the entablature.[2] Among other things, the decorative relationship between frieze and columns was disrupted by the wide central spacing. Rather than lengthening the two metopes and single axial triglyph that span a normal Doric intercolumniation, Mnesikles chose to add an extra metope and triglyph to the span. As a result, the normal rhythm and dimensions of the individual frieze elements were preserved, but a metope was uniquely positioned over the axis of the building.[3]

Fig. 39

Continuing the lines of the central intercolumniation, the processional theme of the Propylaia was carried into the interior by means of two parallel rows of three Ionic columns each. Their purpose was indeed allusive and symbolic, but they also provided the practical and aesthetic advantage of proportionately taller and slimmer columns for the interior, columns that had to reach a course higher than the exterior epistyle but that, if Ionic, could still disappear (theoretically, at least) behind the thicker Doric columns of the facade.[4] Mnesikles also found in them a practical means for unifying the two different levels of the building. The traditional slender proportions of Ionic al-

68

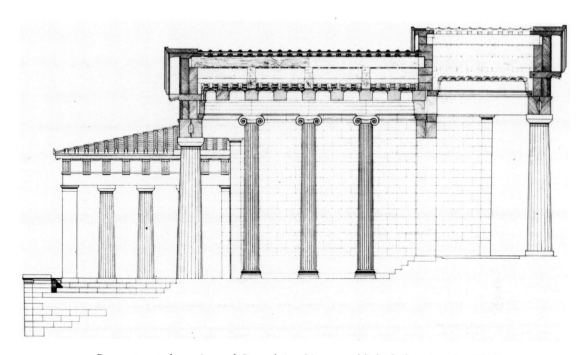

39. Reconstructed section of Propylaia. [An unpublished drawing by W. B. Dinsmoor, since superseded by one to appear in the forthcoming *The Propylaia to the Athenian Akropolis, II,* under preparation by A. Dinsmoor. Photo: American School of Classical Studies at Athens (neg. no. AK 295).]

lowed them sufficient height to reach the elevation of the Doric columns of the opposite, higher, east facade and, therefore, to carry a horizontal course of the entablature all the way through the building, from west facade frieze to interior Ionic epistyle to Doric epistyle of the east facade.

The designs for the projecting west wings of Mnesikles' Propylaia are similarly unprecedented in Greek architecture and exhibit a similarly complex balance and interplay of architectural canon with religious, topographical, structural, and aesthetic requirements. The Propylaia's projecting west wings neatly frame the final ascent of the Sacred Way and are the elements that initiated the architectural channeling of the Panathenaic procession toward the axis of the gateway. Their effect from the Sacred Way below is clearly and intentionally symmetrical: The wings present twin Doric *tristyle-in-antis* (three columns between wall ends) facades;[5] but in fact, the wings are symmet-

Fig. 32

69

rical with each other *only* in their facades. The north wing is a common megaron form, with front porch and inner room; it is built on the site of an earlier structure and preserves its general outlines. The south wing, on the other hand, is not built on the lines of an earlier building and has no inner room. Nor is its porch the same depth as that on the north; in fact, it doesn't even have a complete porch. Curtailed by the irregular boundaries of the sanctuary of Athena Nike, the body of the south porch ends suddenly at its westernmost column; directly behind, a freestanding pier carried the roof from the colonnade to the back wall of the porch. No less uniquely, the remaining westward extension of the wing is pure facade, only as deep as the stylobate, and ends in a freestanding anta. Its sole purpose is to complete the veneer of symmetry with the north wing. Mnesikles' primary goal in his western wings was to create a symmetrical approach to the main block of the Propylaia; but because of strict requirements of traditional cult boundaries, he found it necessary to customize his architecture to the peculiar conditions of the site. On the surface his south wing is standard Doric; just a scratch below, however, it is pure invention.

Mnesikles did manage to create the impression of symmetry in his two little western wings, but he was also faced with the problem of how to unify them visually with the much larger-scaled and immediately juxtaposed west colonnade. This he accomplished most obviously through the symmetrical, right-angled relationship of the three elements, their Doric order, and through their continuous four-stepped base. Given its resemblance to a temple facade, a three-stepped Doric base for the west colonnade might appear more canonical; but the Propylaia west facade sits at the top of a steep slope, and the fourth step may have been added in an attempt to compensate for the foreshortened view from below. This also seems a likely explanation for the fact that the west facade columns are slightly greater in height than those of the east.

Fig. 40 Although the continuous four-stepped base visually unites the three elements of the west facade, Mnesikles, in a sensitive concession to their contrasting scales, changed the material of the bottom step from white beneath the west colonnade to dark blue-gray beneath the wings. Thus the structural continuity of the steps remained unbroken, but its chromatic continuity was interrupted, and the immediate visu-

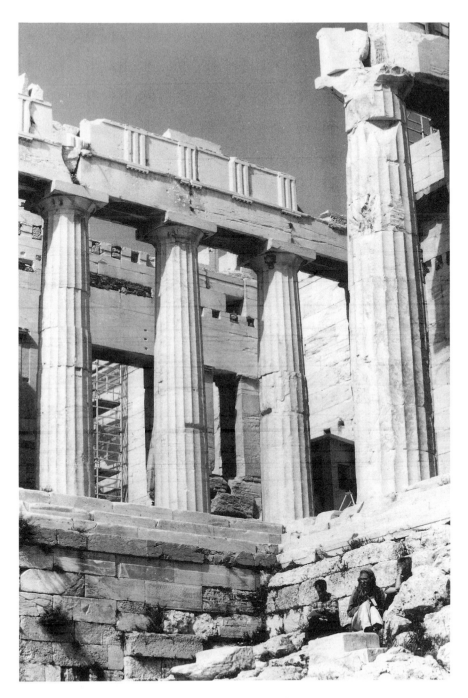

40. Propylaia: detail of W facade, showing blue step; from SW. [Photo: R. F. Rhodes (neg. no. 94-3-7a).]

71

al effect is of an appropriately reduced three-stepped base for the smaller-scaled Doric wings.[6] The contrast between the dark lower step of the wings and the uniformly light steps of the west facade also served to emphasize the continuity between the Sacred Way and the Propylaia: Unlike the stepped platform of a temple, which defines the perimeter of a discrete entity, the steps of the Propylaia are an extension of the Sacred Way. The purpose of the Propylaia is to usher the Sacred Way onto the Acropolis; the Sacred Way passes through the Propylaia, it does not dead-end into it.

Also related to the Sacred Way and the processional function of Mnesikles' gateway is his use of the same dark stone for the orthostate course within the west porch of the Propylaia.[7] The top of the west porch orthostates reaches the level of the floor of the east porch. Through this coincidence in elevation, and by employing a stone traditionally associated with the transition from ground to building,[8] Mnesikles exactly adumbrated the transition from lower to higher ground that would take place deeper within the gateway. Of the interior staircase that makes the actual physical transition, the first four steps are, like the floor of the gateway, white marble; but the top step, which coincides in elevation with the line of the top of the dark stone orthostates and directly supports the two flanking doorways on either side of the Sacred Way, is of dark stone. As the continuity in color of the west facade steps emphasized the continuity between the Sacred Way and the Propylaia, so the dark course at the top of the interior staircase – at the very place where the actual doorways of the Propylaia pierce the wall that separated the sacred temenos from the world outside – interrupted the continuity of approach. It thereby emphasized the separation of holy and profane, and literally underlined the spiritual transition that took place between the west and east porches of the Propylaia.[9]

Mnesikles dutifully incorporated and accommodated in his new Propylaia preexisting buildings and cult boundaries, the sloping topography of the site, and the traditional religious character of the Acropolis.[10] In many ways this greatly restricted his freedom of design; but, again paradoxically, it also served as the inspiration for the creation of remarkable new architectural combinations and forms

that expressed his and Pericles' new vision of the Acropolis and Athens. The design of his stairway and the unusual variation in the height of the columns from the front to the back of the building were direct responses to the topographical character of the Propylaia site, but as such they also provided unique vehicles for Mnesikles' theories of aesthetics and optical distortion. The lie of the land determined the literal nature of the Propylaia as a vehicle of physical transition from low ground to high, but it also inspired Mnesikles to design a roof that stepped up as the bedrock did from west to east, and that expressed more than the practical requirements of rising ground: In its pure monumentality it reflected the more metaphorical nature of the Propylaia as a monumental vehicle of spiritual transition from the secular world to the sacred. Moreover, in his desire to accommodate physically the ancient procession of the Panathenaia, as well as to introduce a powerful symbol of the traditional role of hieratic procession on the Acropolis, Mnesikles distorted Doric tradition by incorporating into his gateway various elements of Ionic processional architecture; their symbolic value was matched by their ability to unite structurally a building laid out on two different levels. Finally, Mnesikles managed to organize the irregular scraps of available ground at either end of the main west colonnade into seemingly symmetrical Doric wings, but that impression of symmetry required the most remarkably uncanonical variations on Doric in the entire building.

In the Propylaia a fine line was trod between architectural and religious orthodoxy and architectural heresy. In it, Mnesikles wrote his treatise on the potential flexibility of Doric, its ability to stretch beyond the purely canonical even to the incorporation of Ionic meaning and forms, its potential for adapting to the most complex and idiosyncratic requirements of topography, religious tradition, and aesthetics. Through its use in the generally Doric context of the Propylaia, we also learn much about the meaning of Ionic, at least as perceived by Mnesikles. However, Mnesikles' greatest contribution to the history and direction of Greek architecture was likely his vision of Doric and Ionic as equal components of a greater Greek architecture, regional styles whose potential for decorative and proportional harmony one with the other was outshone only by the potential for symbol and meaning inherent in a wedding of these two rich and contrasting architectural traditions and the cultures from

73

which they grew. Doric was the general framework within which Mnesikles worked, but in the Propylaia he broke dramatically with canon, deviated sharply from architectural tradition, and in so doing helped create a bold new canon of mainland architecture.

Mnesikles, however, was not the first with such a vision.

The Parthenon

The other great Doric building of the Acropolis, the Parthenon, was not merely the first building constructed by Pericles on the Acropolis; it was also the centerpiece of his entire building program. As such it is the repository of rich religious, historical, and architectural traditions; but like the Propylaia, it bears the stamp of Pericles' unique vision and of the remarkable innovation and individual genius of its own two architects, Iktinos and Kallikrates.

The Ionic Elements

The Parthenon is often viewed as the "culmination of the Doric order," the ultimate accomplishment of Doric temple architecture. The implication is that Doric was finally perfected in the Parthenon and that, in the very highest sense, the Parthenon was the most Doric of all Doric temples. Certainly it stands firmly in the tradition of Doric and in the traditions of the Athenian Acropolis; but it is not pure Doric, and should perhaps be viewed more as a building of vital transition in the history of Greek architecture. "Culmination" can perhaps be applied more accurately to the Parthenon's direct predecessor as biggest and most important temple of the mainland: the Temple of *Fig. 41* Zeus at Olympia. This temple was completed just a few years before the Parthenon was begun[11] and can be understood almost completely in terms of traditional Doric: It is utterly free of Ionic flavor. On the other hand, the Parthenon's form and spirit partakes generously of Ionic and points emphatically toward the Propylaia and even farther into the future. It is in the integration of Ionic forms and meaning with mainland traditions of architecture and religion that the transitional and revolutionary nature of the Parthenon can begin to be understood.

74

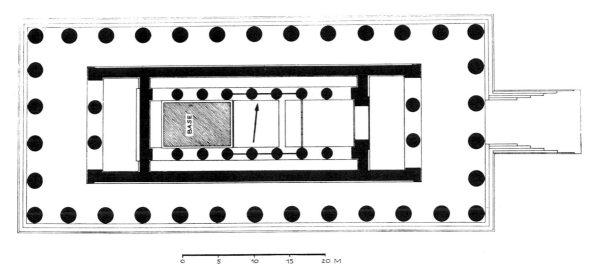

41. Plan of Temple of Zeus at Olympia. [From H. Berve, G. Gruben, and M. Hirmer, *Greek Temples, Theatres and Shrines* (London, 1963), p. 322, fig. 13. By permission of Hirmer Verlag.]

Before Mnesikles did so in the Propylaia, the architects of the Parthenon capitalized on the processional qualities and associations of Ionic to emphasize the traditional Acropolis theme of procession as central to their building.[12] This they did most obviously through the eight-column width of the facades, the greatly contracted corner intercolumniations and graduated metope widths of the facades, the doubled colonnades of the porches, the slenderer, more Ionic proportions of the peristyle columns, the Ionic columns of the rear room of the cella, and, of course, the Ionic frieze.

It is a basic fact that the Ionic emphasis in the Parthenon represents a deliberate and conscious choice: It cannot be explained purely in terms of the Older Parthenon, and it differs radically from traditional Doric, as illustrated by the other great mainland temple of its generation, the Temple of Zeus at Olympia. Moreover, there can be no question that part of Pericles' vision of Athens was as cosmopolis. It has been widely recognized that however much was due to conscious allusion on the part of the architects and Pericles, as opposed to the interpretation afforded us by the clarity of historical perspective, the long list of Ionic elements in the architecture of the Parthenon speaks

in rich layers of meaning. It speaks in part of Athenian religious tradition and the ingenuity of Iktinos and Kallikrates, but also of the well-treasured Ionian roots of Athens, which could be traced in historical tradition as well as in her dialect. It also bespeaks the reunion of Athens and her East Greek sisters occasioned by the Persian Wars and by the consequent foundation of the Delian League. It also nominates Athens as the new cultural and intellectual center of the world, a role inherited from Ionia, and as mistress of a Greek empire that stretched beyond the borders of the mainland and its sober Doric traditions to Ionia, the home of the immensely elaborate and colossal temples of East Greece. The intricately planned Ionicisms of the Parthenon are crucial contributions to the creation of a truly international style of architecture on the Acropolis and point to Athens as the first great cosmopolis of the Greek world.[13]

Refinements

The kind of illusion created by the exaggerated contraction of the corner column spacings and the incremental widening of the facade metopes seems to have preoccupied Iktinos and Kallikrates,[14] and the Parthenon exhibits a whole range of subtle architectural refinements whose purpose appears to have been the creation or correction of optical distortion. The most widely discussed refinement in the Parthenon is curvature – in particular, curvature of the temple platform, the stylobate, and the entablature. Convex curvature of the stylobate first appeared in Doric architecture a hundred years earlier, where it almost certainly represented a practical solution to the drainage of the temple platform; but in the Parthenon it has evolved beyond the useful and into the realm of decorative canon. Curvature has now become one of the things that makes Doric Doric and, like columns and triglyphs, has become an appropriate field for proportional experimentation and theorization. Whatever its exact function – whether to counter the illusion of sagging horizontals, or to create an exaggerated perspective and, therefore, the illusion of greater size, or something entirely different – curvature has unquestionably moved beyond the purely practical: The meticulous effort and expense with which it is carved, stone by individually planned stone, into the temple platform, and especially into the epistyle and frieze and cornice, is

Fig. 42

76

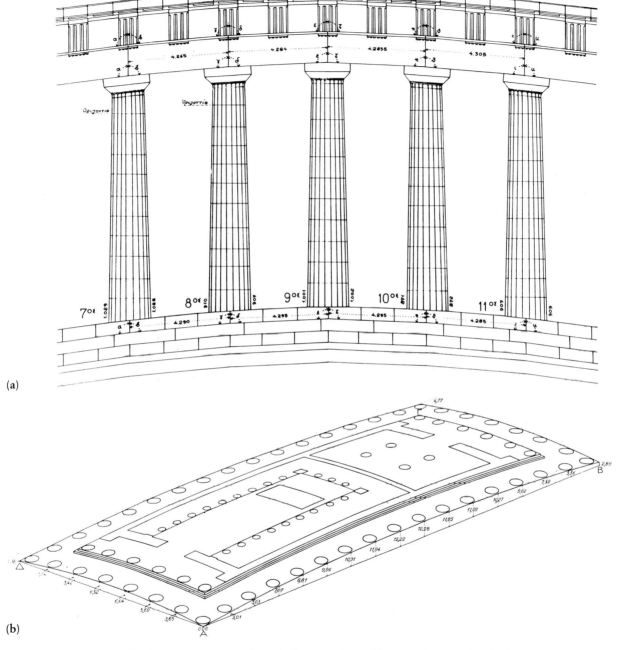

(a)

(b)

42. Parthenon curvature: (a) platform and entablature; (b) temple platform.
[From A. Orlandos, ʽΗ ᾽Αρχιτεκτονικὴ τοῦ Παρθενῶνος (Athens, 1986), pl.
20. By permission of the ᾽Αρχαιολογικὴ ῾Εταιρεία, Athens.]

77

not justified simply by drainage. It almost certainly has to do with contemporary theories of optics, as well as those of ideal geometric relationships.

The latter are clearly part of a general operational principle in the design of the Parthenon, one known to the Greeks as "the commensurability of parts,"[15] that is, the appropriate relationship in size and character of one part with the next and of each with the whole. This principle is embodied most forthrightly in the precise numerical ratios of the major design elements in the Parthenon:[16]

number of flank columns:number of end columns = $2x + 1 : x$
stylobate length:stylobate width = $9 : 4 \ (2x + 1 : x)$
stylobate width:height of order (base of column through cornice)
 $= 9 : 4$
axial spacing of columns:column diameter = $9 : 4$

The Sculpture of Polykleitos

General proportional relationships were the rule throughout the history of Doric temple design, and a concern for the commensurability of parts was hinted at in the Temple of Zeus at Olympia; but commensurability, like the curvature of early Doric buildings, is elevated to a completely different realm in the Parthenon. Its closest parallel is perhaps not in architecture, but in the sculpture of the time, in particular, that of Polykleitos of Argos.

Fig. 43 Polykleitos' most famous sculpture was the Doryphoros, known as his "Canon" because, according to him, it embodied his theory of beauty, a theory of the commensurability of parts. As in the Parthenon, every part of the body was directly and precisely related to every other part, and each individual part was so related to the whole. On one level this resulted in a precisely constructed, symmetrical figure, not totally unlike the *kouros,* the standard male sculptural figure of the Archaic Period; but, as Rhys Carpenter suggested long ago in explanation of the fact that no one had been able to extract that canon from the copies of his sculpture, perhaps an added concern of Polykleitos was that his figures not only exhibit the beauty of numerical, geometrical ideals, but that they also have life.[17] Perhaps to this

78

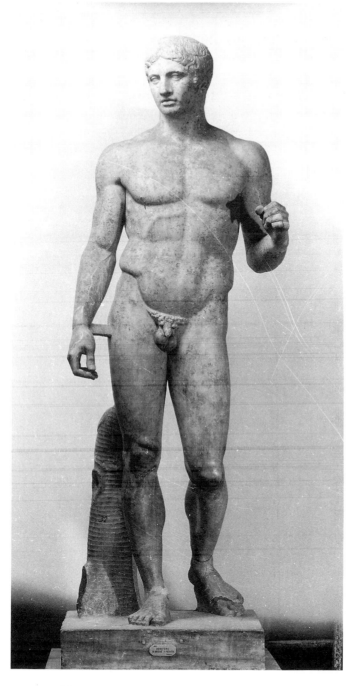

43. Polykleitos' Doryphoros (Roman copy). Museo Nazionale, Naples. [Photo: Deutsches Archäologisches Institut, Rome (neg. no. 66.1831).]

end he consciously blurred the boundaries and transitions, blurred the symmetry of specific anatomical features, of specific axes, ratios, and number. In short, it is possible that the Polykleitos' intention was to give the impression of life in his human figures by imposing subtle irregularity on the strict precision of his theoretical framework.

The refinements of the Parthenon may well correct optical distortions that result from inadequacies in human vision; but it is also often suggested that they introduce a tension, experienced only on a subconscious level, between the expected and the experienced. The eye expects true verticals and horizontals and like dimensions of like elements; what it gets is curves and minute but intentional deviation from the uniform. Refinements might correct illusions we experience consciously, but on an instinctive level the eye perceives these deviations from the true and battles to reconcile the gap between experience and expectation. As Polykleitos perhaps imparted a sense of life to his bronze figures through minute distortion, so Iktinos and Kallikrates may also have intended to breathe life into the Parthenon, to make it shimmer with unanticipated harmonies, through the barely perceptible bending and softening of hard lines and fixed volumes.[18]

The Sculptural Style of the Parthenon

The architectural refinements of the Parthenon represent an elaborate attempt at the expression of beauty through numbers and geometry, tempered by a strong concern for specific *impression* in the eyes of the beholder; here an important component in the Athenian expression of the ideal was the perception of the individual, as opposed to the absolute truth of geometry. In other words, the great architectural monuments of Periclean Athens were oriented not just toward the gods, but toward humanity. Similarly, the style of their sculpture, as opposed to absolute correlation with abstract proportion or even with nature, was of major concern.

In the sculpture of the Parthenon it is clear that Pheidias and Greek sculptural tradition have come a long way toward naturalism from the strictly symmetrical geometry of Archaic times. Comparatively speaking, the bodies on the Parthenon look like bodies of real people moving in real space, no longer four sided, no longer paratactic.[19]

This interest in naturalism and in the unambiguously accurate representation of the human body in all its anatomical detail and motion is the continuation of a movement already well-illustrated in the change from the Archaic kouros to its functional and stylistic successor, the Kritios Boy.

Fig. 53

However, just as geometry and proportion were not the sole concerns of Polykleitos in his Doryphoros, neither was the goal of Pheidias purely the imitation of nature. He was at least as concerned with the impression evoked in the viewer as he was with mimetic fidelity.[20] In fact, as Iktinos and the builders of the Parthenon were capable of surveying and building to the first order of accuracy and, thus, of creating true verticals and horizontals, so Pheidias and the sculptors of the Parthenon had the capability to reproduce nature almost photographically in their sculpture. They chose instead to unite the compositions of the pediments, in many ways to *create* those compositions, through an overall scheme of impressionistic, abstract line. That line is expressed through the drapery of the pedimental figures. This is not an accurate recreation of drapery; even the essential lines and behavior of drapery are not represented. As has often been noted, the essence is more of continuously flowing water, continuously flowing lines that map the bodies underneath, model them and lead the eye without break through a delightful series of cascades to and from the central focus of the narrative.

Fig. 44

Nor is the overwhelming concern of the Ionic frieze the accurate representation of nature. Instead, Pheidias was intent upon creating an impression of the speed and wildness of the horses, illustrated best in their impressionistic, flamelike manes and in the contrast with their compositional antithesis, the easily seated, deadpan riders.

Fig. 45

In the sculpture and in the architectural refinements of the Parthenon, we can still see clearly the old Greek balancing act between nature and pure geometry, a balancing act perhaps more immediately obvious in the silhouette figures of the Dipylon vases and in the symmetrically composed kouroi. In the Parthenon pediments that balance is between the minutely detailed representations of humans and their actions and the abstract geometry of the drapery, between the mimetic fidelity of the bodies and the impressionistic line of the drapery; in the architectural refinements, it is the balance between the clear, hard

Fig. 56

edge of intricately proportioned line and plane, and the deviations from those pure forms conditioned by purely human, purely perceptual considerations.

The story of the Parthenon is on one level a narrative of state-of-the-art theories of abstract number and proportion, and of loyalty to nature; and on another, paradoxical level, of the necessity of modifying those pure numbers, distorting nature that they might be apprehended through human perception. In other words, to a degree never before witnessed, the Parthenon expresses, on a partially conscious, partially subconscious level, temple architecture as an architecture prescribed in equal parts by divine *and* human requirements.

44. Parthenon E pediment, figs. L and M. [From *A Description of the Collection of Ancient Marbles in the British Museum,* pt. VI (London, 1830), pl. XI. By permission of the Trustees of the British Museum, London.]

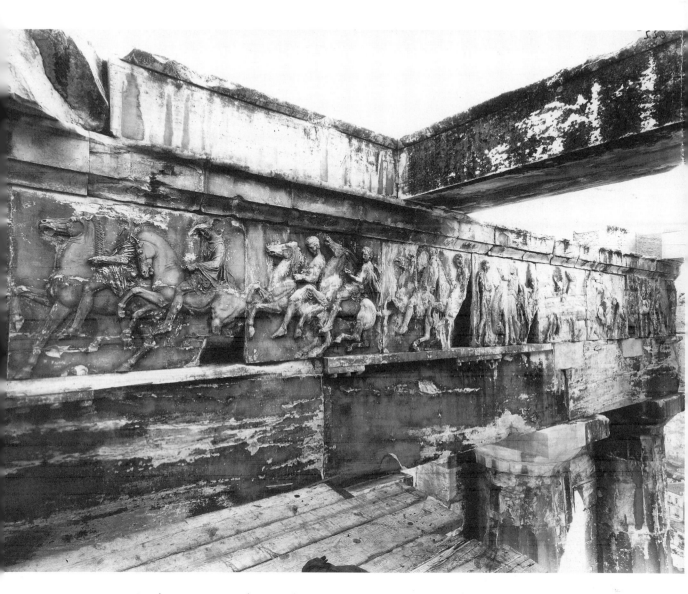

45. Parthenon W Ionic frieze. [Photo: Deutsches Archäologisches Institut, Athens (neg. no. Hege 2545).]

The Development of Interior Space in the Parthenon

As we have seen, the expression of procession in Doric architecture by Ionic means is one of the great innovations and contributions of the Parthenon. Closely related to this, and to Ionic's peculiar appropriateness as an interior order, is another major architectural shift embodied in the Parthenon: a turn inward, a shift in weight from the overwhelmingly exterior emphasis of traditional Doric temple architecture to a more equal treatment of the interior. This is not to say that there was no elaboration of interior space in Doric temples before the Parthenon: The earliest evidence for a Doric interest in interiors is very early indeed – as early as the early sixth century B.C. – and is found in the shift from an odd to an even number of columns on temple facades. This shift was accompanied by a change from a single axial row to a double row of interior roof supports. The result was that the axis of the temple was opened, and the cult image could be placed on that axis and viewed without obstruction. This change clearly indicates an early concern with temple interiors. It is essential to remember, however, that it was made possible only by a structural

46. Plan of the Hephaisteion, mid-fifth century B.C.; hatched areas represent later additions. [From H. Berve, G. Gruben, and M. Hirmer, *Greek Temples, Theatres and Shrines* (London, 1963), p. 392, fig. 67. By permission of Hirmer Verlag.]

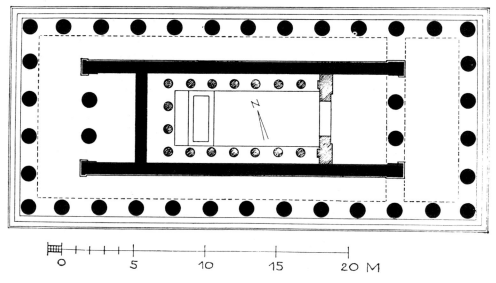

change in the roof: As long as the roofs of temples were hipped[21] on the ends, they seem to have required a central exterior support and, therefore, an odd number of columns on the ends; it was apparently only with the introduction of the pediment that this structural requirement disappeared.[22] In other words, early Doric did show some concern for the interior, but its earliest elaboration was occasioned only by a change on the exterior: From the very beginning Doric architectural design was conceived from the outside in.

Another example of the elaboration of Doric temple interiors was the creation of double-tiered interior colonnades. Their purpose was in part practical, in that such an arrangement facilitated the use of less massive Doric columns; but their decorative intent is also obvious in such painstaking details as the continuation in column taper from lower to upper tier.

Aside from the cult image, sculptural decoration was almost exclusively confined to the exterior of mainland Doric temples until a set of six metopes was carved over the columns at each end of the cella in the Temple of Zeus at Olympia.[23] These sculptures were not inside the cella building, but they were within the peristyle and represent the opening up of a nonexterior space to the kind of decorative elaboration normally reserved for the entablature of the exterior colonnade. They also serve as direct precedent for the sculpted friezes on the ends of the cella building of the Hephaisteion, an almost exact Athenian contemporary of the Parthenon. The main differences between it and the Temple of Zeus are that the Hephaisteion friezes are Ionic, and although the extent of the western frieze coincides with the width of the opisthodomos, the eastern one continues beyond the pronaos antae across to the axis of the third column on the flanks. There it joins with the frieze course of the peristyle, its architrave (epistyle) with the peristyle architrave, and thus articulates as a distinct architectural unit – marks it off at entablature level – that space at the front of the temple within the peristyle. Appropriately enough, given the traditional concern in Ionic for interior spaces, the spirit of this newly created semi-interior space is Ionic: The frieze is Ionic; its support directly above the third flank columns reflects the kind of direct structural relationship between peristyle and cella regularly found in Ionic temple architecture, but almost never in mainland Doric; the resulting compartmentalization of the peristyle resembles Ionic in

Fig. 46

its two-intercolumniation depth (i.e., deep enough for an intermediate row of columns and, therefore, as deep as an Ionic dipteral colonnade) and in the general frontal emphasis it lends the building.

So in the century and a half of Doric architecture preceding the Periclean rebuilding of the Acropolis, there are scattered signs of a gradually developing interest in the interior of the temple. At the end of that period this interest has become tightly interlaced with a new and enthusiastic infusion of characteristically Ionic architectural elements into Doric. Still, nothing prepares us for the Parthenon. Iktinos and Kallikrates and its great sculptor Pheidias created a new kind of mainland temple, one in which Doric and Ionic form and meaning are inseparably bound together, in which symbolic procession is articulated architecturally to such a degree and with such calculated intent as never before, and in which Doric design turns purposefully within, to the Ionic frieze within the peristyle and even beyond to the fully interior spaces of the cella.

The single greatest influence on the form of the Periclean Parthenon was the Older Parthenon, its immediate predecessor, from which it took its location, its orientation, its general size and arrangement, *Fig. 47* and many of its details of plan and elevation. It was built on the platform of the Older Parthenon, it borrowed the prostyle arrangements of its porches and, therefore, the dipteral effect of its facades, its double cella, many of its unfinished column drums, and perhaps members of the entablature as well. Iktinos and Kallikrates, however, enlarged the temple platform and increased its column count by one on the flanks and by two across the ends. Although this significantly altered the proportions of the peristyle, the most significant and most dramatic result of these changes was a complete alteration in the proportions of the cella building itself. The extra intercolumniations in the width of the new temple could have resulted in a commensurately deeper peristyle; instead, they yielded an extremely wide cella. While the depth of the peristyle remained essentially the same as that of the Older Parthenon, the cella expanded in width by almost the full two intercolumniations. So if the greatest effect of the change in the overall dimensions of the Parthenon was at least a significant intent of the change, then the widening of the Parthenon peristyle was closely related to, perhaps even inspired by, the architects' conception of the interior.

86

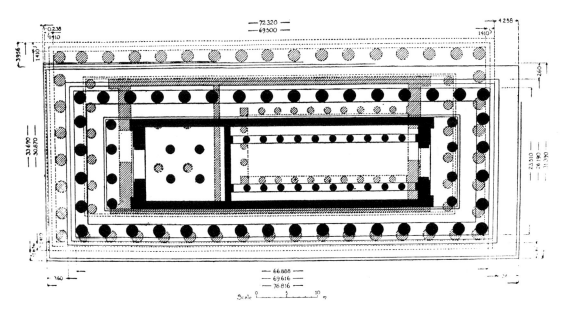

47. Plan of Periclean Parthenon overlying Older Parthenon. Periclean Parthenon, hatched; Older Parthenon, black. [From B. H. Hill, "The Older Parthenon," *AJA* 16 (1912), 535–58, pl. IX. By permission of the *American Journal of Archaeology*.]

What was that conception? What were the requirements of the Parthenon cella? They were the housing, protection, and display of the cult image; that is, the original and most essential requirements of the Greek temple. Obviously, requirements of protection cannot explain the new proportions of the cella, but there is clear evidence that the aesthetics of display played a major role in the architectural design of the interior. For the first time in Greek architecture the two-tiered colonnades of the cella return behind the cult image. Unlike the other two, which ultimately supported the ridge beam of the roof, the return performed no structural function. Its purpose was purely decorative, to form a monumental architectural backdrop for the cult image of Athena. So why is the cella so wide? Because Pheidias and Pericles had in mind the grandest, the richest, the most intricately wrought image of a patron god or goddess ever created, an image so large it could not be placed in just any temple: Its house had to be designed around it. The physical and symbolic magnitude of Pheidias' Athena Parthenos required an appropriately scaled and appropriately

Fig. 58

87

beautiful display case, the largest and most elaborately decorated Doric cella ever created on the mainland. The influences on the design of the Parthenon were myriad, but the single most important reason for the change in plan from the Older to the Periclean Parthenon seems to have been Pheidias' conception of Athena Parthenos.[24] If so, one of the new Parthenon's most essential breaks with the past is that, unlike its Doric predecessors, which were exterior creations and whose interior character was ultimately conditioned by exterior requirements, the Parthenon was conceived in large part from the inside out.

4 The Integrated Parthenon

Fig. 48

THE PARTHENON IS THE PRODUCT of a long religious, architectural, and intellectual evolution, and thus is understandable in a general sense as a product of its history and its culture. However, the Parthenon does not simply tell a story of tradition: In its architectural and sculptural detail, its thematic program, its expressed view of divinity and humanity's relationship to it, it also speaks of broken traditions, changed directions, inspiration and genius; of a revolutionary, perhaps blasphemous vision of the temple and of Athens.

The Parthenon Frieze

In its general thematic organization the sculpture of the Parthenon reflects and emphasizes the tradition of procession in the religion and architecture of the Acropolis. Stylistically, the Parthenon sculptures seem to embody more abstract and more exclusively contemporary theories of beauty and human perception. In a more specifically historical sense, however, the themes of the sculptural program reflect the immediate experience of the Athenians in the Persian Wars.

The meaning of the Parthenon's Ionic frieze is ambiguous, perhaps intentionally so. Its nature falls somewhere between the formal, emblematic processions of traditional Ionic architectural sculpture and the narrative compositions of the Doric world. The essential role of religious procession on the Acropolis, the employment in the frieze of technical and compositional devices of narrative, and the absence

89

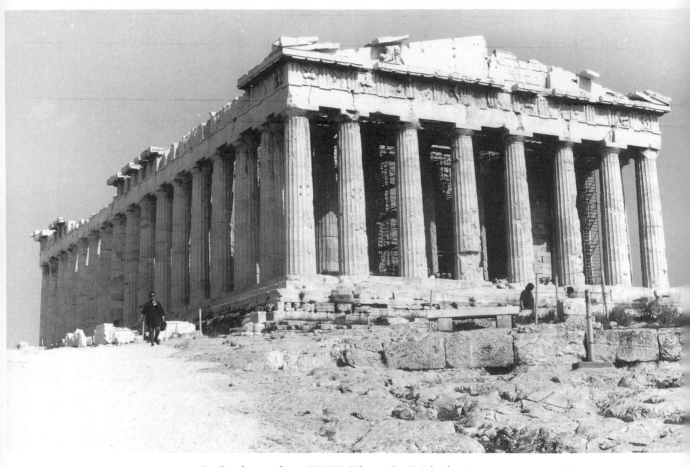

48. Parthenon from WNW. [Photo: R. F. Rhodes (neg. no. 94-5-17).]

of blatant mythological reference all serve to create the impression that the participants in the procession of the Ionic frieze of the Parthenon are human, even historical; but the lack of specificity also elevates these humans, like those in the historical scenes of the Nike temple, to the realm of the heroic.

The frieze might simply represent a generic procession; or it might represent the procession of the Grand Panathenaia itself.[1] Alternatively, it might represent a procession that celebrates Athenian victory over the Persians, perhaps through either mythological allusion[2] or a depiction in which spoils of the Persian Wars are offered to the Olympian gods. After all, the Parthenon was the first temple built on

Fig. 49

90

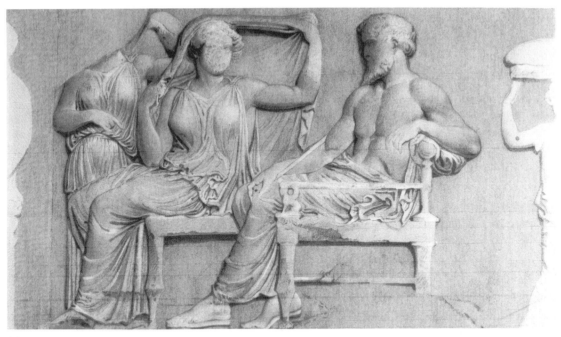

(a)

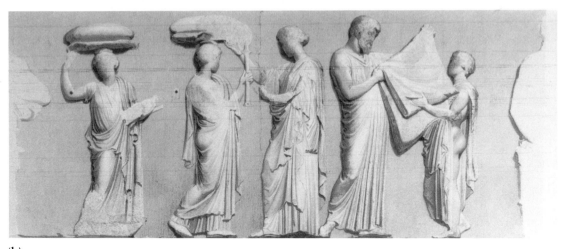

(b)

49. Parthenon E Ionic frieze: (a) Hera and Zeus; (b) central scene. [From *A Description of the Collection of Ancient Marbles in the British Museum*, pt. VIII (London, 1839), pls. II, III. By permission of the Trustees of the British Museum, London.]

91

the Acropolis after the Persian sack, and its construction was directly occasioned by the removal of the Persian threat after forty years of war; in addition, the temple the Parthenon replaced was in likelihood a monument to the Athenian victory over the Persians at Marathon. Sacred procession is no less appropriate in the context of a victory celebration than in the context of the Panathenaic festival. Perhaps its Ionic frieze was intended to emphasize the nature of the Parthenon as a thank-offering to the gods.

What is unambiguous about the frieze is that it represents a procession, a human one, and that this procession culminates with a scene of presentation or display in the midst of the Olympian gods. What is also unambiguous is that sacred procession was a crucial aspect of the Athenians' offering to their gods on the Acropolis, and that its expression was meticulously interwoven throughout the fabric of its architecture and architectural sculpture. Finally, there can be no question that the Parthenon and the entire Periclean Acropolis were in a significant sense a monument to victory over the Persians and a thank-offering to the gods. Perhaps the intended and ultimate value of the Ionic frieze of the Parthenon is not to be found in its precise identification but in its ability to unite two major themes of the Periclean Acropolis: victory and procession.

Sculptural Themes

The historical circumstances of the Parthenon require that on a very basic level it be read as a celebration of victory over and release from the violent, barbarian, semihuman threat from the East, and whatever the interpretation of the Ionic frieze, that theme is clearly pursued in much of the architectural sculpture of the temple. It is often observed that all four sides of the Doric frieze deal with the general theme of the struggle between civilization and barbarism, reason and passion, culture and the natural state of things. The battles of the Greeks against the Amazons, Centaurs, and Trojans and the battle of the gods and the Giants did not find their first representation in the metopes of the Parthenon – they had a long history in architectural relief and elsewhere – but they certainly took on added signifi-

cance in the context of the Persian conflict and in the specific context of the Parthenon.

The same struggle between those irrational, hostile, bestial forces and the enlightened, reasoned world of civilization and the Greeks is forcefully illustrated in the west pediment of the Parthenon, in the struggle between Poseidon and Athena for control of Athens. This is *Fig. 57a* a struggle between the earthshaker, the old Titan-born god of earthquakes, the god of the terrifying sea, the god of uncontrollable, violent forces of nature, and the goddess of intellect and reason, a second-generation Olympian, symbol of wisdom and light, of the positive forces of the cosmos. In this contest of miracles Poseidon has struck the Acropolis rock with his trident and has caused a spring of salt water to rush forth; Athena's spear, in turn, brings forth an olive tree, and it is this decisive moment in the struggle that is illustrated in the pediment. As the appointed judges of the contest the Athenians awarded their city to Athena.

On the east pediment Athena is born, an event that, chronological- *Fig. 57b* ly, must have taken place before the contest of the west pediment, but that on a metaphorical level represents the consequences for Athens of Athena's victory and of the Athenian judgment: the revelation of the power of intellect and the establishment of Athena, wisdom, civilization, light as the leader and focus of Athens.

The Temple of Zeus at Olympia

To appreciate fully the implications of the thematic program of the Parthenon, it is necessary to turn briefly to the other great mainland temple of the Parthenon's generation: the Temple of Zeus at Olympia, the only major temple constructed on the mainland in the thirty years between the Oath of Plataia and the final peace with the Persians around 450 B.C.[3]

Already in the Temple of Zeus there are signs of revolution, most *Fig. 41* particularly in its detailed proportional relationships and in the sculptural elaboration of the space within each end of the peristyle. Nevertheless, the temple is pure Doric, and as different in appearance as its pedimental sculpture is from that of the earliest Doric temples, it too fits securely into the tradition of the Doric mainland.

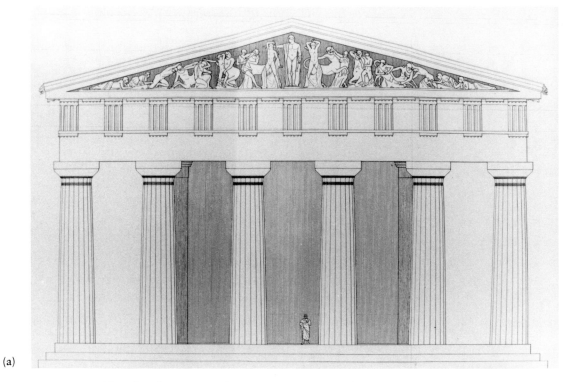

(a)

50. Temple of Zeus at Olympia, reconstructed facades. (a) W facade. [From P. Grunauer, "Der Westgiebel des Zeustempels von Olympia. Die Münchner Rekonstruktion, Aufbau und Ergebnisse," *JdI* 89 (1974), 1–49, fig. 30. By permission of the Deutsches Archäologisches Institut, Athens.] (b) *(facing)* E facade. [From P. Grunauer, "Zur Ostansicht des Zeustempels," X. *Bericht über die Ausgrabungen in Olympia* von Alfred Mallwitz (Berlin: Verlag Walter de Gruyter & Co., 1981), 256–301, pl. 29. By permission of the Deutsches Archäologisches Institut, Athens.]

Fig. 50a The Battle of the Lapiths and Centaurs in the west pediment is exactly the kind of violent, action-packed narrative traditional to rear temple pediments. In the east (front) pediment, however, there are no

Fig. 50b Gorgons or lions ripping oxen apart; in fact, the scene, unlike those on early temple pediments at Corfu and on the Acropolis in Athens, appears completely unintimidating, inspires no immediate awe. There is neither direct confrontation nor action – just a group of people quietly milling around; nor is there even any immediate indication that a universal theme is represented here, much less a discourse on

94

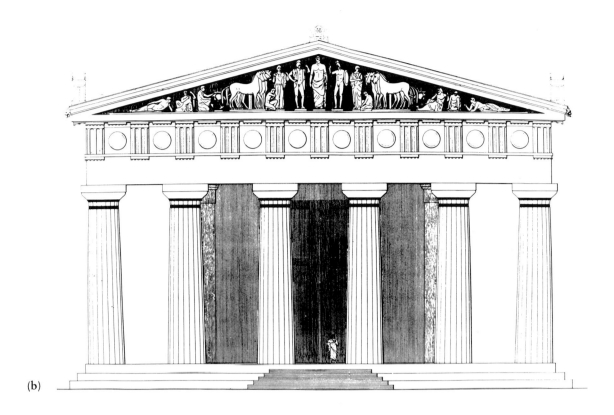

(b)

the abstract nature of divinity. Appearances, however, can be deceiving.

The Doric convention of a narrative group on the back pediment of the temple and an emblematic, confrontational group on the front continues throughout the course of the sixth century. The one major change we do see is the humanization of the basic concept of divinity, as represented in the east pediment. The direct kinship of the east pediment of the late-sixth-century Temple of Apollo at Delphi with the earlier monster pediments of Corfu and Athens is obvious in the rampaging lions on either side of the central group;[4] but the central group itself does not consist of Gorgons or monstrous carnivores – instead, there is Apollo in his four-horse chariot flanked by standing human figures. Like the lions and Gorgons of earlier pediments, Apollo and his horses and the male and female figures on either side gaze straight out from the pediment. In direct and meaningful contrast to the Gigantomachy of the Apollo west pediment, no conventions of

Fig. 51

95

narrative display are employed here: The figures of the east pediment do not move back and forth along the pedimental floor, they do not overlap and interact with each other, their eyes are not confined to their architectural environment; they stand up straight, in single file, each outlined clearly, each backed up against the impermeable pedimental wall, each staring in direct confrontation at the viewer. Yet the east pediment is not a boringly static narrative created by a backwoods hack; it is the crowning decoration of the great Temple of Apollo, one of the most important temples of the Archaic period, at the most important religious site in Greece, commissioned by one of the most powerful and wealthy families in Greece, the Alkmaionidai

51. Temple of Apollo at Delphi, reconstructed E facade; late sixth century B.C. [From M. Courby, *La Terrasse du Temple. Fouilles de Delphes* II: *Topographie et Architecture* (Paris: E. de Boccard, Éditeur, 1915–27), pl. XII (*Relevés et Restaurations* par H. Lacoste, 1920). By permission of the École Française d'Archéologie, Athens.]

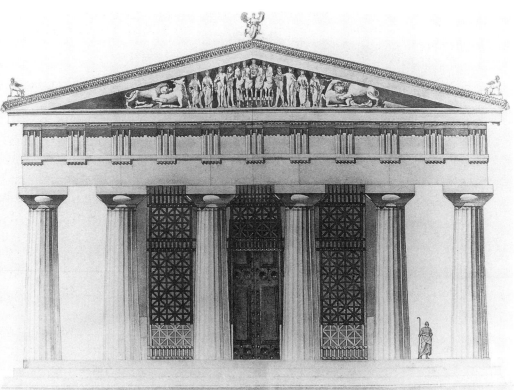

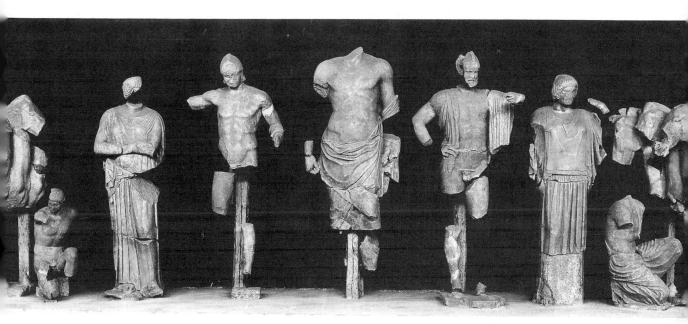

52. Temple of Zeus at Olympia, old reconstruction of E pediment: central figures. Archaeological Museum, Olympia. [Photo: Deutsches Archäologisches Institut, Athens (neg. no. Olympia 214).]

of Athens, and almost certainly executed by one of the leading sculptors of the time. Its composition is not "backward"; it is *intentionally* static, its figures rigidly frontal, because its purpose is confrontational, emblematic, nonnarrative and, therefore, abstract. The only real difference between this and earlier east pediments is that here in the Temple of Apollo the emblem of divinity has taken human form.[5] Significantly, a similar transformation in divinity is preserved in the mythology surrounding the establishment of Delphi as the seat of Apollo: Before he arrived it belonged to a pre-Olympian deity, Gaia, Mother Earth, and he was able to wrest it from her only through the monumental struggle with and the impossible defeat of the monstrous serpent Pytho, symbol of the old chthonic religion and guardian of an oracle of the underworld.[6]

This humanizing of the Greek conception of divinity is taken a step further in the Temple of Zeus at Olympia. There, too, in comparison with the violent action of the west pediment, the central figures on the east are still and isolated; they interact with each other neither

Fig. 52

97

through movement nor glance; they face out from the space of the pediment. However, as the rigid Archaic kouros pose relaxes in the contemporary Kritios Boy, so the figures from the east pediment at Olympia have turned slightly away from the strictly frontal; and as the stiff symmetry and taut anatomy of the kouros have softened in the Kritios Boy, so the Olympia figures have softened and become more human than the pedimental kouroi at Delphi.

Fig. 53

This new humanity has brought with it the faintest hint of narrative. There is nothing in either the kouros or the Delphi figures to suggest a story – they are both religious symbols, emblems – but with a slight turn of the head the Kritios Boy and the Olympia figures have shed the open confrontation of traditional religious emblem and moved into their own private space. They look neither at us nor at each other and so appear isolated in a crowd, self-absorbed. Suddenly, they have an existence beyond pure confrontation; they seem to have a history and a future, a story to tell.

Narrative does play a significant role in the east pediment, and not simply through the implied introspection of its figures; as we shall see, they also tell the specific story of Oinomaos and Pelops. Yet narration does not completely displace the pediment's traditional, emblematic character. Indeed, the techniques of narrative representation are conspicuously absent from its central group; but what about the meaning? Does the contrast between the still, frontal figures of the east and the active, profile figures of the west pediment preserve the compositional techniques of traditional processional architecture without the meaning? In fact, the sense of divine confrontation we have grown to expect at the east end of Doric temples does exist at Olympia but, paradoxically, it is inspired by the narrative itself.

On the surface, the figures of the east pediment tell the purely local story of the competition of Oinomaos, King of Elis, and a local hero, Pelops. Oinomaos had offered the hand of his daughter, Hippodameia, to any man who could defeat him in a chariot race and was willing to risk the penalty of death for losing. Unfortunately for the suitors, Oinomaos' chariot was pulled by the invincible horses of Ares, and he never lost; the skulls of his rivals decorated his palace. Nevertheless, Pelops raced him, but not before the king's charioteer, Myrtilos, had been bribed to replace the metal linchpins of the chariot's axle with wax. The wax melted, the chariot crashed, Oinomaos

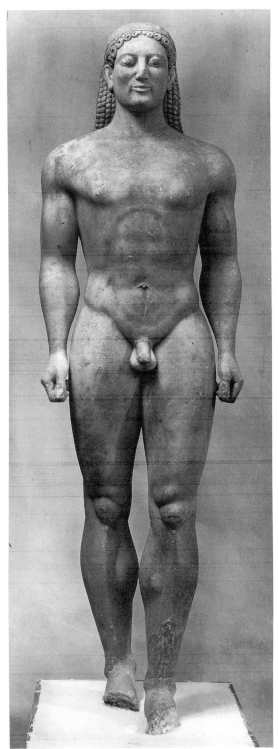

(a)

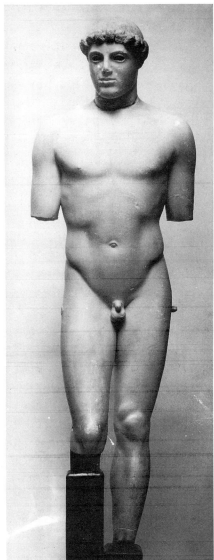

(b)

53. (a) Anavysos Kouros. National Archaeological Museum, Athens. [Photo: Deutsches Archäologisches Institut, Athens (neg. no. Nat. Mus. 4262).] (b) Kritios Boy. [Photo: Deutsches Archäologisches Institut (neg. no. Akropolis 1692).]

99

was killed, and Pelops got married. It is a simple story, not very awe inspiring. It does not bring the viewer face to face with the mysterious nature of divinity, nor interact with the viewer in the manner of earlier east pediments; or does it?

The figures from the east pediment at Olympia do indeed tell a story, but of a kind very different from the narratives found on earlier Doric temples or on the west pediment of the Zeus temple itself. The moment chosen is not the traditional moment of maximum action or violence, the heart of the fray. Rather, it is the calm before the storm, a brief moment of rest and reflection before the action unfolds, a moment that requires the participation and understanding of the viewer who, unlike the actors in the narrative, knows the outcome. The recognition of the dramatic possibilities of such a moment is usually associated with the contemporary painter Polygnotos,[7] but this direct interaction between the viewer and the viewed at Olympia is also very much in the tradition of the old confrontational east pediments: The viewer is directly engaged by the pediment, only here through the requirement of participation rather than through the frontal gaze of its figures; but is the viewer confronted by divinity, or, for that matter, by anything that might be characterized as religious or spiritual?

Fig. 54

The calm before the storm: That the storm might be more than simply the chariot race, the victory of Pelops, and the death of Oinomaos is suggested by the remarkable figure of the old seer, the one figure in the pediment who is out of character with the calm, unaffected, heroic figures of the central group. The old seer is eminently human, flabby and bald, emotional: He raises his hand to his cheek and furrows his brow in consternation, even dread. He is unique among the figures, and the viewer's eye and mind are drawn to him; he becomes central to the meaning of the pediment.

What was dreadful about the outcome of the race? Pelops was about to rid Elis of an evil king and establish himself as the eponymous hero of the Peloponnesos. Perhaps the seer is reacting to the manner in which Pelops would win: by treachery. Perhaps it is the

54. *(facing)* Temple of Zeus at Olympia, E pediment: old seer (detail). Archaeological Museum, Olympia. [Photo: Deutsches Archäologisches Institut, Athens (neg. no. Hege 647).]

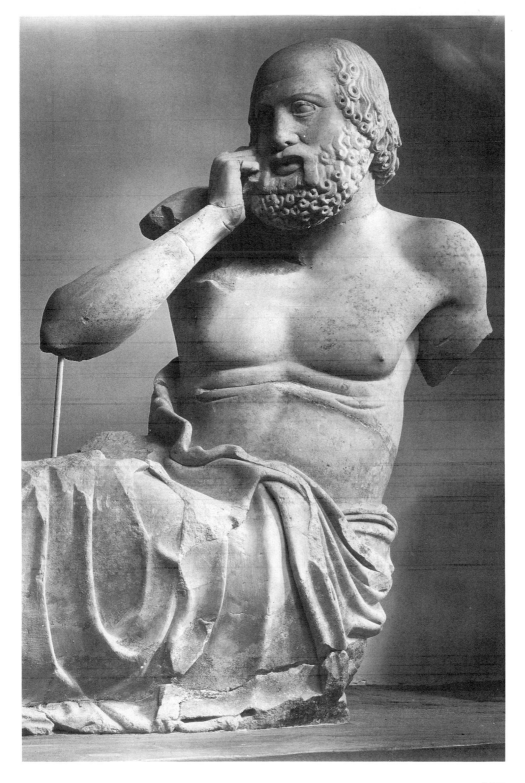

ambiguity of this victory that he sees. Perhaps he sees even greater treachery and ambiguity ahead.

After the race Pelops, Hippodameia, and Myrtilos left on a honeymoon trip, and soon, it seems, Myrtilos attempted to rape the bride. Whether or not this was part of the deal he and Pelops had negotiated before the race, Pelops was furious and threw his coconspirator off a cliff to his death. That might have been the end had Myrtilos not managed to call down a curse on Pelops and his family before he hit. That curse worked itself out mainly on Pelops' sons, Atreus and Thyestes, who hated each other, in part because Thyestes had seduced Atreus' wife. In a feigned move toward reconciliation, Atreus invited his brother over for a lavish feast, of which Thyestes lustily partook. After, as a sated Thyestes pushed his chair back from the table and sent his compliments to the chef, Atreus informed him that he had just eaten his own children. Thyestes, however, would have another son, Aigisthos, and it was through him and Atreus' sons, Agamemnon and Menelaos, that the curse was carried to yet another generation.

Menelaos had the poor fortune to marry the woman who inspired the Trojan War. As leader of the Greek forces, Agamemnon's first crisis was the becalming of his fleet before it had even set sail from the mainland. His solution was to sacrifice his daughter, Iphigenia, to Poseidon. It worked, but left his wife Clytemnestra furious, and she soon moved his cousin Aigisthos into the palace with her and plotted Agamemnon's death. On his first day home from the war, he was butchered in his bath.

In moral outrage, Orestes, the son of Agamemnon and Clytemnestra, murdered Aigisthos and his mother, and thus carried the curse one generation further. In spite of the fact that Orestes had acted according to his conscience, matricide brought the Furies down on him, and they tormented him incessantly. After years of torture he finally brought his case before the highest court of law in the land, the Areopagos at Athens, but the moral ambiguity of the case resulted in a hung jury. It was beyond human capacity to fathom such things, and it fell upon immortal Athena to cast the deciding vote in favor of Orestes.

The old seer is the memory jog, the catalyst that sets off a series of associations in the mind of the viewer, exploding a scene from a single, local myth into the panoramic view of a great mythological cy-

cle that carries the viewer not only through the Trojan War and its aftermath, but down to the judicial system of contemporary Athens and to the crucial philosophical and moral issues of the day – issues that at the same time preoccupied Aeschylus in his *Oresteia* and Sophocles in his *Oedipus* trilogy. How would the Greeks have read this in their present historical circumstances, poised as they were on the verge of total victory over the Persians, yet quickly falling under the imperial sway of Athens? What did the future, what did the nature of the gods and humanity, really hold in store for them? The old seer is the key to the larger narrative of the east pediment, and, appropriately enough, he more than any is shown according to narrative convention, in profile, interacting with the other figures. Through his narrative character he is also the most human of the actors, the intermediary between the myth and reality: Indeed, his reactions mirror those of the viewer.

The east pediment of the temple of Zeus at Olympia is narrative, but also confrontational. Yet it is not confrontational in exactly the sense of earlier east pediments. Its figures do not invade the viewer's space or directly confront the viewer with the power of divinity. Instead, two elements of experience that were essentially synonymous and simultaneous in the presence of earlier east pediments are here experienced consecutively: engagement and confrontation. Here the engagement is not visceral and direct, but intellectual; it is accomplished through the requirement of participation. The action of the story is not explicitly rendered and so must unfold in the mind of the viewer before the meaning and devastating ironies implicit in the Polygnotan moment of the pediment are apprehended. The moment of apprehension is the moment of divine confrontation, and that confrontation is made profound through the contrast between the blissful ignorance of Pelops and Oinomaos and the woeful foreknowledge of the viewer.[8]

The east pediment at Olympia is humanized beyond that at Delphi through the anatomy and pose of its figures, the introduction of narrative, and through the parallel roles of the old seer and the viewer. Immortal themes are addressed, but those themes bring the viewer, through a series of unavoidable associations, all the way to contemporary thought and contemporary history. Nevertheless, it is still very much in the tradition of Archaic pedimental emblems in its direct en-

gagement of the viewer and confrontation with the inscrutable, sometimes horrifying nature of the universe, of divinity: Things are not as they appear, and one can never be sure of the outcome; never judge people or nations blessed until they have died well.

Contrast this with the implicit message of the Parthenon's Ionic frieze. Up to this point in the history of Greek architecture, gods and heroes have been depicted on temples. On the Parthenon, the Athenians themselves seem to be depicted; and not just on the temple, but in the same field as the gods and in the same manner. The divine calm of Apollo amid the wild chaos of Olympia's west pediment now resides in every Athenian horseman on the frieze as he effortlessly controls his panicked mount. The Athenians in the Parthenon frieze are shown doing the same thing as the gods and heroes elsewhere on the temple: battling (and here successfully) bestial, irrational forces. In its Ionic frieze the Parthenon has moved well beyond Delphi and Olympia, indeed into a different realm in humanizing the conception of divinity.[9] Here it is not just anatomical forms and poses that are human; here the actors are specifically, perhaps historically, human. Here mortals move freely and easily in the same field as the gods, a field in which the only distinction between the two is one of scale. Is this the kind of hubris that Sophocles was condemning in his *Oedipus?*

Fig. 55 (margin)

Fig. 56 (margin)

The Parthenon Pediments

As we observed earlier in our examination of procession on the Acropolis, the pediments of the Parthenon follow the tradition of hieratic direction in temple architecture in their general thematic content. So, it appears, do they in their specifics. As in the west pediment at Olympia, the moment chosen in the west pediment of the Parthenon, in the contest between Athena and Poseidon, is the moment of maximum action, the climax of the narrative. The east pediment of the Parthenon, however, shows a moment of rest, the moment *after* the action, the moment after the birth of Athena. As in the east pediment at Olympia, the viewer, through the moment chosen, is drawn in as an active participant, is required to complete the story in his or her mind. There is little indication that any dramatic action has just

Fig. 57a (margin)

Fig. 57b (margin)

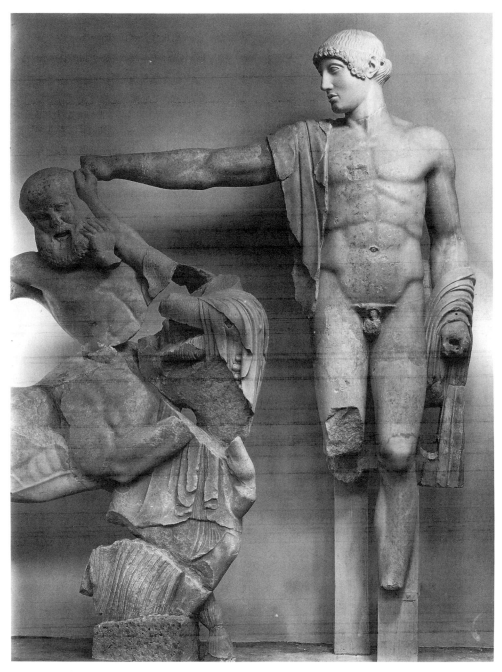

55. Temple of Zeus at Olympia, old reconstruction of W pediment: Apollo. Archaeological Museum, Olympia. [Photo: Deutsches Archäologisches Institut, Athens (neg. no. Hege 587).]

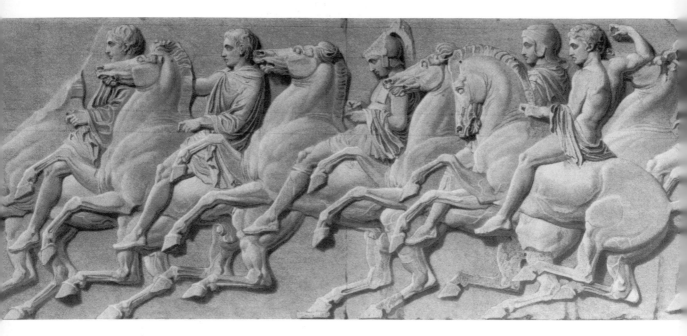

56. Parthenon N Ionic frieze. [From *A Description of the Collection of Ancient Marbles in the British Museum*, pt. VIII (London, 1839), pl. XVIII. By permission of the Trustees of the British Museum, London.]

57. *(facing)* Parthenon, reconstructed facades: (a) W facade (b) E facade. [From A. Orlandos, ‘Η ’Αρχιτεκτονικὴ τοῦ Παρθενῶνος (Athens, 1986), pls. 6 and 4. By permission of the ’Αρχαιολογικὴ ‘Εταιρεία, Athens.]

taken place: Zeus is not bending over holding his bloody head after Hephaistos split it open to free Athena; he is sitting regally. In other words, there is no attempt here to represent the scene as a convincing and action-packed story. Rather, in contrast to the turmoil of strong diagonals and momentary poses in the west pediment, the relatively calm, vertical figures of the east seem less narrative than emblematic: Particularly in the central group, there is little overlapping, less movement than posing, little in the way of traditional narrative convention. Even the action implicit in the diagonals of Athena and Hephaistos is muted by the heavy immobility of Zeus between them. This contrast, together with his probable frontal or at least three-quarter pose, serves to emphasize the emblematic quality of Zeus[10]

106

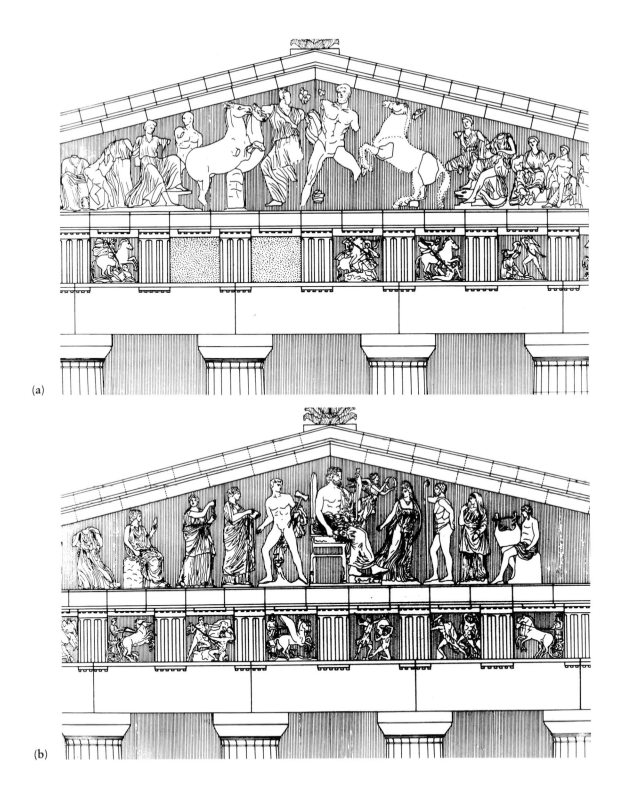

(a)

(b)

107

and the traditional, emblematic qualities of the east pediment as a whole. Those qualities are further enhanced by the depiction of universal forces as well as specific Olympians: Day and Night are symbolized by the chariots of Helios and Selene in the corners of the pediment. Similarly, as a general concept of divinity was represented on the front of temples in earlier times, the fact that Zeus, not Athena, is the central, largest figure of the Parthenon's east pediment speaks in a more general sense of divinity and the spirit of the temple than about the specific deity to whom it was dedicated. This story is about Athena, but the emphatic presence, the central focus, is Zeus, the father of the gods, the lord of all divinities.

Through the moment chosen, the east pediment of the Parthenon engages the viewer as the east pediment at Olympia does, but in the Parthenon there is none of the wrenching ambiguity of meaning that we see in Olympia. Instead, there is an emblematic epiphany of Athena as a significant aspect of the general concept of divinity, an epiphany of reason, of light, and it takes place at the visual and processional focus of the Parthenon's exterior, that spot most emphasized by the plan of the colonnade, the sculptural program, and the vertical emphasis of the Doric order; moreover, it is more elaborately emphasized here than in any other temple before or after. This pediment is not simply a culmination of infinite processional detail in the architecture and sculpture of a specific building; it is the symbolic exterior focus of a building that, as a whole, symbolizes the epiphany of Athens as the intellectual and artistic center of the world – as well, of course, as its most powerful political and military force.

The Interior

The Parthenon's narrative does not end here in the east pediment. For the first time in mainland architecture, the architectural procession turns inward: We are led by detailed Ionic processional allusion to the central intercolumniation of the facade, which, like the central intercolumniation of the great Ionic dipteroi, extends back into the third dimension, is carried inward to the cella building by an inner row of columns, a colonnade that happens to support the culmination of its own processional frieze on exactly the same axis. The

dipteral porch of the Parthenon, like that of an Ionic colossus, intentionally channels us to the interior of the temple, an area traditionally inaccessible in Doric temple architecture. The intent is finally proven not simply by Ionic processional detail, but by the unprecedented decorative elaboration of the cella's interior: Pheidias' magnificent cult image of gold and ivory, and the creation for her of a stunning interior architectural environment that, for the first time ever, steps squarely outside the strict requirements of structural function. The Doric colonnade that rises in double-tiered splendor behind Athena Parthenos supports nothing but itself; it is purely decorative – an appropriately monumental backdrop for the richest cult image ever constructed. The Parthenon was meant to be entered.

Fig. 58

In perfect harmony with this new integration of exterior and interior in Doric temple design, the pedimental figures shift from the strict profiles and strictly parallel plane, in which the figures of traditional west pediment narrative move and live; they also shift from the single-file frontality of figures backed up to an impermeable east pediment wall. Instead, the inhabitants of these pediments twist and gaze at every conceivable angle, in places stack two and three deep into the background, strongly imply that the space they inhabit is no longer confined, like the decoration of a pot, to the flat exterior surface of the temple: They give the illusion of space, an illusion of the third dimension that punctures the solid shell of the temple at the gables, just as Ionic allusion and interior opulence do on the axis below. The temple is now conceived not primarily as a piece of sculpture on whose surface decorative symbols are carved, but as a monument in which the sculptural space, the spatial envelope that surrounds the temple, flows through once impermeable surfaces into the heart of the temple, to the heart of its design, to Pheidias' colossal cult image: It is from this image that the proportions of the cella, the proportions and count of the peristyle, and much of the basic character of the Parthenon ultimately emanate.[11] The Parthenon is conceived in a manner that unites the exterior and interior, from the inside out and the outside in, both practically and symbolically.

Fig. 57

For the first time in mainland architecture, the architectural procession turns inward – to the monumental display of its great cult image – beyond the epiphany of the exterior to the contemplation of what made it all possible. How were reason, intellect, civilization ele-

vated to the emblematic representation of divinity on one of the great-
est temples ever built? Inside, the common denominator, the final ex-
planation is revealed: Athena Parthenos – still armed after leading the
Athenians in monumental battle against the Persians, finally relaxed,
helmet pushed back on her head, shield resting against her leg – ex-
tends a gift to her city, for whom she fought earthshaking Poseidon
and now darkest Persia: the gift of victory, winged Nike, winged vic-
tory and all her spoils – freedom, democracy, power; the leadership
of the world. Never before had a city stepped so close to the realm of
the gods or so close to Athena herself in her role as bringer of victo-
ry, light of the world.

58. *(facing)* Athena Parthenos reconstruction. [From C. Praschniker, "Das
Basisrelief der Parthenos," *ÖJh* 39 (1952), 7–12, frontis. By permission of the
Österreichisches Archäologisches Institut, Vienna.]

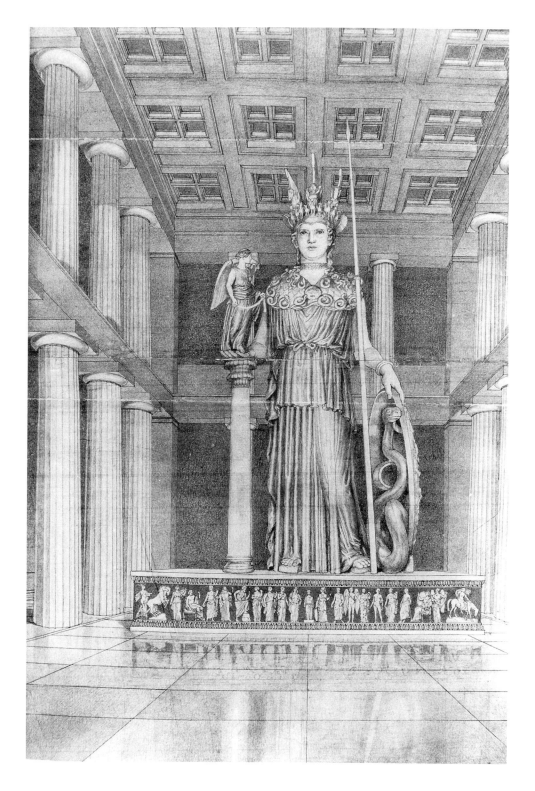

111

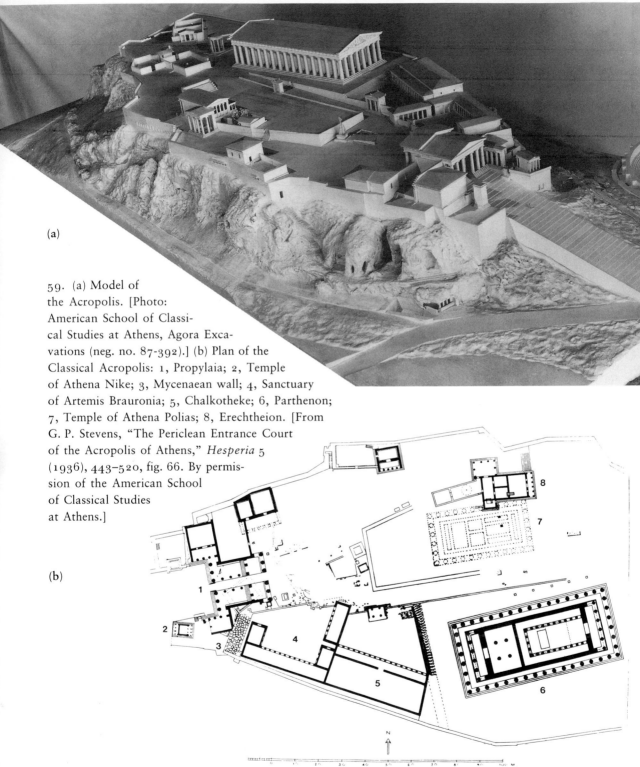

(a)

59. (a) Model of
the Acropolis. [Photo:
American School of Classi-
cal Studies at Athens, Agora Exca-
vations (neg. no. 87-392).] (b) Plan of the
Classical Acropolis: 1, Propylaia; 2, Temple
of Athena Nike; 3, Mycenaean wall; 4, Sanctuary
of Artemis Brauronia; 5, Chalkotheke; 6, Parthenon;
7, Temple of Athena Polias; 8, Erechtheion. [From
G. P. Stevens, "The Periclean Entrance Court
of the Acropolis of Athens," *Hesperia* 5
(1936), 443–520, fig. 66. By permis-
sion of the American School
of Classical Studies
at Athens.]

(b)

5 Creating Canon
The Ionic Temples

T HE FINAL TWO PIECES in Pericles' sweeping architectural vision of the Acropolis were the two Ionic temples, the Temple of Athena Nike and the Erechtheion. Appropriately, they both partake of the spirit of reconstruction following the Persian sack of the Acropolis – the Nike temple replacing an earlier shrine on the same spot, the Erechtheion replacing the Old Temple of Athena Polias – and thus, like all the other elements of the post-Persian Acropolis, are closely united with the religious, historical, and architectural traditions of Athens.

Fig. 59

The Temple of Athena Nike

The Nike temple is not usually seriously considered in analyses of the Periclean building program; it is not generally considered to make any great contribution or to give any crucial insight into its meaning. After all, it is so small and so Ionic, barely more than a treasury; yet it is hard to deny the significance of the Propylaia or the unique insight into the meaning of the Acropolis it provides, and Nike's bastion and terrace are visually one with it. Even her temple is conceived in a piece with the gateway: Its Ionic order is clearly designed in direct relationship with the Ionic order of the Propylaia itself.[1]

Fig. 60

The Panathenaic procession, embraced by the Propylaia, was greeted first by little Athena Nike. From every angle her Ionic temple stands out, isolated atop the ancient defensive bastion of the Acropo-

Fig. 61

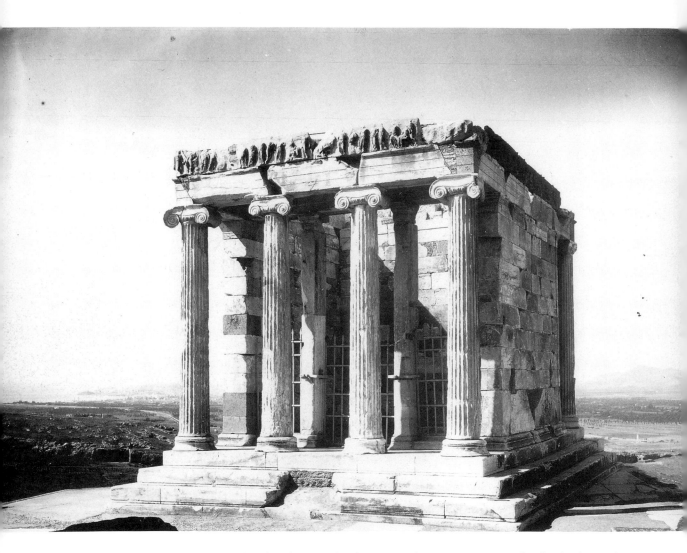

60. Temple of Athena Nike from E. [Photo: American School of Classical Studies, Athens (neg. no. AK 106).]

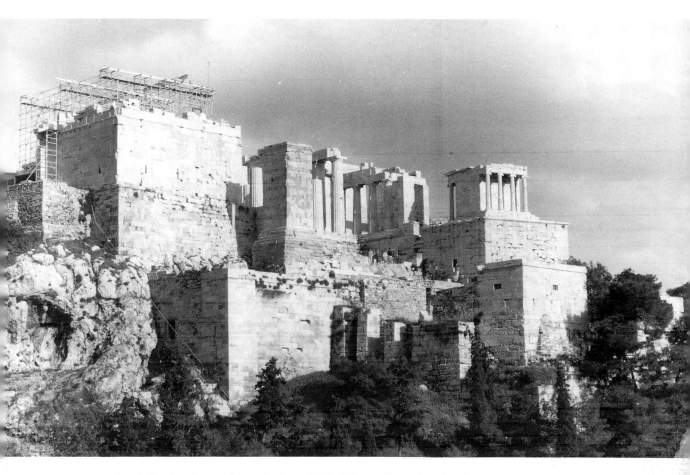

61. Nike bastion and temple from NW. [Photo: R. F. Rhodes (neg. no. 94-7-18).]

lis – a beacon of divine sanction and protection. In spite of her scale, in many ways Nike is the most immediately noticeable, the most striking element of the great entranceway to the Acropolis. She *is* an essential part of that entranceway: Her bastion and terrace are visually one with the Propylaia, and it is in this specific context, not in a general context of "temples on the Acropolis," that her meaning and significance are to be found.

The Propylaia was built most immediately as the monumental entranceway to a monumental, multistructured celebration of victory over the Persians, a celebration whose nature is expressed most elab-

orately and articulately in the crown of the Acropolis, the first and central building of the Periclean program and the great temple of Athens' patron goddess: Athena's Parthenon. There, that theme, the crucial common denominator of the Periclean building program, is expressed most directly and most unambiguously at the architectural and sculptural culmination of the entire Acropolis, in the cella of the *Fig. 62* Parthenon, in the form of Athena Parthenos. What is she represented doing? What does she say? She relaxes in the aftermath of war and extends her greatest gift to her great city: the gift of victory, visualized in a little winged figure, Athena Nike, fluttering delicately on her right hand.

Just as the image of Athena Parthenos extends victory to the worshiper, so Athena Nike is extended to the people of Athens, greeting the procession on the outstretched arm of the Propylaia. Just as the image of Athena Parthenos, giver of victory, ultimately explains the Parthenon, so the little temple of Athena Nike, goddess of victory, serves as the symbol, the emblem, of the entire Periclean building program.[2]

Why was the temple built in the Ionic order instead of Doric? After all, as far as we know there was no pre-Persian precedent for Ionic temples on the Acropolis, although there were a number of small, templelike Doric treasuries, and small Doric treasuries are just small versions of monumental temples. In fact, this may help explain why Doric was not chosen for Nike: The essential formal difference between Doric temples and Doric treasuries is that one is emphatically monumental, the other not, and that difference is accomplished exclusively through scale; the contrasting nature of the two was magnified by their direct juxtaposition. On the Acropolis, where small-scale Doric had always meant treasury, another solution was sought for the temple of Athena Nike.

At this time there was no strict mainland canon of Ionic temple architecture, not even in terms of scale; and unlike the simple, sober Doric order, Ionic at any scale was elaborately decorative, with beautifully turned bases, complexly carved capitals, intricate, ubiquitous moldings, and sculpted friezes. Scale and material are not the only means to monumentality, and with the contracted proximity of the various sculpted decorations on small-scale Ionic buildings, the monumentalizing potential of detailed, decorative elaboration is clear. The

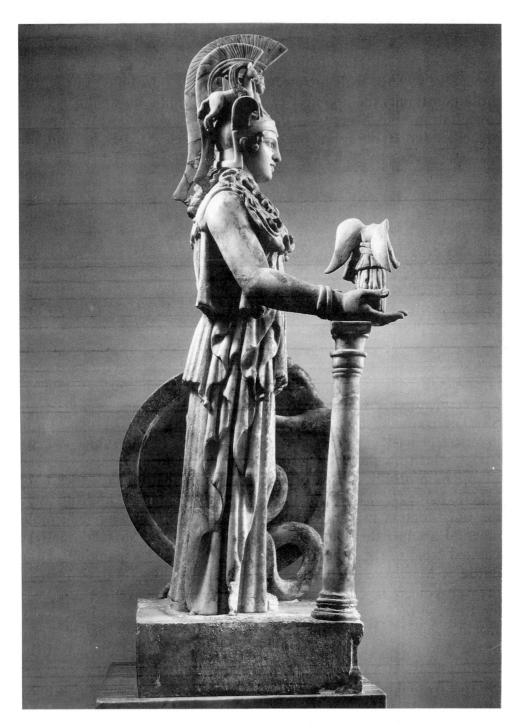

62. Statuette of Athena Parthenos: Varvakeion Athena. National Archaeological Museum, Athens. [Photo: Deutsches Archäologisches Institut, Athens (neg. no. Nat. Mus. 3717).]

117

temenos of Athena Nike is miniature in comparison to others on the Acropolis, so large-scale architecture was not a possibility; but within those constraints the architect of the Nike temple, no doubt in close consultation with Mnesikles, designed a building whose decorative precision and elaboration, like fine jewelry, elevated it beyond the realm of treasuries and fountain houses into close and fitting harmony with the temple facade of the most monumental gateway ever constructed. This would have been impossible in the Doric style.

As we have observed, the traditional monumental architecture of Ionia is one of procession, and as such is particularly appropriate at the very front of the Propylaia, as greeter of religious procession and herald of the elaborate processional program around which Pericles and his architects designed their monuments. The architectural procession of the Acropolis led, and had led since Archaic times, from west to east, step by step, from the secular to the gradually more sacred: from the realm of treasuries and west temple pediments, of narrative and the myths of humanity, of legendary battles between Greeks and easterners, to, ultimately, confrontation and the emblematic epiphany of divinity itself at the east end of Athena's great temple. The conscious integration of Nike into this formal procession is manifest in its Ionic order and, more literally, in the subjects of its frieze, which on the sides visible from the main approaches to the Acropolis probably consist of actual historical battles or, at least, of generic battles between Athenians and their enemies.[3] Until this time the only context in which historical scenes were presented in monumental art in Athens had been secular, as in the Stoa Poikile (the Painted Stoa) in the Athenian agora, which housed a painting of the Battle of Marathon. Here, then, on the first architectural element of the Acropolis to be experienced by the procession – even before passing through the Propylaia – are the most human, the most historically specific, the least divine subjects in the entire processional program of the Acropolis. The temple of Athena Nike is the beginning of the architectural procession of the Acropolis both physically and metaphorically, and as such it partakes of both the sacred and the profane.

In spite of the fact that the present Temple of Athena Nike seems not to have been constructed until the midst of the Peloponnesian War, in the 420s B.C., the commission to the architect Kallikrates of a

small Nike temple around the time the Parthenon was begun further indicates that a victory monument on the bastion was an integral part of the original Periclean program, and that it was originally conceived in response to the Greek victory over the Persians.[4] This is not so clear in the case of the parapet wall (nearly four feet high) erected around the edges of the Nike bastion, perhaps as late as 410 B.C. Its purpose was in part practical,[5] but given the prominent position and symbolic significance of the Nike temple, the function of its parapet was probably more sophisticated than simply protecting priests and pilgrims from falling off the bastion. Indeed, it carries some of the most elaborate and most beautiful sculpture ever created in the classical world.

The Parapet

Much discussion of Nike on the Acropolis centers on these sculptures, and they are often used to illustrate the kind of artistic retreat into fantasy that war sometimes provokes. These nonnarrative, swirling, mannered Nikes dancing across the parapet, oblivious to years of war between Athens and Sparta, call to J. J. Pollitt's mind a provocative and compelling analogy with Depression-era movies "centered on a stylish and carefree hero and heroine" happily dancing their way through fanciful stage sets and fatuous plots.[6] Perhaps the Nikes do represent artistic escapism. Perhaps part of their purpose was exactly that, to take the viewer's mind off the harsh reality of the Peloponnesian War. However, were they created specifically for that purpose alone – that is, if their appearance did not call to mind some familiar tradition or spur some other universal connection – it is hard to believe that the Athenians would not have been struck with the blatant irony, particularly if they were carved, as many believe, after the catastrophic defeat of the Sicilian expedition. It is still harder to believe that, as, for instance, in Euripides' later plays, this irony would have been intentional: Biting social commentary is one thing in the theater, quite another on the figurehead of the city's religious center. Yet the purpose of such a large, intricate, and expensive project cannot have been trivial, particularly given its crucial position on the Acropolis. This band of Nikes was displayed more prominently to the city than any other sculpture on the Acropolis: It did not turn

Figs. 63–5

discreetly toward the Nike temple, but bared its face to the city, forcing itself into the eyes and consideration of every person who approached the Acropolis.

The sculptural decoration of the parapet consists of a series of Nikes setting up trophies of victory and leading sacrificial bulls to Athena. Unlike the sculptures of the Parthenon, no specific story is told here, and few narrative devices are employed: There is little overlap, little interaction of figures, little variety. Nike is repeated over and over again, wearing the same clothes, doing the same things, bringing the same offerings to Athena. It *does* seem purely decorative, even frivolous to our goal-oriented minds: If a sculpted frieze does not tell a story, what good does it do?

What was it *required* to do?

Certainly, one requirement was to keep people from falling off the bastion, but that did not require elaborate relief sculpture. Another requirement was that the parapet fit into its context of the Ionic order, of architectural and religious procession, of Athena Nike, the spiritual and physical emblem of the Acropolis, visible from virtually everywhere in the city.

Articulated in this manner, it appears that the Nike parapet does satisfy considerably more than escapist needs. Its nonnarrative nature does not represent a kind of vapid, ornamental Doric design, but is in a traditional *Ionic* spirit, as is appropriate for the temenos wall of an Ionic temple: In nonnarrative, processional, Ionic friezes, the same figure is often represented again and again. As a monumental Ionic frieze decorated with a procession of Nikes, the parapet fits and foreshadows the processional theme of the entire Periclean Acropolis. Finally, in the isolated character of its figures, like earlier Ionic friezes and the emblematic representations on Doric east pediments, the parapet underscores and illuminates the role of Athena Nike as the emblem of the Acropolis. In other words, in spite of its late date, the Nike parapet fulfills all those needs that are consistent with the original conception of the Periclean building program. The Nike temple, although perhaps constructed as late as the Peloponnesian War, was clearly part of Pericles' original plan. The parapet was created to surround a monument originally conceived in terms of victory over the Persians, created to frame the emblem of a building program that, as

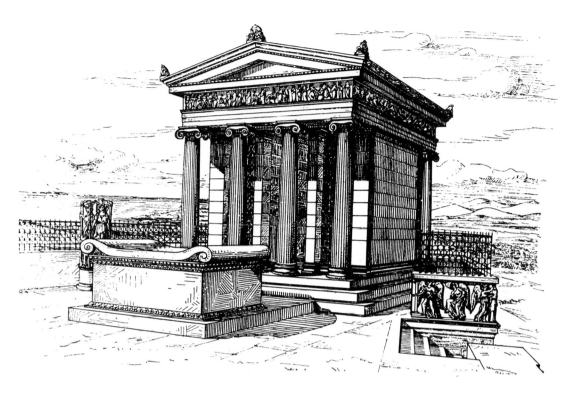

63. Reconstruction of Nike temple and parapet. [From O. Jahn and A. Michael-is, *The Acropolis of Ancient Athens as Described by Pausanias and Other Writers, Inscriptions and Archaeological Evidence* (first published in Bonn, 1901; Chicago, 1976), fig. XX. By permission of Ares Publishers, Inc.]

a whole, was conceived in relation to the Persian, not the Peloponnesian, War.

What, then, about the sculptural style itself, in particular the drapery style of the Nikes? This seems to be the general sticking point. It is this that seems to speak most directly of the Peloponnesian War and escape from reality. When compared to the draperies of the Parthenon sculptures, it does indeed lack volume and substance and logical relationship to the figures themselves, and even to the laws of nature, as it flaps in graceful calligraphic folds, elaborately contrived frames for each individual Nike. However, the Nike sculptures are in a wholly Ionic context, the context of a delicate, intricately decorative, miniature Ionic temple, not in the immense pedimental window

Figs. 64, 65

Fig. 44

121

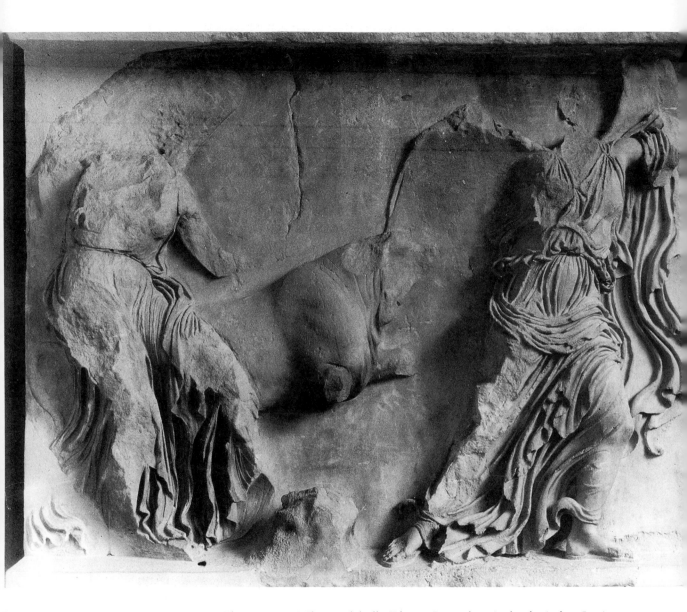

64. Nike parapet: Nikes and bull. [Photo: Deutsches Archäologisches Institut, Athens (neg. no. Hege 2363).]

65. Nike adjusting her sandal. [Photo: Deutsches Archäologisches Institut, Athens (neg. no. Akropolis 1734).]

of the largest Doric temple in the world, massive, solid, sober. There, in the Parthenon, powerful volumes, great weights, immovable solidity are appropriate, requisite for its pedimental sculpture. Requisite for the Ionic parapet is grace, delicacy, lightness – flight. Her traditional epithet, "Winged," indicates flight as Nike's salient attribute:[7] What more appropriate way to emphasize that attribute than through the impression of lightness, lent by airy, windblown drapery, silken cloth that gains its substance, its volume, only as it billows in the air, as if to lift Nike back into the ether barely after she has alit. Placed as it is on an eminence, an unsheltered, windblown projection, the drapery style of the parapet is doubly appropriate.

Its aptness reaches beyond a specific context, however, beyond elaborate invention and into the realm of iconographical tradition. In the west pediment of the Parthenon itself, a flying figure, Iris, is represented with billowing, windswept drapery. More to the point, another, non-Athenian Nike, the Nike of Paionios, also set on a base high above the Sacred Way, this time in front of the Temple of Zeus at Olympia, exhibits the same style of drapery: a style in which the drapery gains substance only off the body, in which billowing folds are the heart of the composition and its meaning. The Nike of Paionios was carved sometime around 420 B.C. Nationality and perhaps the disastrous Sicilian expedition separate it from the parapet; yet their essential spirit and form are remarkably similar. The same may well have been true of the Nike in the Parthenon east pediment (if it existed) and of the Nike alighting on the hand of the cult image of Athena Parthenos in the cella of the Parthenon. Nike is by far the most common winged goddess portrayed in Classical art, and aside from her wings, her most consistently recognizable attribute – both in Athens and outside, perhaps both before and after the Sicilian Expedition – seems to have been her flying drapery.

It is true that the Nike sculptures do not follow the traditional rules of Classical drapery. At Olympia the shadows of the pedimental drapery articulate, model, make the bodies of the figures understandable as three-dimensional volumes to a degree impossible through simple nudity, particularly in the glaring sun of Greece, where all but

Fig. 66

66. *(facing)* Nike of Paionios. Archaeological Museum, Olympia. [Photo: Deutsches Archäologisches Institut, Athens (neg. no. Hege 666).]

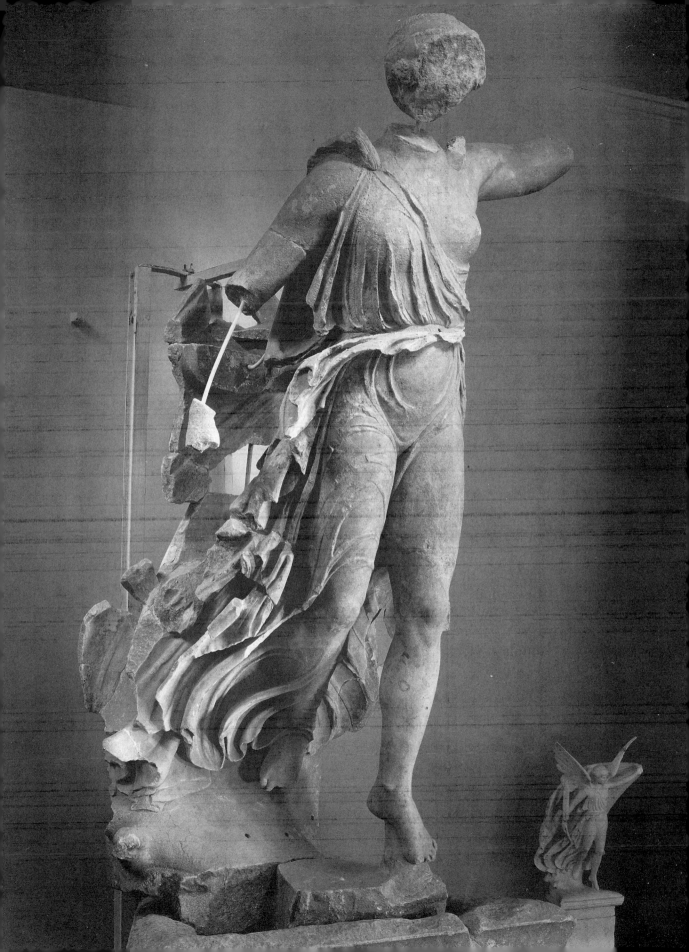

the least subtle shadow is routinely bleached out. In the Parthenon the role and effect of drapery is much more complex. There it articulates the female body as lush, through shadows that mold and model and through the distinctly sensuous qualities of abstract line; this line, in turn, unites the various figures in a single, fluid composition. It also makes a complex two-directional compositional movement possible: As the reverberations of the central scene of each pediment radiate outward and cascade into the corners of the pediment, each figure, successively touched, reacts and turns in toward the source.

Fig. 65 The drapery in the Nike parapet, on the other hand, does none of these things, at least not to the extent shown in the Parthenon or Zeus Olympia. The drapery folds of the Nikes cross their bodies, but do not model them. Instead, the drapery seems almost unaffected by the body, as in the unbroken catenary curves of the famous Sandalbinder. Alternatively, perhaps it is affected by the body, but in a different way from that in the Parthenon. The drapery is inspired to disappear into sheer transparency at its touch; and the curved outlines of the body inspire exactly, are mirrored by the fluttering lines of the free-hanging drapery folds or the areas of their shadow. Each body is essentially a blank plane of shadowless marble, flat in the bright sun and meticulously outlined with the heavy shadows of drapery. The effect and the intent is two-dimensional, emblematic. In traditional Ionic friezes and Doric east pediments, where the emblematic nature of the figures is paramount, there is little concern with the narrative devices of convincing movement or overlapping or careful modeling of figures, little concern with three-dimensionality. This is not because the sculptors were unable to do it: Elaborate narrative traditions existed simultaneously. It is because their intention was the unambiguous, immediately comprehensible presentation of emblems in their simplest, clearest, most unobstructed outline. Indeed, the modeling of the bodies, the sense of the third dimension, of interaction with space and other figures imparted in the Parthenon by drapery, is not only unnecessary but inimical to the purpose of the Nike parapet; that purpose is to frame the architectural emblem of the Acropolis with emblematic representations of its deity, legible from a great distance, and to extend the sense of procession, of transition, beyond the confines of the Acropolis itself. The composition and style of the parapet sculpture are processional. The unobstructed planes of the bodies are

126

the emblems in the procession. The agitated shadows are their articulation, the aesthetic excitement in the composition and, more important, the attributes of Winged Victory. Long before the shallow relief of wings was visible, long before the individual details of anatomy could be seen, the exuberant shadows of flying drapery isolated the figures and identified the procession as one of victory. Above, an ornate little Ionic temple, the architectural embodiment of Nike, softly alit on its windswept perch, the outstretched arm of the great Doric Propylaia, alit amid the fluttering draperies and weightless line of the parapet, as Nike herself fluttered on the massive hand of Athena Parthenos.

So although there is a provocative contrast between the sculpture of the Nike parapet and that of the Parthenon, a contrast that may well speak of dramatic change in the Athenians' concept of themselves and their gods – a change perhaps precipitated by the disasters of the Peloponnesian War – the character of the sculptures is also perfectly fitted to the parapet's function and position on the Acropolis. Indeed, one can well imagine that the general idea of just such a sculptured parapet was a part of the original Periclean plan for the Nike bastion; and one can almost imagine that the unique qualities of its sculptural style, of its fluttering draperies, molded to the unique requirements of the Nike bastion, were already being formulated in the mind of Kallikrates shortly after he received his commission in 448 B.C.

The Architecture of the Nike Temple

Despite the detailed allusion to Ionic procession on the Acropolis, and particularly in the Propylaia–Nike bastion complex, the Temple of Athena Nike is not traditional Asiatic Ionic, either in its scale, its plan, or in its architectural details. Its stylobate dimensions are tiny, only 5.39 × 8.16 m. It has no surrounding colonnade but is *amphiprostyle tetrastyle,* that is, it has four-columned porches in front of and behind a simple square cella; so, unlike the great dipteroi of Ionia with their strong frontal emphasis (and unlike the little Doric oikemata of the Acropolis, which typically present only one columned fa-

Fig. 67

127

cade and a single sculpted pediment), the Nike temple is two-sided: It does not turn an unadorned back to the city. Instead, its double function as eastern-facing cult building and western-facing herald is reflected in its pair of equal facades; the back wall of the cella even carries *antae* (decoratively molded wall ends) as does a normal prostyle facade. The cella and columns rest on a three-stepped base, rather than the usual two-stepped platform of Ionia, and the columns are much squatter than those traditional in Asiatic Ionic, standing less than eight lower diameters high. Nor does the profile of either the column base or the anta capital, or the continuation of these moldings around the base and top of the cella walls, reflect Asiatic Ionic practice. Compared to the elaborately decorative capitals of Ionia, those of the Nike temple are rather austere, with plain volute eyes and simple, vertically fluted bolsters; nor is an anthemion necking carved at the top of the column shafts. The columns do carry three-fasciaed epistyles of the sort developed in Ionia, but the entablature includes a frieze instead of the horizontal line of dentils traditional there.

Closer sources for the form of the Nike temple are perhaps to be found in the Ionic temples of the Cyclades, which were smaller in

67. Plan of Temple of Athena Nike. [From J. Travlos, *Pictorial Dictionary of Ancient Athens* (London, 1971), p. 153, fig. 205. By permission of Ernst Wasmuth Verlag.]

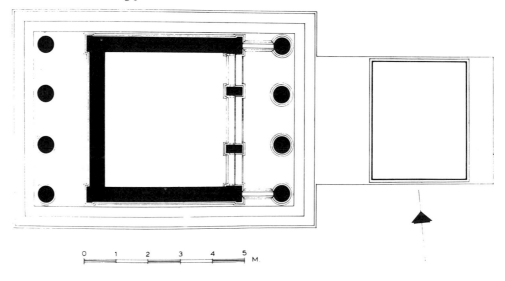

scale than those of Ionia and were often prostyle or in-antis designs rather than peripteral. They also often combined three-fasciaed epistyles with high frieze courses rather than with a low row of dentils at the base of the cornice. Unfortunately, very little fifth-century Ionic architecture of the islands or Asia Minor is preserved.

Still, the Nike temple seems most immediately a product of the mainland tradition of architecture,[8] both Doric and Ionic, particularly of Ionic treasuries. As we might imagine, many of the differences between these treasuries and Ionic architecture farther to the east are probably directly attributable to the overwhelmingly Doric context of the mainland. Their in-antis plan and miniature scale directly reflect the Doric treasuries that preceded and surrounded them, and the running frieze, whatever its ultimate origin, brought these Ionic treasuries into proportional harmony with their Doric neighbors and may indeed have been inserted into the entablature of mainland Ionic treasuries for just this purpose;[9] a three-stepped platform helped effect similar proportional harmonies. Likewise, the tendency to place sculpture in the pediments of Ionic buildings is characteristic only of the mainland, and surely derives from Doric practice. The lack of carved decoration on the moldings of the Nike temple clearly repudiates eastern Ionic practice in favor of the more austere mainland tradition of simply painting patterns on molded surfaces. Even a detail such as the profile of the Nike column bases (a concave scotia between two half-round torus moldings) represents a mainland, rather than eastern, evolution.[10] Finally, the slight inward inclination of the side walls and columns of the Nike temple represents a distinctly Doric refinement and can certainly be attributed to the Doric context of mainland Greece.[11]

Certain other features of the Nike temple seem to be more directly conditioned by scale or by their specific context on the Acropolis than by general traditions of mainland architecture. For example, it is often suggested that the short proportions of the Nike temple plan are, like many peculiarities of the Propylaia, a result of restrictions of space imposed by neighboring sanctuaries. Similarly, the stocky proportions of its columns might respond in part to their position in the midst of the numerous and more massively proportioned Doric columns of the Propylaia; it might also have been felt that columns of traditional Ionic proportion would run the risk of appearing insub-

129

stantial, rather than merely slender, in the context of a tiny temple.[12] Finally, the low proportions of the abaci of the Nike temple capitals – otherwise remarkably similar to the Ionic capitals of the Propylaia – are probably due to their easy visibility, barely above eye level, as contrasted with the heavily foreshortened and distant aspect presented by the taller abaci of the Propylaia.

The Nike temple helped establish a typically Athenian style of Ionic architecture. Among its many characteristic features are its three-stepped platform, its "Attic" base, and the insertion of a running frieze between the epistyle and cornice. Crucial for understanding the formulation of this style and the spirit of Athenian Ionic is the fact that as one element in a closely integrated building program, the Nike temple shared in a scheme that crossed over the boundaries of individual buildings as well as the boundaries of purely Doric or Ionic architecture. Besides sharing general characteristics of the two orders, certain details of the Nike temple respond directly to or mirror features of other buildings in the ensemble. For example, the peculiarly Doric refinement of inclined columns and inclined cella walls that appears in the Nike temple is reiterated in the Ionic Erechtheion;[13] and almost every detail of the Nike temple columns, from the total height to the heights and widths of individual elements of the capital, represents a half-scale version of the Ionic columns in the west porch of the Propylaia.[14] Similarly, the specific proportional height of the Nike temple columns may have been designed in direct response to the proportions of the Propylaia columns: It is probably not simple coincidence that 7.82 lower diameters (the proportions of the Nike columns) falls exactly halfway between the proportions of the Doric columns (5.66 lower diameters) and the Ionic columns (10 lower diameters) of the neighboring Propylaia west porch. In addition, the proportion of the capital height to the lower diameter of the Nike columns closely reflects that proportion in the Ionic columns of both the Propylaia and the Erechtheion; and the spacing of Nike's columns is almost exactly half that of the Erechtheion north porch. Finally, the solutions to specific decorative problems are also often similar in the Nike temple and the Erechtheion, such as the use of diagonal volutes in the corner capitals with the resulting complication of their inner angle, and the con-

tinuation of the column base and anta capital profiles at the bottom and top of the cella wall, respectively.

Ionic was never as strictly canonical as Doric, especially on the mainland, so in the Ionic architecture of the Acropolis the architect or architects had the freedom to create a style uniquely appropriate to its position in the Periclean building program. As a result, the Nike temple and the Erechtheion are remarkably innovative buildings, not just in their interrelation but in their specific designs. This is particularly true of the Erechtheion, one of the most complicated and original buildings ever constructed in antiquity.

The Erechtheion

As is detailed in a set of contemporary building inscriptions *Fig. 68* from the Acropolis, construction on the Erechtheion was begun in 421, when the first phase of the Peloponnesian War had drawn to a close; and as is obvious from a general view of the remains, the Erechtheion is not a standard, canonical temple of any sort. It is a unique and complex building because the requirements it had to fulfill were unique and complex: It replaced the old Temple of Athena Polias, it explicitly commemorated the Persian sack of the Acropolis and the ultimate victory over the Persians, and it incorporated numerous cults and ancient shrines in a single building. The main, east cella was Athena's; the west cella was Poseidon's, as was the north porch, which incorporated a shrine preserving the exact spot in the Acropolis bedrock where Poseidon struck his trident in his contest with Athena. Numerous other sacred spots were accommodated in the design, including that very spot where Athena performed her miracle, too, the spot where her olive tree sprang from the rock; also included was the tomb of Kekrops, the mythical first king of Athens and judge of that same contest between Athena and Poseidon. The desire to incorporate all these ancient cult spots and, consequently, various levels of the Acropolis surface in a single building resulted in a remarkable bilevel construction. This respect for and expression of not only the *Fig. 69* peculiarities of cult and tradition but also of the natural contours of the Acropolis rock itself was not without precedent in the Periclean building program. Neither Mnesikles nor the architect of the Erech-

131

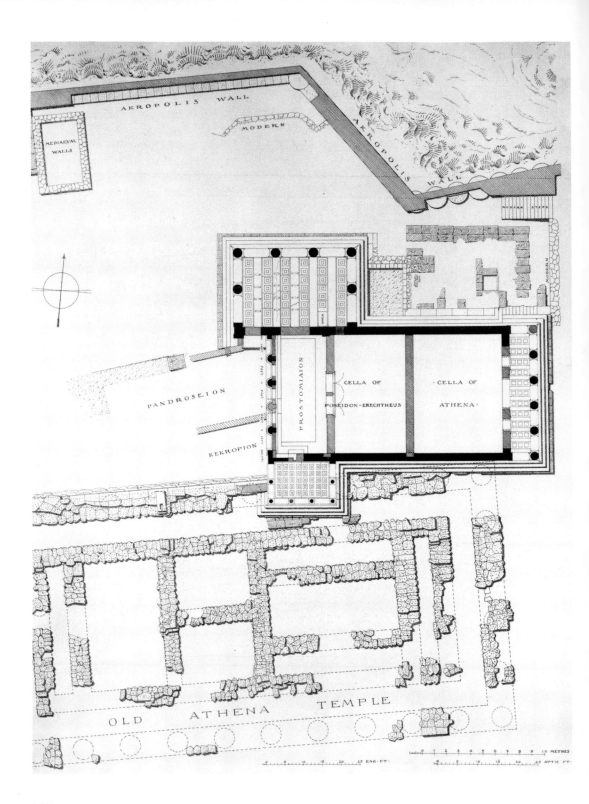

MEDIAEVAL
WALLS

AKROPOLIS WALL

MODERN

AKROPOLIS

WALL

MODERN ATHENA

MODERN

PANDROSEION

KEKROPION

PROSTOMIAION

CELLA OF
POSEIDON-ERECHTHEUS

CELLA OF
ATHENA

OLD ATHENA TEMPLE

0 1 2 3 4 5 6 7 8 9 10 METRES

0 5 10 15 20 25 ENG. FT.

0 5 10 15 20 25 ATTIC FT.

132

68. *(facing)* Plan of Erechtheion (N of old Athena Temple). [From J. M. Paton, ed., *The Erechtheum* (Cambridge, Mass.: Harvard University Press, 1927), pl. I. Photo: American School of Classical Studies, Athens (neg. no. AK 154).]

69. *(below)* Erechtheion: reconstructed elevations. [From J. M. Paton, ed., *The Erechtheum* (Cambridge, Mass.: Harvard University Press, 1927), pl. XIII. Photo: American School of Classical Studies, Athens (neg. no. AK 165).]

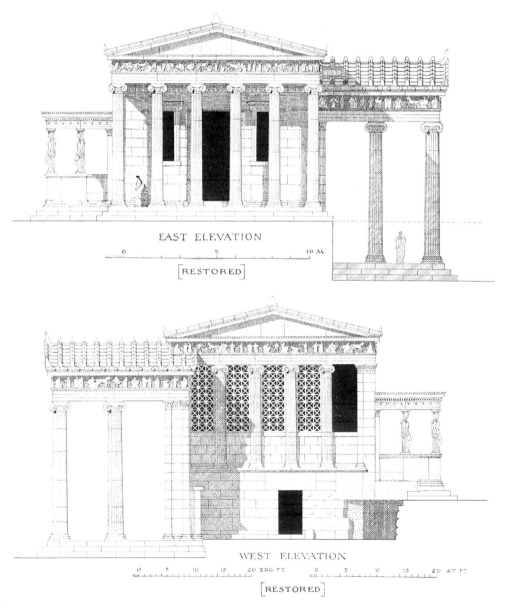

EAST ELEVATION

[RESTORED]

WEST ELEVATION

[RESTORED]

theion leveled his site neatly with fill or excavation, thereby avoiding the serious problems presented by the wedding of architectural tradition and canon with natural topography; instead, they chose to express, emphatically, those irregularities of site in the plan and elevation of their buildings, and to turn those seeming difficulties into opportunities to enhance further and enrich their programmatic roles on the Acropolis. By so doing, Mnesikles emphasized the transitional purposes of the Propylaia; the architect of the Erechtheion, on the other hand, emphasized the intricate mythological narrative associated with the natural features in that area of the Acropolis.

Like the Nike temple, the east porch of the Erechtheion, its main entrance, is an example of the new Athenian Ionic style. It is more elaborate than Nike, however, with its braided column bases and its rich anthemion, delicately carved beneath the capitals and directly projected onto the cella wall behind; as well as with its running frieze of blue Eleusinian limestone – another architectural connection with Mnesikles and the Propylaia – a frieze to which white marble figures were doweled, cameo-like, in unambiguous Ionic procession.

Fig. 70 The north porch is even more elaborate, more colorful than the east, with colored glass inlaid in the minute interstices of its capitals' intricate guilloche and gleaming bronze wire set in the countersinking of their volutes. The doorway of the north porch, with its delicate rosettes, is one of the richest pieces of carving in all of Ionic architecture.

Fig. 69 The west facade of the Erechtheion is something altogether *else,* unique in Greek architecture, constructed as it is on two separately articulated superposed levels, the lower corresponding with the level of the north porch, the upper with the east porch. The upper level consists of four Ionic columns in antis, a columnar arrangement that is, in the most general sense, Doric in origin, but that in its specifics is absolutely unique, even bizarre. Not only do the columns stand high and inaccessible on a blank wall – emphasizing, as Mnesikles did, the uneven lie of the land – but their lower portions were engaged to the wall, their intercolumnar spaces closed.[15]

As was discussed earlier, the north foundation wall of the old Athena Polias temple was incorporated into the Erechtheion as a retaining wall for one of its outdoor shrines and as a kind of symbolic relic for the caryatids of the little south porch to stand on. There again *Fig. 71* columns, this time in the shape of women, sit high on a solid wall. De-

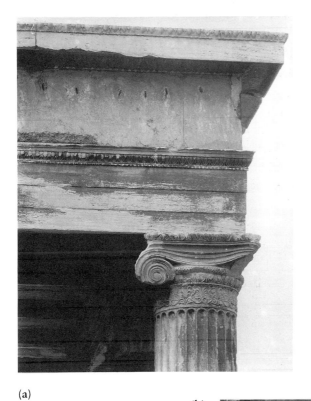

(a)

(b)

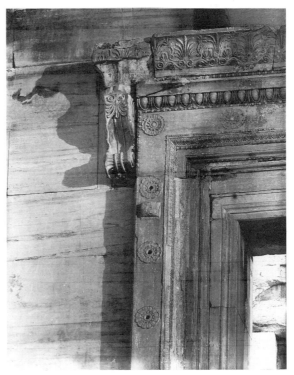

70. Erechtheion: details. (a) N porch superstructure. [Photo: Deutsches Archäologisches Institut, Athens (neg. no. Hege 1843). (b) N porch door. [Photo: Deutsches Archäologisches Institut, Athens (neg. no. Hege 1845).]

135

spite the fact that these caryatids were perhaps intended as reminders of the terrible burden of shame the traitorous women of Karyai were required to carry even to their graves, the architect and sculptor of the south porch seem to have done everything in their power to ease that load, to let them carry it effortlessly, shifting it easily onto one leg – practically lounging under the weight of the entablature. To this end they even reduced the height of the entablature to its pure Ionic form by removing the Attic frieze. Finally, in addition to easing the caryatids' load both visually and physically, they increased both the actual and the apparent strength of the ladies by means of their solid locks of hair (which thicken their necks in elevation and section), and by always situating the weight leg, with its columnar, flutelike folds, toward the nearest corner of the porch.

The preceding description is intended to illustrate the remarkable integration and harmony in the Erechtheion of sculpture and architecture, of cult and plan, of history and topography, of innovation and tradition. The architect of the Erechtheion chose the Ionic order for its flexibility, because it was bound by no strict canon. It was he and the architect of the Nike temple who would *create* that canon, a canon appropriate for radically different scales and one that admitted the use of human-shaped columns.[16]

Ionic was also particularly appropriate for a building whose fragmented plan, with numerous enclosures and porches and entranceways, seems a series of invitations to interiors.[17] It also dispelled any

Fig. 72

possible appearance of competition with the Parthenon. As a Doric temple set beneath the crown of the Acropolis, the Erechtheion could only have paled beside the Parthenon, undistinguished as it would have been by either order or greater antiquity; it would simply have

Fig. 73

been less grand. Instead, the Erechtheion complements the Parthenon in its architectural style and with its caryatid porch, facing as it does the north metopes of the Parthenon, which carry the representation of the war between the Greeks and the Trojans, that decoration on the temple most easily and directly related to the war between the Greeks and the Persians.[18] Moreover, the Panathenaic procession, as it passed between the two temples of Athena on the Sacred Way,

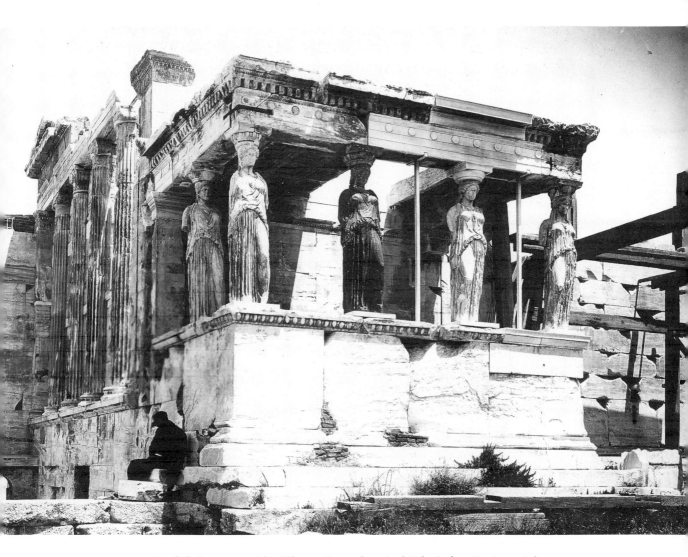

71. Erechtheion: caryatids. [Photo: Deutsches Archäologisches Institut, Athens (neg. no. Akropolis 644).]

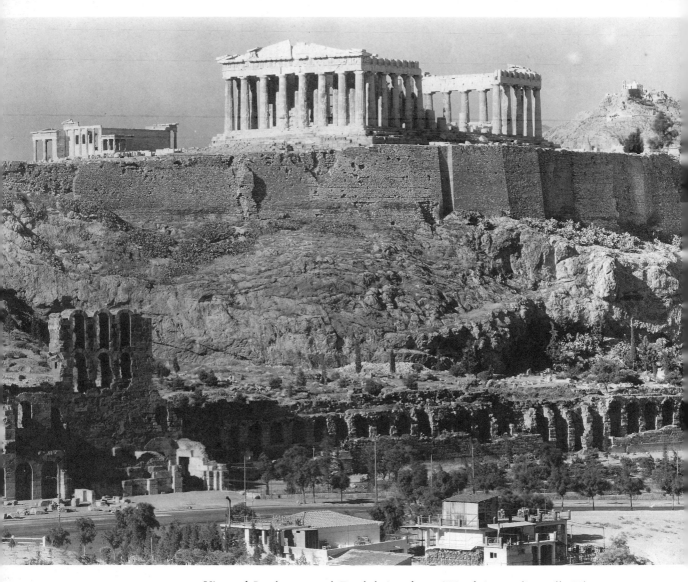

72. View of Parthenon and Erechtheion from SW of Acropolis wall. [Photo: Deutsches Archäologisches Institut, Athens (neg. no. Hege 2537).]

73. *(facing)* Erechtheion and Parthenon from NNW. [Photo: Deutsches Archäologisches Institut, Athens (neg. no. Hege 1870).]

138

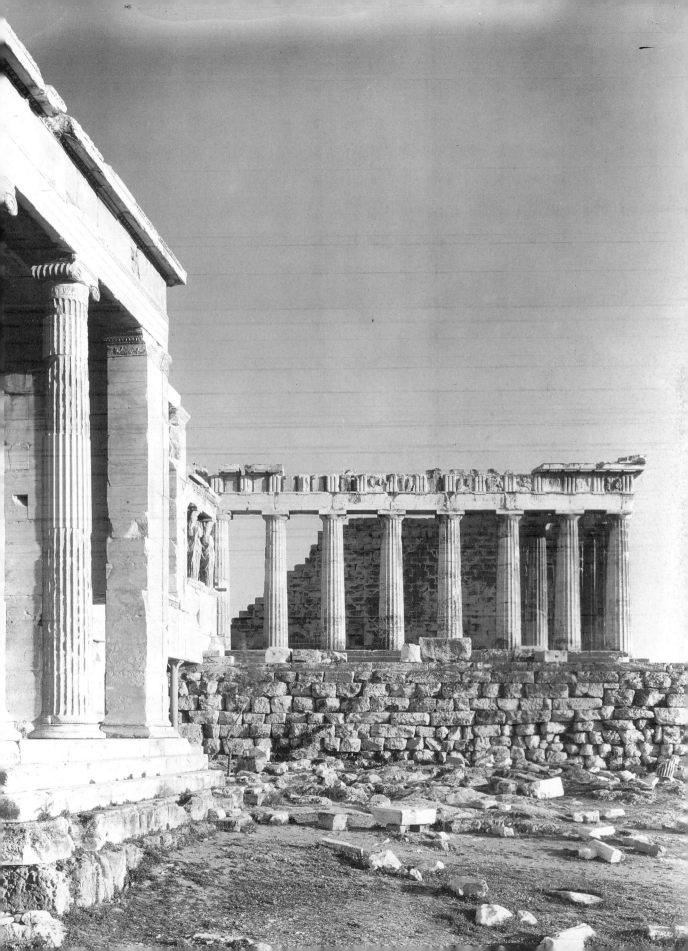

was echoed not only by the Ionic frieze in the shadows of the Parthenon's peristyle, but by the brightly lit cameos of the Erechtheion's exterior frieze, cameos that endlessly march in single file, rarely touching, never crowding, never blurring the boundary between Ionic procession and Doric narrative. The Erechtheion's Ionic frieze speaks in even less specific terms than the Parthenon's. Not only are its figures ideal, they are removed from the normal realm of human activity: They don't move in bunches, they don't crowd and shove; instead, they isolate and repeat themselves as the neat, traditional, emblematic, Ionic expression of procession in temple decoration, eminently appropriate for its position on an Ionic temple and on the Sacred Way.[19]

Ionic and Doric are artfully combined in both the Erechtheion and the Parthenon. In varying degrees, the sculpture of the Parthenon performs a basically Doric, narrative function. Even its Ionic frieze is carved according to the conventions of Doric narrative, with multilayered, overlapping, three-dimensional movement and energetic action. Its architectural shell is also Doric. At the heart of the Parthenon's architecture, however, and crucial in the thematic plan of its sculptural program, is Ionic processional architecture. Conversely, the Erechtheion is ostensibly Ionic, and its processional qualities, unlike the Parthenon's, are expressed most openly and most emphatically not in its architecture or sculptural themes, but in its nonnarrative sculptural decoration, its Ionic frieze and its anthemion bands. On the other hand, its complicated, fragmented plan and elevations are the architectural expression of the complex aggregation of myths, of *narratives* that surround the foundation of the city of Athens. It is almost as if the Parthenon and Erechtheion were conceived in chiastic symmetry,[20] as reversed images of each other, the new Ionic heart of one wrapped in local Doric tradition, the radical Ionic exterior of the other concealing the essential core of ancient Athenian religion.

Fig. 74
Perhaps the most remarkable characteristic of the Periclean building program on the Acropolis is the ingenious interweaving of infinite practical and symbolic elements into a single, unbroken fabric, a complex tapestry in which the meaning and significance of each individual building is only further elucidated and enhanced by its rela-

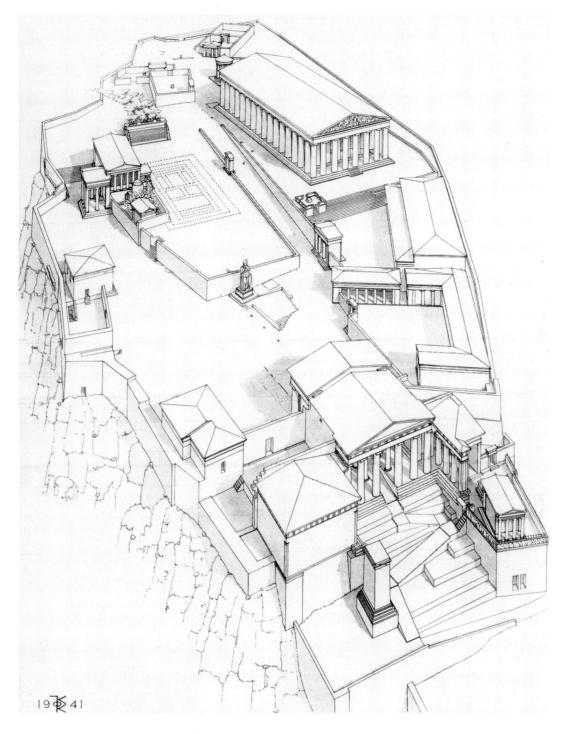

19.41

74. Acropolis, as restored by G. P. Stevens. [Photo: American School of Classical Studies, Athens (no neg. no.).]

tionship with the building program as a whole. The Nike temple *is* a lovely, jewel-like temple, whose elaborately sculpted Ionic style places it in monumental harmony with the impressive Doric backdrop of the Propylaia; but in its relationship to the Parthenon's cult image with its gift of victory, and to the Propylaia's transitional, processional nature – as well as by its location on an isolated bastion before the Propylaia – the Nike temple is also presented as the unambiguous emblem of the Periclean Acropolis, as the herald of the glorious spoils of victory. Likewise, the Propylaia is a magnificent Doric gateway, but in its wings and in the graduated spacings of its facade and its Ionic interior, and in its direct, mathematical relationships with the Parthenon, the Nike temple, and the Erechtheion, it is the building that links and organizes all the rest in a common architectural expression of that most ancient of all uniting religious principles of the Athenian Acropolis: procession. The Parthenon and the Erechtheion house the most ancient cults of the Acropolis, and are virtuosic arias of monu-

Fig. 75

mental Doric and Ionic design; but the initial impression of their mutual independence – in date, in architectural style, in religious function, and in the architectural expression of that function – gives way to an overwhelming sense of relation, of common conception, of architectural rhyming across the Sacred Way. The Parthenon – organized, sober Doric on the architectural surface, narrative Doric on the sculptural surface – has Ionic procession as its unifying spirit, joining its constituent sculptural and architectural parts in a larger, synthetic meaning. It is mirrored by the overtly Ionic, overtly processional Erechtheion, whose idiosyncratic architectural form, although possible only in flexible mainland Ionic, is compelled by nothing Ionic, but by the basically narrative, pseudohistorical nature of the cults it housed.

Pericles, with his architects and sculptors, saw Doric and Ionic not as inimical forms and concepts, but as elements of a common religious and architectural tradition to be mined, combined, and exploited to enhance the richness of the structural and symbolic fabric in his building program. On the surface the Parthenon and the Propylaia, the Erechtheion and the little temple of Athena Nike, can be neatly

75. *(facing)* S to the Parthenon from the caryatid porch. [Photo (montage): Deutsches Archäologisches Institut, Athens (neg. no. Hege 1568).]

categorized as Doric and Ionic, respectively. Yet look below the surface and find similar international, Periclean conceptions of architecture, of the inseparable nature and significance of structure and decoration, of narrative and procession, religion and history, tradition and innovation. Each building is uniquely suited to its own purpose, is a masterpiece in its own right, and is immeasurably influential; but first and foremost, each is an integral part of a greater building program, a greater conception: a single vision of Athens and her gods and their place in the world.

6 Architectural Legacy and Reflections

THE PERICLEAN ACROPOLIS is a peculiarly Athenian crea-
tion, perhaps the greatest expression of that city's unique position
in the Greek world of the fifth century, yet its immediate impact
was felt far beyond the walls of Athens. The purpose of this chap-
ter is to survey selectively contemporary reflections of the Periclean
Acropolis and its architectural legacy in the later fifth and fourth cen-
turies B.C. To begin with, it is helpful to review briefly some of the sa-
lient characteristics of the Periclean building program on the Acrop-
olis:

The first is the conscious connection with and articulation of spe-
cific history in the architecture of the Acropolis. This is initially seen
in the north Acropolis wall, which incorporates fragments of build-
ings ruined in the Persian sack of 480. It is seen also in the window
left in the Classical masonry of the Nike bastion; in the incorporation
of the Mycenaean fortification wall into Propylaia; in the use of the
Athena Polias north foundation wall as a retaining wall for the out-
door shrine immediately west of the Erechtheion; in the overlapping
of that wall by the south porch of the Erechtheion; and in the possi-
ble allusion to the Persian Wars in the caryatids themselves, who not
only carry the burden of the Erechtheion's roof, but are forced to sur-vey
eternally the Greek destruction wrought by the Persians and their
Greek sympathizers. Less literal, but intentional, is the general, at
times almost allegorical, reference to the Persian Wars in the overall
design of the Acropolis and its buildings, and in the function of the
Periclean Acropolis as victory monument, articulated most specifical-

ly in the architectural and sculptural programs of the Parthenon and the little temple of Athena Nike.

Second is the intentional preservation and emphasis of traditional Athenian religious character in the siting of the buildings, in their formal, architectural reliance on their immediate predecessors, and in their sculptural emphasis on hieratic direction.

Third is the internationalization of architectural style, most specifically through the incorporation of Ionic elements into ostensibly Doric buildings and, through those Ionic elements, the incorporation of elaborate processional detail in the architectural program of Pericles. This, in turn, is closely tied to the tradition of hieratic procession in Doric temple architecture and to the tradition of the Panathenaic procession on the Acropolis. On the other hand, the internationalization of Athenian architecture is also obvious in the invention, for the Nike temple and the Erechtheion, of the new Ionic style of Athens, conceived in the Doric context of the mainland and in the spirit of practical and symbolic synthesis that characterizes the Periclean Acropolis as a whole.

Fourth is the accompanying movement toward the elaboration of interior space, a significant alteration of the traditional character of Doric architecture.

Fifth – and related to the implications of the increasing accessibility of the temple to individuals, as seen in the interior elaboration and inward direction of processional elements in the Parthenon's architecture and particularly evident in its sculptural program – is the further humanization of gods and the consequent exaltation of humanity in the context both of the temple and of the religious sanctuary as a whole.

Last is the complex interrelationship of all these buildings and qualities within a comprehensive and coherent conception of the Acropolis as a unified whole, a single program of architecture and symbol.

All these characteristics of the buildings of the Periclean Acropolis can be included under the general headings of innovation and tradition. Tradition was religious pedigree and symbolized the continuity of Athens and her institutions from the legendary past to the present – and, by implication, on into the future. That continuity was threatened terribly by Persian invasion; and when threatened with annihilation, tradition becomes an even more important psychological anchor:

146

The future cannot necessarily be controlled, but at least the past cannot be altered. Much of Periclean religious architecture is built around tradition; but the manner in which the ties with tradition are articulated is the product of the unique vision of Pericles and his architects, as is the expression of a new concept of humanity and its relationship to the gods.

The Temple of Apollo at Bassai

The same interweaving of religious and architectural traditions can be seen in the fifth-century Doric Temple of Apollo Epikourios at Bassai, high in the mountains of western Arcadia. According *Fig. 76* to Pausanias, a traveler of the second century of our era, the temple was constructed as a thank-offering to Apollo for sparing Arcadia the destruction of the plague that ravaged Athens and killed Pericles in the first years of the Peloponnesian War. The cult of Apollo on the site, however, goes back far beyond the Peloponnesian War, as probably does the epithet Epikourios (perhaps meaning "Succourer").[1] In fact, the existence of a series of earlier, underlying temples on the site and the long continuity of the Apollo cult there are crucial for the analysis of the architecture of the Classical temple.

The site of the Temple of Apollo Epikourios is one of the most spectacularly beautiful in all of Greece, and until recently nearly every visitor left it with a strong conviction of the inseparability of religion, landscape, and architecture. Among other things, it inspired one of the most detailed and most poetic passages in Vincent Scully's *The Earth, the Temple and the Gods*.[2] It is in this powerful interplay of site and temple that the interrelationship of tradition and innovation can perhaps be sensed most clearly at Bassai. In its ancient context, it is evident in their graceful and seamless integration; today it is brutally obvious through their tragic clash. Constructed for the most part of the same gray limestone that comprises the surrounding mountains, the unassuming little Temple of Apollo – not part of a monumental building program, only one-fourth the size of the Parthenon, and lacking exterior pedimental or metopal sculptural elaboration – draws its monumentality primarily from its relationship to the powerful landscape.[3] "Temple and landscape are now one architecture,

147

which clearly expresses a double reverence in its form: both for the mighty earth, with all its power, and for man, with the god who champions his lonely acts upon it."[4] Unfortunately, today the temple is no longer visible from the surrounding landscape; nor is the landscape visible from the temple. It is no longer possible to experience the temple in its most significant context, in the context of its most basic inspiration: The Temple of Apollo, which draws its monumentality primarily from its relationship to the surrounding landscape, is today covered with a permanently anchored tent. For the sake of the conservation and preservation of antiquity, the powerful interrelationship of temple and mountain and sky – and, thus, much of the essential meaning of the temple – has been destroyed utterly.

Tradition and innovation did not originally collide so ferociously at Bassai. Indeed, here there is such an integrated and ambiguous mixture of new and old that the date and meaning of the Classical temple are still debated. Is this a rather primitive Early Classical building with a few freakishly modern features? Is it a High Classical temple built in the backwoods of the Arcadian mountains by rubes who knew something of the contemporary architectural scene but who were bound in their backwardness to an essentially primitive conception of temple architecture? Or is it a High Classical temple, state-of-the-art in conception, in which old-fashioned elements are intentionally included in the design as architectural indications of the continuity of ancient religious tradition on that site?

Fig. 77 The most immediate impression of the Apollo temple is that of a long, narrow building, reflected in the decidedly Archaic column count of 6 (on the ends) × 15 (on the flanks), much longer than the normal Classical proportion of $2x + 1$, represented by the $8 × 17$ column count in the Parthenon, as well as by the $6 × 13$ column count in the Temple of Zeus at Olympia and most other mainland temples of the fifth century. Its predominant material, limestone, is the normal building material of the Archaic mainland, and stands in stark contrast to the luxurious marble buildings of Periclean Athens. Its north–south orientation is nearly without parallel on the mainland after the very early Archaic period: From very early on, Doric temples of the mainland were oriented with their fronts to the east and their backs to the west. As with the Acropolis at Athens, whose entrance is on the west, the orientation of the Bassai temple dictates that it be initial-

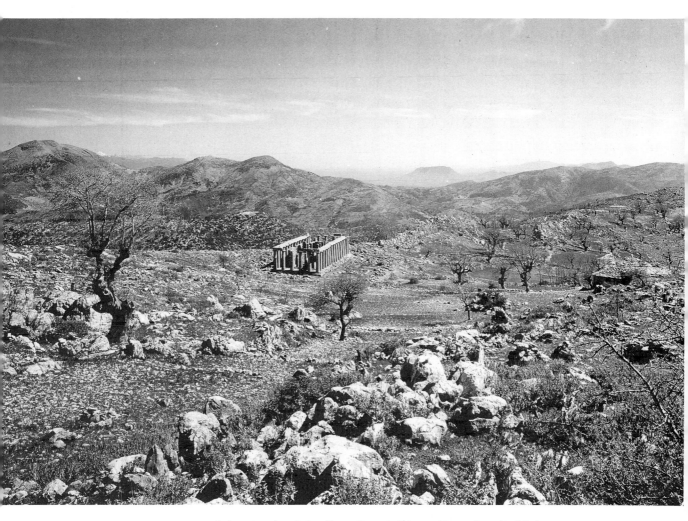

76. Distant view of the Temple of Apollo at Bassai. [Photo: Deutsches Archäologisches Institut, Athens (neg. no. Hege 2144).]

ly approached from behind, and thus evokes the spirit of Archaic religious procession. Another Archaic feature is that the diameters of its columns are not uniform from ends to flanks: Those of the north front are wider than those of the flanks or the south end. Also, the Temple of Apollo at Bassai lacks many refinements that are essentially canonical by the Classical period: There is no horizontal curvature of the stylobate, and the columns have no inward inclination. Beyond the site, the only clear precedent for the interior arrangement of col-

149

umns connected to the cella wall by spurs is in the Temple of Hera at Olympia, perhaps the first Doric peristyle temple in Greece, constructed at least a hundred and fifty years before the Apollo temple, around 600 B.C. Finally, the little adyton where the cult image stood, the space behind the return of the interior colonnades, is a feature normally associated with very early temples.

On the other hand, many architectural details of this Temple of Apollo seem to be contemporary with the Parthenon or later. For example, the specific relationship at Bassai of the exterior colonnade to the cella building, in which the third column on the flanks aligns with the antae and columns of the pronaos, first appears in Athens in the mid-fifth-century Hephaisteion and is a trademark of Attic Doric temple architecture of the second half of the fifth century; at Bassai that same alignment also occurs between the opisthodomos columns and the peristyle. The stiff-profiled capitals are very similar to those of the Parthenon and the Propylaia on the Athenian Acropolis. Moreover, the style of its sculptural friezes – an Ionic one in the cella and Doric ones that, like that of the Temple of Zeus at Olympia, decorate the porches rather than the peristyle – is very late: late fifth century or maybe even early fourth.

Why this mix of old-fashioned and modern? Apollo Epikourios was worshiped on this site long before the present temple was constructed, and significant remains of its Archaic predecessors (there seem to have been three) are preserved.[5] It appears that the Classical temple inherited not only the long, narrow proportions of its peristyle from these, and probably even its column count, but also its north–south orientation and even the specific length and width of the cella. Similarly, even the very earliest of the predecessors (ca. 600 B.C.) had two chambers in the cella and a secondary entrance through its east wall,[6] as well as an interior arrangement that included spur walls and engaged columns.

The Classical Temple of Apollo Epikourios preserves much of the form and character of its Archaic predecessors on the site; through numerous "primitive" features of plan and orientation, clear and unambiguous references to them are made. In this sense the Apollo temple may be an example of true archaism, a building whose purpose is in part to preserve architecturally and emphasize, through the employment of recognizably anachronistic features, the connections and

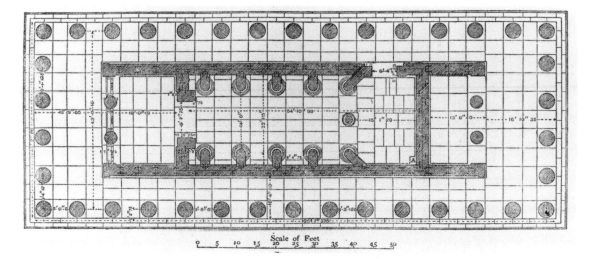

77. Plan of Temple of Apollo at Bassai. [From J. G. Frazer, *Pausanias's Description of Greece* (New York: MacMillan, 1898; reprinted by Biblo & Tannen, New York, 1965), vol. IV, p. 396, fig. 41. By permission of the Master and Fellows of Trinity College, Cambridge.]

continuity between the Classical cult and the religious traditions of the site. Perhaps other old-fashioned features of the Classical temple similarly represent intentional quotations of the earlier temple, or at least intentional allusions to antiquity.[7]

Archaism, "the creative use of old forms for new expression,"[8] is not uncommon among vase painters of Early Classical Athens, and it can exist only in a society that is aware of and concerned with its own history. What architecturally could be more indicative of such an awareness than the memorials on the Acropolis to specific historical events, or even the preservation in the Periclean Acropolis of the site and character and sometimes even the form of the pre-Persian monuments? Although it is probably not fair to project this Athenian attitude onto the rest of Greece, it might not be totally unreasonable in the case of the Temple of Apollo at Bassai, for its architect *was* an Athenian: He was Iktinos, the architect of the Parthenon.[9]

Archaism was not an invention of Classical Greece. The spiritual elevation of a theme, man, cult, or building through association with antiquity, with the venerable, heroic past, can be traced back at least

151

as far as the late Dark Age in Greece, to Mycenaean allusion, war chariots, and figure-of-eight shields on the great ceramic gravemarkers of the Dipylon Cemetery in Athens. Certain details of the Doric order may ultimately derive from the imitation of Mycenaean decorative architecture still visible in the late Dark Ages. Moreover, although not archaistic in any strict sense, it is nevertheless worth remembering that the form of the Periclean Parthenon was determined to a large extent by the form of a temple begun on the same site some forty years earlier. In this context, even if Bassai's anachronistic features are ultimately the product of backward provincialism, their existence, at least, should not shock us. Therefore, in light of Greek genes, not to mention the temple's Athenian architect, and especially considering the existence of remarkably similar early Archaic temples on the same site, it is at least reasonable to consider the possibility that the old-fashioned, out-of-date qualities of the Classical Bassai temple are, at least in part, the intentional product of an up-to-the-minute, religiously informed, innovative architectural mind.[10]

Fig. 78 It is on the interior of the Temple of Apollo that most of Iktinos' ingenuity was expended. Here is the unabashed interiorization of Greek temple architecture, something that was hinted at by the Hephaisteion's architect in Athens and was a guiding principle in the Parthenon, but that at Bassai has an altogether different character. The Parthenon has elaborate interior spaces, but also has an unbelievably elaborate, sculptural exterior. At Bassai there are also two foci, one of which is its interior space; the second, however, is not a decorative exterior, but the temple's setting in the landscape. In addition, the character of the interior space created by Iktinos at Bassai is so elaborate and so very different from anything before that it must be viewed as a significant step beyond the Parthenon in a changing religion, and in a changing relationship between humanity and divinity, between the worshiper and the temple.

For the first time, Ionic columns appear in the main cella, creating a profound interior focus not simply through their elaborately decorative nature but through the unexpected and paradoxical expansion of architectural scale from the exterior Doric order to the loftier Ionic of the interior.[11] Ionic columns appear here in the main cella for the first time, and they have been altered significantly for this special position. As on the corners of the Nike and Erechtheion colonnades,

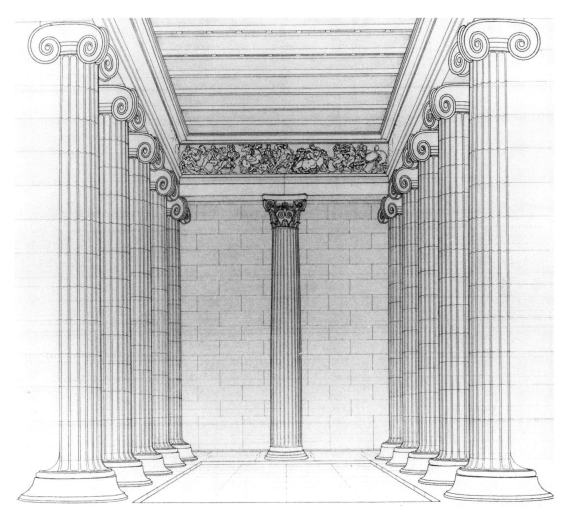

78. Temple of Apollo at Bassai, reconstructed interior. [From F. Krischen, *Die griechische Stadt* (Berlin, 1938), pl. 40. By permission of Gebr. Mann Verlag.]

the volutes of the Ionic capitals here are pulled out at 45° so all sides of the capitals can display their intricate lines. To fit their spur walls, the columns themselves are perfect half-cylinders, the bases three-quarter circles. Besides preserving the character of the earlier cella, the spur walls create shadowy niches, a varied, interesting, and perhaps useful (if only we knew the rituals) interior space.

Then there is the column at the back of the cella, decorative like the return of the interior colonnade in the Parthenon, and carrying

153

the first example of a Corinthian capital in an architectural context. This capital, too, was designed specifically for its position on the only column in the cella that would be viewed from all angles. From a practical standpoint the Corinthian capital, essentially round as opposed to the four-sided nature of Ionic, was a perfect choice; symbolically, it may have been as well. As the focal point of the cella, set as it is alone on the axis of the temple in a position normally occupied by the cult image, the Corinthian column had more than a simple or standard practical or decorative significance. Perhaps it also called to mind ancient axial colonnades, colonnades that antedated pediments and pedimental decoration and that necessitated the placement of the cult image to one side, as at Bassai. Alternatively, perhaps it evoked another aspect of ancient cult: the *xoanon,* the earliest cult image, an aniconic wooden column worshiped in the earliest days as the embodiment of the god.[12] Perhaps, too, it reflected the continuing association of gods, particularly their chthonic aspects, with images of trees.[13] Greek legend and tradition fairly consistently place the invention and closest relatives of the Corinthian capital in a funerary context or, more generally, a chthonic context, one that calls to mind early Greek religion and early Greek conceptions of divinity, chthonic conceptions represented so vividly in early pedimental sculpture and ultimately tied to the strong sense of divinity evoked by the landscape. What more fitting associations in the heart of a temple like Apollo Epikourios than those of intimate, personal religion (i.e., funerary associations), of the continuity of ancient religious tradition, and the indivisible relationship of nature and divinity?

The final aspect of the interior to be considered is the sculpted Ionic frieze. This runs around three sides of the cella, supported on its interior columns, and adds a final overwhelming sense of decorative elaboration, accessibility, and even intimacy to the cella: After all, if the cella of the Bassai temple, in keeping with Doric tradition of the mainland, was not intended to be entered and experienced and contemplated, why was the lion's share of ingenuity and decorative elaboration lavished on the interior?

Consistent with this impression are the subjects of the frieze. Both are battles: the Centauromachy and the Amazonomachy. The fact that their connections, like the sculptural subjects of treasuries or the west end of temples, are more human than divine further orients the

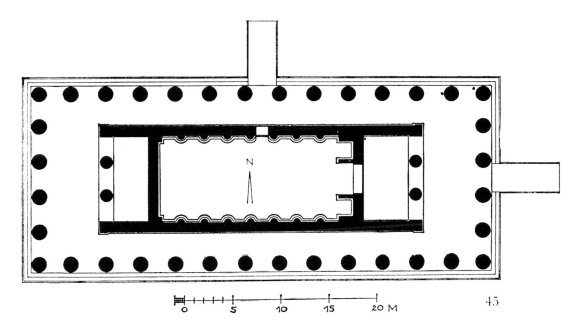

79. Plan of Temple of Athena Alea at Tegea. [From H. Berve, G. Gruben, and M. Hirmer, *Greek Temples, Theatres and Shrines* (London, 1963), p. 355, fig. 45; after C. Dugas, *Le Sanctuaire d'Aléa Athéna à Tégée au IVe siècle* (Paris: Librairie Orientaliste Paul Geuthner, 1924), pls. 9–11. By permission of Hirmer Verlag and the École Française d'Archéologie, Athens.]

spirit of the cella toward humans, worshipers, and not divine epiphany.[14] The detailed and inventive elaboration of the Bassai cella, including this vast and beautifully carved frieze, indicates just how quickly Iktinos' conception of interior space developed after its initial expression in the Parthenon.

The Temple of Athena Alea at Tegea

In the cella of the Temple of Athena Alea at Tegea, a Doric temple constructed around the middle of the fourth century B.C., there is no evidence of a sculpted frieze, but in its design is found one further step in the elaboration of interior space. Here the interior columns carry Corinthian capitals (and perhaps Ionic in an upper tier), and they are directly engaged to the cella wall. In other words, the

Fig. 79

155

interior colonnade no longer serves the dual masters of structure and decoration. In the cella of the Parthenon a decorative backdrop of columns was introduced in the context of the return of freestanding structural colonnades: These reduced the free-span of the cella and ultimately supported the ridge beam of the roof. At Bassai the cella was further elaborated decoratively and, as later at Tegea, the interior columns were engaged; but at Bassai they were engaged to spur walls, which themselves effectively reduced the free-span of the cella. At Tegea the columns have been relieved of any structural responsibilities whatsoever, and of any pretense of those responsibilities; their function is purely to enhance the beauty of the interior space, to create a visually pleasing and appropriate environment for whoever enters the temple. At Tegea the interior columns have been reduced to decorative wall patterns.

The temple at Tegea also provides an example of how another idea expressed in the Periclean building program and at Bassai continues and develops: that of architectural "archaism." As at Bassai, the temple of Athena Alea is long and narrow, 6 × 14 columns, much longer and narrower than its mainland contemporaries; and, as at Bassai, these proportions and the general plan of the temple can be attributed to the existence of an Archaic predecessor on the same site.[15] Also reminiscent of Bassai is the doorway on the long side of the cella wall, whose existence is probably due to requirements of architectural and religious tradition. Here at Tegea, however, is also another kind of architectural quotation, one whose source is not its predecessor on the site but the great Periclean building program itself: Among other things, the axial spacing of the columns is an exact copy of that of the Propylaia.[16]

Pergamon

Already in the fourth century Periclean Athens had begun to take on an air of mythology, and artistic quotation and allusion to it continued to be made throughout the Hellenistic and Roman periods.[17] Over the centuries there were revivals of Classical Athenian style, imitations of specific Athenian models, copies, and variations. Here buildings and nations were being elevated to the realm of the

heroic not simply by association with legends of the mythological past, but through association with the very specific historical moment of the Golden Age of Athens – as for instance, with the caryatids in the Forum of Augustus at Rome or the Propylaia-like entrance to the Hadrianic Pantheon.[18]

Crucial in the mythologizing of Athens was the kingdom of Pergamon, which, perhaps more than any other Hellenistic source, communicated its own view of Pericles' city to Rome and, ultimately, to the rest of history. Born as a power in the aftermath of Alexander's death and in constant competition with the other fragments of his empire, Pergamon quickly recognized the efficacy of art and architecture as tools for legitimizing an otherwise unpedigreed nation. The kingdom's victories over the Gauls in the third century B.C. provided the city with an official self-image and became the perfect vehicle for associating herself with the venerable traditions of fifth-century Athens, as the reincarnated guardian of Greek culture against the threat of barbarian destruction. First, a large temple to Athena was dedicated on the Pergamene acropolis, constructed not in the traditional Ionic style of the area but in Doric, like the greatest of all Athena temples, the Parthenon.[19] The choice was unusual and intentional and, particularly in light of the character of subsequent Pergamene monuments, seems to represent a direct allusion to Athens and its Acropolis. Like the Periclean Acropolis, the heights of Pergamon became an immense victory monument. As in Athens, a statue of Athena Promachos (leader in battle) was set up on the acropolis, together with numerous other sculptures emphasizing the magnitude of the Gallic defeat. In the following century, in the wake of further victories over barbarian forces on the edges of the kingdom, the association with Athenian victory over the Persians was enlarged to include specific references to the Periclean building program and Athenian patronage of the intellect and the arts: A colossal image of Athena Parthenos, whose base carried some of the same figures that adorned the base of Pheidias' statue in the Parthenon, was dedicated in a new library on the acropolis at Pergamon. At the same time a new Panhellenic festival similar to the Panathenaia at Athens was instituted at Pergamon and dedicated to the goddess Athena as bringer of victory. Further, in open homage to their spiritual model, the rulers of Pergamon lavished architectural and sculptural gifts directly upon the city of Athens. In

fact, it is a dedication on the Acropolis in Athens that is most reveal‐ing of the overall intent of the official architectural and sculptural programs of Pergamon.

The so-called Lesser Attalid dedication probably stood to the southeast of the Parthenon and may have consisted of as many as fifty half-life-size figures. From an ancient description and Roman copies the themes represented can be restored as battles of the gods and the Giants, the Greeks and the Amazons, the Athenians and the Persians, and the Pergamenes and the Gauls. In the Parthenon – in whose shad‐ow the Attalid group stood – and elsewhere in the Periclean building program historical events, most specifically the war with the Persians, were elevated by association with myths and legends (e.g., the Ama‐zonomachy, Centauromachy, Trojan War, Gigantomachy). The Per‐gamenes, by adding representations of their own victories over the Gauls, also associate themselves with the traditional myths of victory over barbarian forces; but more directly, through their context on the Athenian Acropolis, the Pergamenes associate their accomplishments with those of Periclean Athens, and thereby elevate them to that al‐most mythological pinnacle of human achievement.

In the sculpted Gigantomachy of its exterior frieze, the Great Altar of Zeus at Pergamon continues to project the city's image as protec‐tor of the Greeks and guardian of culture. Indeed, with its traditional theme and frequent use of classicizing style, and with many of its fig‐ures and groups clearly based on ones from the pediments and meto‐pes of the Parthenon, the frieze serves as a comprehensive emblem for the city. Moreover, the minutely detailed iconography employed in the representation and identification of the endless gods and divine creatures of the frieze is a paradigm of the precise academic approach necessary in copying Periclean sculpture or architectural detail, and in setting up detailed associations between Pergamon and Athens.

Fig. 80 In addition, something of the processional quality of Athenian reli‐gious architecture may also have found its way into the Great Altar. Most immediately, like Athena's great temenos on the Acropolis in Athens, the temenos of Zeus is entered from the back, in this case the east, and the back wall of the altar is the first to be encountered. As in the Ionic frieze of the Parthenon, the movement of the figures in the Pergamon Gigantomachy frieze leads or proceeds with the vis‐itor, in one of two directions, around to the front of the altar.[20] Also

158

80. Plan of Pergamon Acropolis: detail showing Zeus altar and temenos on S.
[From H. Kähler, *Pergamon* (Berlin, 1949), following p. 65. By permission of
Gebr. Mann Verlag.]

reminiscent of the Parthenon and Bassai, and even of Olympia, is the movement from a more emblematic or divine theme and technique on the exterior to a more intimate, human theme and representation within,[21] a movement from the deeply carved Gigantomachy on the outside of the altar complex to the local foundation myth of Telephos, rendered in low relief inside the colonnade. The Telephos frieze is meant to be contemplated and examined at close range rather than experienced dramatically from afar.

In fact, the overall conception of hieratic procession on the Athenian Acropolis seems to have influenced Pergamon on an even larger scale and more fundamental level: It seems to have been applied to the plan of the city as a whole. As expanded and reorganized in the second century B.C., the various parts of the city were laid out on the slope of the mountainside according to function; they were joined by a single road in an ascending progression from most mundane at the bottom to holiest at the top, from the residential blocks in the plain, to exercise grounds and schools on the lower slopes, to lecture halls and centers for cultural activities, to the political and legal quarter, and finally to the acropolis itself, the home of Athena and the king and the religious center of the city.[22]

New Directions

The architectural expression of religious tradition and an increasing interest in the elaboration of interior space are two major characteristics of the Periclean Acropolis that find continued life in the architecture of the later fifth and fourth centuries B.C. Another, related aspect of the Periclean building program that has far-reaching consequences is the breaking of canon and the establishment of new canon. The architects of the Nike temple and of the Erechtheion were free of the strict requirements of canon and, thus, relatively free of architectural tradition as a causal factor in the final design. They were more or less free to create their own style of Ionic architecture and to tailor that style, or leave it flexible enough to accommodate the very specific needs of the building program. In that sense, these two buildings are perhaps most uninhibitedly representative of the vision of Pericles. These architects created canon in their Ionic buildings,

and as such stand at the beginning of an Ionic tradition that continues through the Classical and Hellenistic periods, on through the Roman Empire and, ultimately, to the Rennaisance and today.

Even more remarkable, however, and certainly bolder and more revolutionary in their specific context, are the two great Doric buildings on the Acropolis: the Propylaia and the Parthenon. Here the architects did not have a clean slate on which to design. In addition to the specific requirements of religious and historical tradition on the Acropolis, they had to build in the native style of the mainland, Doric, according to a canon established 150 years earlier for the articulation of religious architecture, in particular, temple architecture; but for the purposes of Pericles' vision, Doric canon had to be bent and riven and filled with the spirit of Ionic.

The incorporations of procession and site – and, in some cases, the forms of earlier buildings – are essential elements in the traditional character of Periclean architecture. The Doric order, however, is the most important symbolic bond between the fifth-century buildings of the Acropolis and the rich tradition of monumental Greek religious architecture in general. It is also the most elaborate and one of the oldest expressions of religious tradition in Greek art. Its remarkably conservative and consistent nature throughout the Archaic and Early Classical periods on the mainland is due to its basic function as religious architecture, as the architectural expression of traditional ritual. So in seeming antithesis to the fastidious Periclean preservation of the spirit of the Archaic Acropolis, part of what happens in the designs of the Propylaia and the Parthenon is the breaking of canon, the breaking of religious tradition. Earlier in Athens – or perhaps in any context other than that of Periclean Athens – in a world in which the basic tenets of religion and art were not already being questioned and rethought, the changes and adaptations of the Doric order on the Acropolis are almost inconceivable: They would be tantamount to sacrilege. Even in that context, however, they could never have been realized without the genius of Pericles' assembled architects and sculptors, who managed to integrate, almost imperceptibly at times, great change and canon into a logical, meaningful, virtually seamless whole.

The breaking of canon results in another side of Greek architecture, perhaps the most characteristic aspect of Greek architecture in

the fourth century B.C. and throughout the Hellenistic period, the multiplication of monumental building types in the Greek world, that is, novel uses of monumental architectural forms. Once Doric was broken out of its traditional mold by Pericles and his architects, it was naturally extended to a larger and larger circle of building types, and many more significant examples of monumental architecture began to be created outside the strictly religious realm. This, coupled with the continued humanization of the gods and a growing interest in the individual and personal experience, led to the possibility that monumental architectural forms could actually be created in the context of the achievements of an individual mortal, as opposed to the gods.

Fig. 81 The tholos – a circular, often columned building – was first monumentalized in Doric in a religious context, probably as a treasury at Delphi; and the early fourth-century tholos in the sanctuary of Asklepios at Epidauros was even larger and more beautiful and decorative-
Fig. 82 ly elaborate than the temple of Asklepios there. However, with the Monument of Lysikrates in Athens – an elaborate base constructed for the display of the prize tripod awarded to the choral sponsor (*choregos*) Lysikrates for his entry in a dramatic contest during the festival of Dionysos – we move into the realm of private monumental architecture. Here, too, for the first time an important architectural innovation appears in a private, nonreligious context: For the first time Corinthian capitals appear on the exterior of a building. For the *second* time a combination of the Attic Ionic frieze and Asiatic Ionic dentils appear together, the composite frieze that continues as canonical Ionic throughout the Hellenistic and Roman periods and down to the present day. The *first* building on which it appeared was another tholos, constructed four years earlier by King Philip of Macedon in
Fig. 83 celebration of his great victory at Chaironeia in 338. With that victory Philip gained immense influence in central and southern Greece, enough that he was able to dedicate his tholos, the Philippeion, within the temenos walls of the great sanctuary of Zeus at Olympia. Standing inside the Philippeion, within the temenos itself, constructed out of gold and ivory, the traditional materials of the great Classical cult images at Athens and Olympia, stood three monumental images: one of Philip, one of his father, and one of his 18-year-old son and heir, Alexander.

162

81. *(right)* Tholos at Epidauros, reconstructed superstructure. Archaeological Museum, Epidauros. [Photo: École Française d'Archéologie, Athens (neg. no. 50.919).]

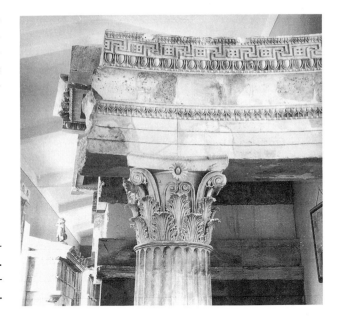

82. *(below)* Lysikrates Monument in Athens, from SE. [Photo: Deutsches Archäologisches Institut, Athens (neg. no. Ath. Bauten 584 B).]

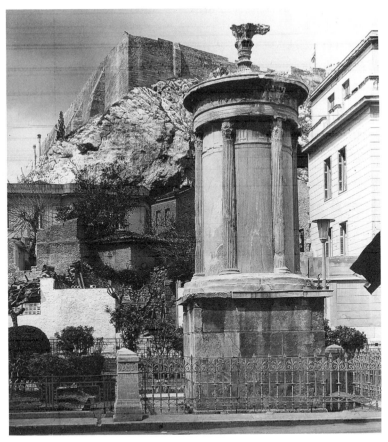

The architecture of the post-Persian Acropolis was rooted in religious and architectural tradition. It was also remarkably innovative. Both of these aspects were passed down to succeeding generations of Greeks. On the Athenian Acropolis, in the buildings of Pericles, is the first clear expression of a radical change in the relationship between humanity and the gods. Their theme is more human than divine; their heart, the interior of the great temple to Athena Parthenos, is accessible and even inviting to the worshiper; the designs of the buildings and their sculpture are clearly directed at human perception as opposed to divine perfection. Yet the significance of this building program goes beyond being a showplace for Periclean ideals. It is also a formative influence and a rich architectural palette that facilitates the further expression of such religious attitudes and ultimately allows and even encourages the incorporation of humanity into the canon of Greek religious architecture. It is not a radical step from the cella of the Parthenon to the remarkably ornate interior of Bassai. Nor is the step from the Parthenon, with its frieze of Athenian citizens, to the Philippeion, with its family sculptures, revolutionary. It is an even shorter step from the Philippeion to the deification of Alexander and the Cult of the Ruler in Hellenistic Greece. It all began with Pericles.

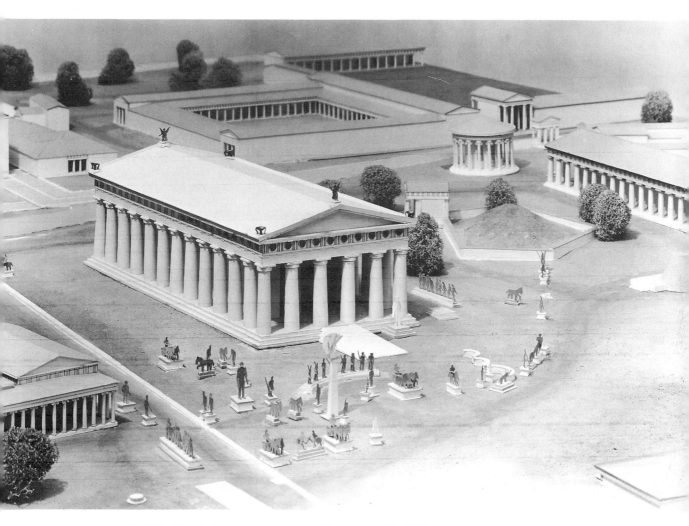

83. Model of Zeus sanctuary at Olympia, with Philippeion in upper right. Archaeological Museum, Olympia. [Photo: Deutsches Archäologisches Institut, Athens (neg. no. 68/802).]

7 God and Man
The Spiritual Legacy of the Periclean Acropolis

THE CHARACTER OF LATER GREEK ART clearly derived in significant measure from the Periclean Acropolis; yet its roots stretch far beyond Pericles. His building program was itself the result of a long religious and artistic evolution, and was firmly grounded in the traditions of both.

The Periclean Acropolis, however, was also very much a product of the unique historical circumstances of Periclean Athens. Religious tradition was assiduously, even compulsively, respected and incorporated into the architecture and organization of the Acropolis, but in unprecedented ways and with unprecedented self-consciousness. Basic religious traditions remained the same and, through their very antiquity, validated the new Acropolis; but traditional means of expression were rethought, reinvented for an Athenian world that itself had been reinvented in the course of the Persian Wars. Not only did Athens emerge from those wars as the leader of the civilized world, but the city's miraculous survival and success seemed to imply on some level a shift in the basic relationship between its people and the gods. A sense of both of these was allowed to permeate the new architecture of the Acropolis, which seems directed in equal parts toward the glory of gods and humanity.

As the Periclean Acropolis is the unique product of specific cultural circumstances, so the art of the later Classical period is the product of myriad influences. Of those, one of the most significant is the Periclean Acropolis and the complex corpus of forms and concepts contained in its architecture, already recognized in the fourth century

166

as representing a pinnacle of cultural achievement. The multiplica-
tion of monumental building types and the increasing monumentality
of private buildings; the humanization of the gods; the monumental-
ization of the individual; the detailed exploration of the human con-
dition; personalized, emotional religion; elaborate temple interiors;
archaism; the detailed exploration of the human condition – all are
characteristic of the century following the Age of Pericles and can be
understood fully only in their specific historical and cultural context.[1]
However, they are also all directly related to the spirit and specifics of
the Acropolis, to which they owe their particular character in one
degree or another. Later Greek art did not originate with the Periclean
Acropolis, but neither its spirit nor its specifics can be properly
understood without it. It is to the spirit that we turn in this conclud-
ing chapter.

The Humanization of Divinity

In the earliest pedimental sculpture of Greece, divinity is rep-
resented in the center of the temple front not as specific Olympian
deities but as an abstract concept in the guise of monsters, of nonhu-
man terror figures. The east pediment compositions are emblematic,
nonnarrative, confrontational, and may ultimately be inspired by the
power of the Greek landscape and the perceived presence of divinity
in it. The rear pediment and the pediments of more secular buildings,
on the other hand, at least in the case of the Athenian Acropolis, are
not purely or even primarily the realm of divine epiphany; there we
enter a more narrative, more human environment – the adventures of
heroes and stories of the gods.

*Figs. 26–28,
30, 31*

By the end of the sixth century, in the Temple of Apollo at Delphi
the rear, western pediment is still narrative, and the front pediment is
still confrontational, nonnarrative, and emblematic – but the central
scene no longer consists of terror figures. The human-shaped figures
of Apollo and his retinue that comprise it still represent the epiphany
of an abstract concept of divinity, and are represented according to
the artistic conventions of the emblematic; but now divinity is defined
in distinctly human, distinctly Olympian vocabulary.

Fig. 51

167

Figs. 50, 52, 54

Fifty years later at Olympia, the Centauromachy of the Temple of Zeus still places the back pediment in the human realm, the realm of legend, of narrative. Continuing the traditions of Archaic temple architecture, its east pediment is confrontational, though now it is not only filled with human figures, but pervaded by narrative. The concept of divinity is expressed here through storytelling, a distinctly human device traditionally considered inappropriate for the abstract purpose of epiphany. Yet here, and unlike in the west pediment, the narrative is understated, and a sense of emblem is still present: The characters of the Pelops and Oinomaos myth do not interact with each other in normal narrative fashion; they stand alone, looking out from their architectural enframement. They are not confrontational in the same way as Corfu's Gorgon Medusa – nor as Archaic kouroi, votives with

Figs. 11, 53a

direct, frontal gaze. The Olympia figures do not look us straight in the eye; instead, they turn slightly away, isolating themselves from us and from each other. This places each of them in their own private realm, a realm of contemplation, of implicit narrative; and it is this – not direct gaze or confrontation – that draws us into the contemplation of the story to which they all belong. Unlike the west pediment, with its neatly interacting, neatly profile figures, this story is not confined by an architectural frame: It reaches out to us initially through the gaze and attitude of the participants, then through the Polygnotan moment chosen and the inescapable connections of myth (conditioned and hastened by the specific apprehensive attitude of the old seer). We follow the story as it gradually unfolds in our minds, picking up speed in concert with the multiplying consequences of Pelops' deeds, until we run headlong into confrontation with divinity and its basic nature: powerful, uncontrollable, unpredictable, inflexible, incomprehensible to humankind. The epiphany of ancient divinity is still present at Olympia, but it is evoked through purely human means.

Fig. 57

In the Parthenon both pediments are narrative, yet as at Olympia the eastern one is still composed with techniques of emblem, with isolated, noninteracting central figures and with Zeus, not Athena – the specific goddess of the temple – at the center. However, there is none of the intellectual confrontation, the disconcerting nature, of the east pediment at Olympia. This is clearly one step farther away from the traditional Greek conception of divinity and the nature of the temple. An analogous change can be seen in the west pediment, whose scene

is not only completely narrative, in the tradition of Doric mainland west pediments, but whose story mixes humans with gods. The contest of Poseidon and Athena takes place in a human context – mythological, yes, but in Athens, among Athenians who serve as the final judges of the contest. On the Ionic frieze are representations of Athenians – generalized, yes, but Athenians nonetheless – and perhaps not mythological ones but historical Athenians taking part in a familiar, roughly contemporary ceremony. They are represented not only on the greatest temple in Athens, in the Greek world for that matter, but in the same field with the Olympian gods. Indeed, in some ways, the Athenians in their formal procession appear more godlike than the gods themselves, who lounge at the east end of the frieze, chatting informally among themselves. In the Parthenon the terror of divine confrontation gives way to benign, unthreatening pedimental compositions and to unambiguous messages of human victory in the overall architectural and sculptural program of the building. Here, where the gods are humanized and humans divinized, the terrible, unfathomable, uncontrollable aspects of the universe have been reduced to metopal vignettes of Centaurs, Giants, Amazons, and Trojans, and spirited horses galloping along the frieze. *Fig. 49*

In the course of the sixth and fifth centuries B.C., a spiritual evolution in the conception of the temple takes place. This evolution can be traced most clearly in architectural relief, where there is a gradual change of emphasis from confrontational images of terror and their direct experience by the worshiper, from the emblematic epiphany of general, abstract conceptions of divinity, to a less visceral display of human-shaped gods in human-shaped scenes. This leads eventually to the Parthenon, whose gods are so completely human that the need for segregation of mortal and divine has disappeared almost altogether, and gods appear side by side with people.

The humanization of the Greek gods does not end with the Parthenon, however. Indeed, it continues and flourishes in the century following the Age of Pericles, not only in the context of temple architecture but also in freestanding sculpture, particularly and most obviously in the sculpture of Praxiteles. It has often been observed that Praxiteles is an artist unawed by the Olympians, tending to see them as the most human of all creations, as fit subjects for jest and even ridicule – much as Euripides cast Apollo as a buffoon in his *Ion*.

Fig. 84 The famous sculpture of Hermes with the infant Dionysos (traditionally atttributed to Praxiteles) expresses a playful, humorous, completely non-Olympian view of two Olympians in which Hermes teasingly dangles a bunch of grapes over the outstretched arms of the baby Dionysos. From the subject chosen to the sensuality of Hermes' body, the artist has rendered his conception in the most human of terms. In his Apollo Sauroktonos, Praxiteles pokes fun at the great *Fig. 85* god of reason and light, the great god of Delphi and conqueror of the fearsome serpent Pytho. Here Apollo the Dragon-slayer is represented as Apollo the lizard-pricker, a prepubescent youth lounging in epicene languor against a stump, idly debating whether to poke an unfortunate chameleon with his little dart or let him go. The world was scandalized by Praxiteles' Aphrodite of Knidos: Until then, no self-respecting woman had appeared nude in Greek painting or sculpture – courtesans, yes, but certainly not goddesses. Here Olympian Aphrodite herself is shown without a stitch, and not in the academic nudity of the Doryphoros: Aphrodite has been caught unawares as she rises from her bath and is reaching for her gown in an attempt to protect her modesty. Adding insult to injury, Praxiteles displayed her in a round cella where she could be conveniently viewed from every embarrassing angle.

The Personalization of Religion and the Exploration of the Human Condition

Temples

Before the Parthenon the humanization of divinity was gradual. In that building, however, the process was accelerated to such a degree and by such unprecedented means that the spiritual relationship between it and earlier temples was nearly obscured. Coincident with this was a dramatic break of perhaps the most elaborate symbolic bond with ancient religious tradition: the strict canon of the venerable Doric order. Together with both these changes was a kind of personalization of Greek religion, indicated most clearly in the new

84. *(facing)* Praxiteles'(?) Hermes and Dionysos (copy?). Archaeological Museum, Olympia. [Photo: Deutsches Archäologisches Institut, Athens (neg. no. Hege 670).]

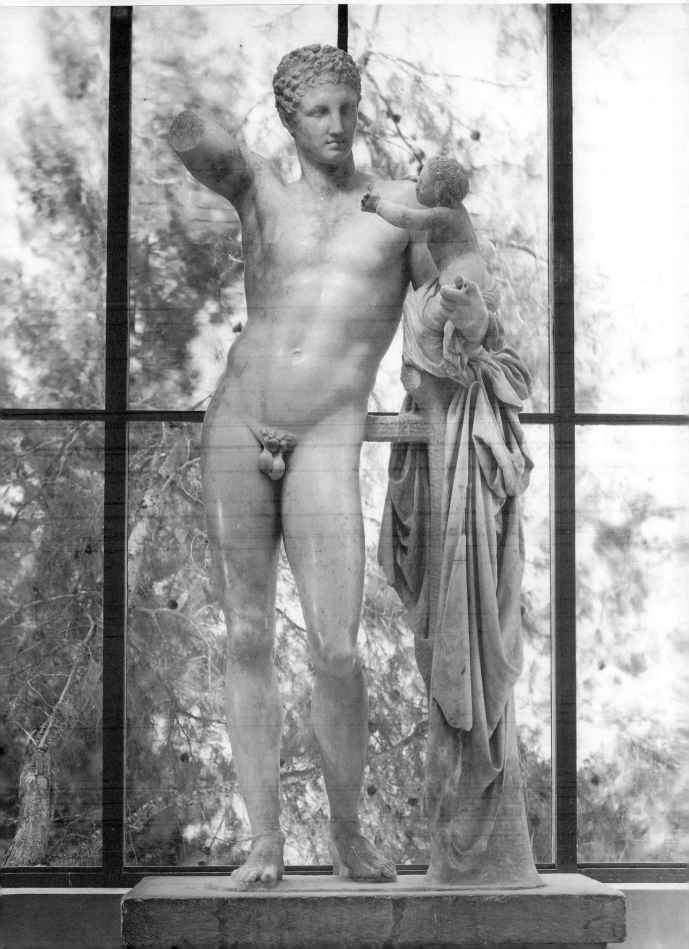

internal focus of the temple. In the Parthenon the interior, traditionally reserved for priests and the cult image, was now the focus of an infinitely detailed program of architectural and sculptural procession; even more remarkably, it was the seed from which the temple grew. At Bassai the temple architecture was focused still further on the interior, which Iktinos made so overwhelmingly elaborate that the changing relationship between humanity and divinity, first clearly seen in the Parthenon, must be understood as a concept that was developed and elaborated almost as soon as it was first expressed.

Does this new accessibility of the temple, intimacy with cult, represent a further humanization of the Olympians, a further step in the clear evolution of the Greek conception of divinity – a conception whose changing nature is unambiguously manifest in the architectural sculpture of Greek temples of the sixth and fifth centuries B.C.?

Almost certainly the break with architectural canon in the Parthenon and succeeding temples, particularly their new internal focus, reflects changing religious attitudes and practices; and one of the keys to the meaning of the Parthenon is found in the further humanization of its Olympian gods. Nevertheless, although they are certainly related, it is not clear that the new internal focus of the temple and the humanization of its gods are parts of the same evolution. Particularly at Bassai – with its double focus on its setting in the landscape and on its interior space, as opposed to a decorative, programmatic elaboration of its exterior, and with its conscious and detailed quotations of earlier temples on the site – we seem to be witnessing more a re-creation of traditional religious expression than the logical extension of the Parthenon's spirit. That is, Bassai suggests a return to a more personal confrontation with religion, to a more traditional concept of divinity – less human, Olympian, and narrative, and more emotional; a return to a religion inspired by nature, which was an original inspiration for temple building and is best symbolized not by clean-shaven, golden-tressed youths, but by monsters, Gorgons, child murder, and blood. In the *Bacchai,* these concepts are portrayed not only as separate but as principals in a violent conflict between old and new. Ironically, but understandably in light of the immense intellectual influence of Periclean Athens, the traditional, inhuman conception of divinity (as represented by the religious power of Bacchos) is cast by Euripi-

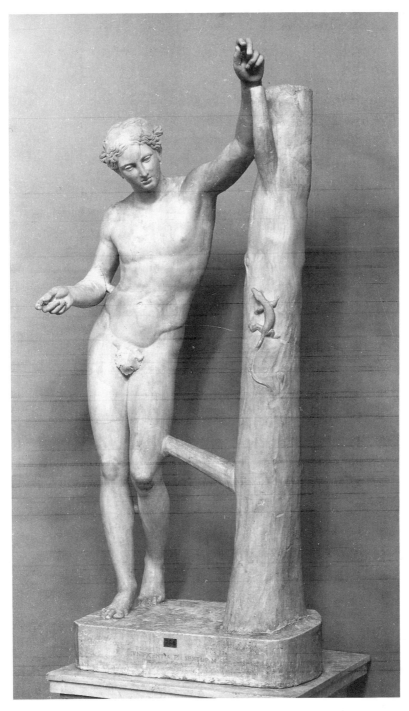

85. Praxiteles' Apollo Sauroktonos (Roman copy). Musei del Vaticano, Rome.
[Photo: Deutsches Archäologisches Institut, Rome (neg. no. 68.3651).]

des as the "new," and the intellectualized, safe religion of contemporary Athens as the "old." In fact, the eminently human religion of the mystery cults, of Demeter and Dionysos – which, like Bassai, is emotional, violent, spiritual, and intimate – was not an invention of the late fifth century, nor grew out of gradually humanized gods. It was more a rediscovery, the fruit of true religious experience, of the age-old confrontation of humanity and nature.

The unpredictability of the universe is part of the human condition, and as it was denied a thematic place in the pediments of the Parthenon, it was also denied in Pheidias' choice to accentuate the ageless, emotionless, idealized aspect of the human figures on the Parthenon. The generation preceding the Parthenon had explored the human condition, physical and emotional, with ever-increasing enthusiasm and detail: in the flayed anatomies and contrasting characters of Euphronios' red-figure heroes and villains, in Euthymides' twisting bodies, in the tragedies of Aeschylus and Sophocles, in Olympia's east pediment. However, in the intentional contrast between the Olympian calm of the riders on the Parthenon frieze and their frenzied mounts, the Athenians were not explored as humans but were further associated with the gods themselves, subtly connected with Apollo of the west pediment at Olympia; they are unperturbed, in complete control amid total mortal chaos. The unpredictability of the universe was not of primary concern in the Parthenon; nor was an examination of the human condition in its various aspects. In this sense the Parthenon and the art of the Periclean Age may be (and have been) viewed as a kind of break in the continuous fabric of Greek art and religion; for when Greece emerges from the Peloponnesian War and the democratic tyranny of Periclean Athens, the traditional artistic preoccupation with the representation of humans in a multiplicity of conditions – a preoccupation with understanding through ever-increasing detail rather than through generalization or idealization – returns to both religious and secular Greek art. This goes hand in hand not with the reciprocal humanization of gods and divinization of humanity, but with the personalization of religion suggested by Euripides' *Bacchai* and Bassai's interior, and by the interiors of the Temple of Athena at Tegea and other fourth-century Doric temples. As closely related as the Temple of Apollo at Bassai and the Parthenon are, their spirits are altogether different. The interior at Bassai is the unambiguous archi-

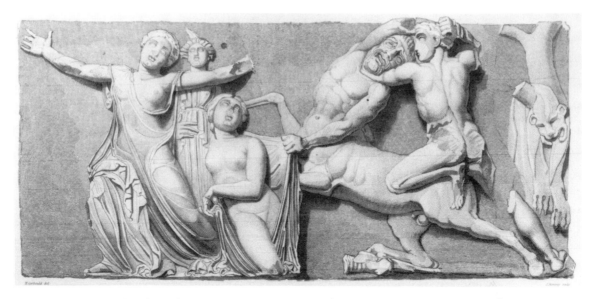

86. Temple of Apollo at Bassai, interior Ionic frieze. [From *A Description of the Collection of Ancient Marbles in the British Museum*, pt. IV (London, 1820), pl. X. By permission of the Trustees of the British Museum.

tectural focus of the temple; it is the decorative and narrative focus and, therefore, also the human focus. Nor do the sculptural forms of its Ionic frieze present a monumental, unchanging, elevated view of humankind: Here mortals are conceived in all their irregularities, all their distortions, their chaos, and their pain.

Fig. 86

In the fourth-century temples of Asklepios at Epidauros and Athena at Tegea a vestige of traditional west-to-east architectural procession remains in the placement of the more traditional, more universal myth in the east pediment; but there is little else to recall the grand Olympian pediments of earlier Classical and Archaic temples. The Temple of Asklepios is one of the most human-scaled of all Doric temples – about one-ninth the size of the Parthenon, one-half that of Bassai – and even the pediments are human, personal in their appeal. Here the emphasis is not on pure beauty and abstract line, as in the Parthenon pediments, nor on the emblematic expression of divinity; rather, the overriding concern is the power of human emotion. Here two mythological themes are portrayed – the Amazonomachy and the Sack of Troy – but they are myths of mortals not gods, and the par-

175

Fig. 87

ticipants are conceived not simply as heroic warriors but as individual human beings reacting to the pain and tragedy of war. This is best represented by the distorted, miserable face of Priam as Neoptolemos, the son of Achilles – and later the brutal murderer of Priam's grandson Astyanax – jerks up his head by the hair in preparation for the final deathblow. This is not generalization or Olympian allusion; it is a specific human in a specific situation, frozen in momentary physical and emotional reaction. This exploration of the human condition – of a man, even a hero, in his most personal emotional and physical states – can be traced in painting and architectural relief back to the Archaic Period, with a noticeable gap in the Periclean Age. Yet the actual elevation of human emotion to the status of pedimental focus represents a distinct break with canon, and in that sense can be ultimately traced back to the apotheosis of humanity in the sculpture of the Parthenon.

Fig. 88

In the pediments of the Temple of Athena at Tegea there is a similar concern with human emotion and with the general representation of humans as emotional creatures. At Tegea, this is indicated uniformly through the upward glance, heavy brow, and deep-set, shadowy, Skopasian eyes of the figures – so-called after the great fourth-century sculptor Skopas, who was the architect of the temple and, perhaps, the sculptor of the pediments as well. Here, even the pedimental themes are personal rather than universal: Gone are emblematic epiphanies, even in human form; gone are gods, period; gone are even the traditional myths of temple narrative – no Gigantomachy, no Centauromachy, no Amazonomachy, no Trojan War. Instead, the pediments are filled with myths of local significance: the Kalydonian Boar Hunt and the battle of Telephos and Achilles, both of which feature descendants of the mythological founder of Tegea.[2]

Freestanding Sculpture

The examination of the physical and emotional nature of humankind was more obvious in architectural relief than in freestanding sculpture, which traditionally consisted of single figures, usually votive, and as such had little access to or need for the techniques of narrative expression; but as the changing Greek conception of their gods

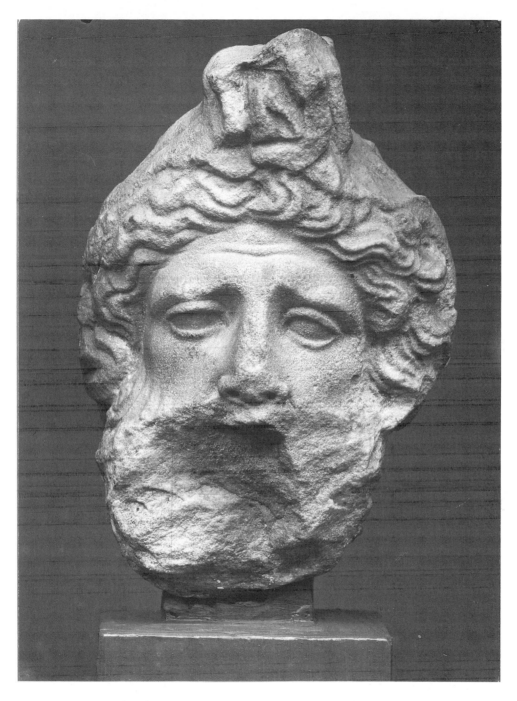

87. Temple of Asklepios at Epidauros, pedimental figure: Priam. National Ar-
chaeological Museum, Athens. [Photo: Deutsches Archäologisches Institut, Ath-
ens (neg. no. Hege 1280).]

was reflected in both media, so was their self-conception, and with increasing vigor and detail in the generations following the Age of Pericles.

The essential meaning and form of archaic freestanding figures were, like the Doric order, unchanging and served as a reminder of the antiquity and continuity of religious tradition. Like Archaic east pediments, they were basically confrontational in their gaze and in their function of inspiring a religious sense in the viewer. As the humanized Olympia east pediment developed out of the abstract emblem of Archaic east pediments, so the Kritios Boy developed directly *Fig. 53* from the tradition of Archaic kouroi; and if the Kritios Boy does not represent a tremendous change in the sculptural character of the kouros, it does represent a remarkable one in the conception of freestanding votive figures. By breaking from strict frontal symmetry – the strict grid of vertical and horizontal axes represented by pairs of like parts in the anatomy – by rotating various horizontal axes slightly out of frontal, by tilting others slightly out of horizontal, the Kritios Boy moves out of the realm of human as emblem and into the realm of human as living organism. Strict and immobile vertical and horizontal symmetry gives way to shifting axes, shifting weight; and the resulting loosening up of the figure humanizes the old kouros. The kouros's body begins to react to his stance, the muscles to flex and relax according to nature; and with his head turned slightly, as in the figures of the Olympia east pediment, the sense of direct religious confrontation is broken and a sense of narrative is imparted to the sculpture. The Kritios Boy turns away from us, breaks the connection of gaze to enter his own space, to be with his own thoughts. Through these devices the kouros is humanized, as was pedimental composition, and even in the conservative realm of freestanding sculpture the desire to examine the intricacies of humanity, and it relationship with its environment, comes to the fore.

Yet in Polykleitos' Doryphoros of twenty or thirty years later, no *Fig. 43* great strides in this direction are obvious; if anything, the Doryphoros is more stable in its composition, more formal in its geometry, its chiastic balance (i.e., its symmetrical organization along the lines of an X, flexed leg to flexed arm, relaxed leg to relaxed arm, etc.), more generalized in its character. Moreover, although the Doryphoros is

178

88. Temple of Athena Alea at Tegea, pedimental figure. National Archaeological Museum, Athens. [Photo: Deutsches Archäologisches Institut, Athens (neg. no. Arkad. 493).]

no longer the symbol of humanity or of god, as the kouros seems to have been, his appearance is more kouros-like, more monumental than that of the Kritios Boy. Like the Kritios Boy he is a human being, but the Doryphoros is a human being that epitomizes permanence in its material, its expression, its bulk, its balance. The Doryphoros does not smile, so he has no potential to stop smiling; he is not frowning, so he won't stop doing that; and he makes no threat to move, for although he gazes out over his right leg, it is his left leg that is free – his right is the weight leg, planted, fixed, immovable. He is the monumental human. In many ways this is the ideal of the Periclean Age, and it is perhaps for this reason that Polykleitos became the most revered sculptor and his "Canon," as the Doryphoros was called, the most influential sculpture of antiquity. Polykleitos seems to have taken the monumental, geometric, religious qualities of the kouros and wedded them to true human form. In a sense he elevated humanity to the realm of the kouros, not unlike the way Pheidias raised humanity to the realm of the gods on the Parthenon; and like Pheidias' work on the Parthenon, Polykleitos' Canon represents a conscious decision to examine something other than the stark realities of the human condition.

Fig. 89 As Athens' power and influence diminished in the late fifth and fourth centuries, significant breaks with Pheidian and Polykleitan tradition begin to occur, as in the so-called Antikythera Athlete. His outstretched arm breaks free of the cube of stone from which the kouros was carved and within whose outlines Polykleitos continued to cast his bronzes. More radically, he breaks out of the Polykleitan mold through his gaze, which no longer isolates him in the introspective contemplation shown by the Kritios Boy or the Doryphoros, but follows his arm and continues beyond to the companion at whom he points. The Antikythera Athlete interacts with his surroundings in a human, almost conversational manner, and even threatens to move in the direction of his gaze, for his weight is now on the opposite foot, and he is free to step toward the object of his concentration. The vestiges of static votive emblem still present in the Doryphoros are giving way to natural human movement within a human environment.

89. *(facing)* Antikythera Athlete. National Archaeological Museum, Athens. [Photo: Deutsches Archäologisches Institut, Athens (neg. no. Nat. Mus. 5357a).]

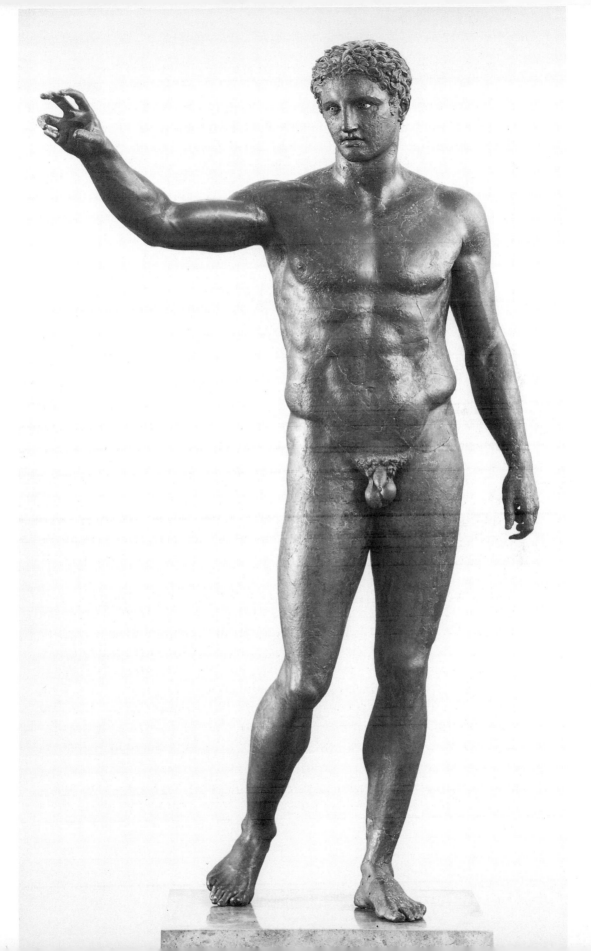

Fig. 90 In the Agias of Lysippos, the more massive proportions, tilted horizontals, and blank expression of the Doryphoros have been replaced by slenderness, torsional S-curves, and deeply shadowed, hooded eyes. Even more than the Antikythera Athlete, the Agias speaks of a human being with human thoughts, one whose body twists in the round, not according to the four cardinal views of the kouros or even the Doryphoros. The Doryphoros' permanent emotional and physical balance has given way to a completely human attitude and a pose that suggests not so much that he is about to stride into the viewer's space – his feet are side by side, not in the midst of a step – but that he is about to shift his weight from one foot to another. In fact, the Agias is the representation of an actual victorious athlete.[3]

Fig. 91 Finally, in the Apoxyomenos of Lysippos – the strigil holder, an athlete scraping off cleansing oil and sand after exercising – the exploration of the interaction of human being and environment has reached another level, in which the surrounding space is not only penetrated by his outstretched arm, but is actually enclosed within the composition by means of his crossing arm. At this point sculptural space is conceived in a completely different way from the Doryphoros, in a manner that closely resembles the actual interaction of humans with their environment. The subject itself, an athlete cleaning his sweaty body, is as immediate, as human, as the Doryphoros is removed.

The examination of the human condition in Greek art, and the consequent multiplication of human types – old, young; savage, civilized; happy, sad; foolish, wise; pained, content; apprehensive, terrified; moving, still; sweaty – leads us, and inevitably led the Greeks, to the question of portraiture. A very generalized type of portraiture existed in Athens as early as the late sixth century B.C., but in it no attempt was made to represent the specific physiognomy of an individual: The goal of the sculptor was simply to suggest the extraordinary character of a political hero, general, or orator through pose and attribute, and through the monumental nature of the representation. In fact, it was only in the fourth century that the creation of human types became so varied, the exploration of the human condition so detailed, as to include the first examples of what we might define today as true portraiture. It appears that portraiture was first born in the court of Alexander the Great, in the form of Lysippos' monumental representations of the king himself.

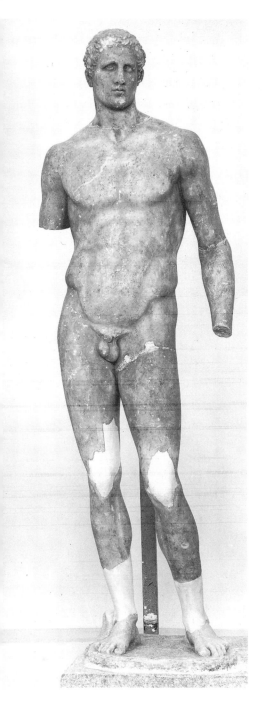

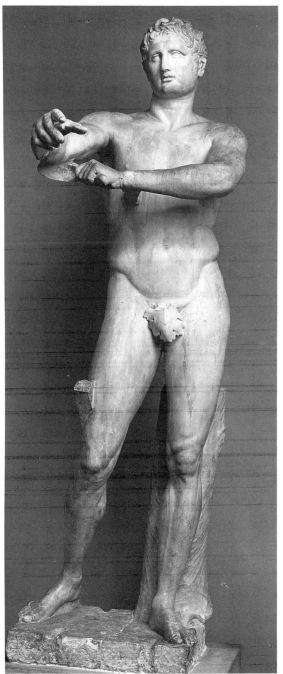

90. Lysippos' Agias (fourth-century-B.C. copy). Archaeological Museum, Delphi. [Photo: Deutsches Archäologisches Institut, Athens (neg. no. Delphi 368).]

91. Lysippos' Apoxyomenos (Roman copy). Musei del Vaticano, Rome. [Photo: Deutsches Archäologisches Institut, Rome (Inst. neg. 56.1318).]

Life-size sculpture was always a monumental art, and monumental art was traditionally religious art. In that context, the monumentalization of a specifically rendered individual would be blasphemous. In the context of the changing relationship between human and god, however – first seen clearly in the architecture and sculpture of the Parthenon and then throughout the architecture and sculpture of the later fifth and fourth centuries – and particularly in the context of monuments like the Philippeion at Olympia, the representation of specific individuals in Greek monumental sculpture becomes comprehensible.

With the development of portraiture in Greece, the humanization of the gods and the elevation of humanity and the specifics of its condition to the realm of the monumental is complete. Between portraiture and the humorous and even disrespectful views of the gods evidenced in the sculpture of Praxiteles, it is then a relatively small step to the conception and representation of individual humans as gods: of Philip and his family in chryselephantine splendor in the sanctuary of Zeus, of Alexander the Great as Herakles or even as Zeus-Ammon.

The roots of later Greek art run deep into the traditions of the Archaic Period, but in a real sense the catalyst for its distinctive development lies in Periclean Athens. The gradual humanization of the Greek concept of divinity can be traced back to the late Archaic and Early Classical periods, but it was on the Periclean Acropolis that that concept became sufficiently humanized to admit the breaking of religious and architectural canon and the inclusion of humans in the formerly divine realm of a temple's sculptural program. The Greek fascination with the articulation in art of the complexities of human existence can be traced back to the same early times; but it was the breaking of canon on the Acropolis, particularly in the Parthenon, that initiated an architectural and sculptural tradition in which the religious and the monumental could be expressed in increasingly personal and individual terms.

By the end of the fourth century and the beginning of the Hellenistic Age, the period following the death of Alexander the Great, those Periclean roots were almost unrecognizable. The Periclean experiment had receded beneath successive layers of artistic and cultural de-

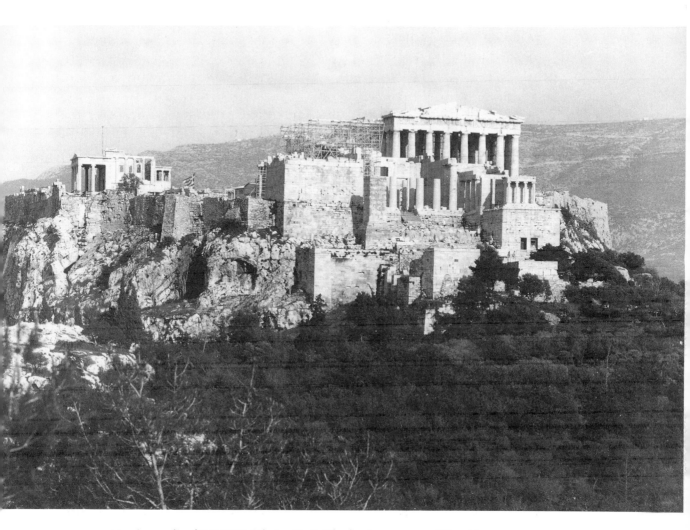

92. Acropolis, from NW. [Photo: R. F. Rhodes (neg. no. 94-CP-35).]

velopment that built upon it while taking on their own unique charac-
ter. Yet Periclean Athens did not easily succumb to cultural burial.
True, it has risen again in the context of modern archaeology and
scholarship, but that is only the last and most academic revival of
fifth-century Athens. One of the reasons the study of Periclean Ath-
ens is still so vital today, stepping far beyond the confines of academe,
is that *it specifically* has been revived and admired and emulated time
and again throughout the history of the Western world. Those brief

185

fifty years became the period of "classic" culture, the five decades identified time and again, in varying historical contexts, as the pinnacle of human accomplishment, the epitome of achievement to which all should strive. As a result, Periclean Athens is intricately interwoven with the fabric of Western culture on almost every imaginable level.

Fig. 92 Were Pericles, Pheidias, Iktinos, Mnesikles, and the Athenians guilty of sacrilege when they broke canon in their building program? Perhaps. Were they guilty of hubris when they placed images of themselves on the Parthenon and designed that building as a monument to themselves and to human accomplishment? Very likely. Were they toppled from their lofty perch, brought low for their pride? Yes; but only briefly. Politically and artistically Athens never again rose to its former glory; but less than two hundred years after Athens' fall, the mighty Attalids of Pergamon – a Hellenistic kingdom of Asia Minor and the new champion of Greek intellect and culture – resurrected Periclean Athens as their emblem, and employed its art and history as universal symbols and iconography for the triumph of civilization over barbarism and for ultimate human achievement. Pergamon strove to be Athens. The gods brought Athens low for pretending to their prized Olympian thrones; but, ironically and almost immediately, the Age of Pericles and its unparalleled accomplishment took on the flavor of mythology. Long before the Greek period ended, the dreamed-of deification of Pericles and his city had been accomplished at Pergamon. Also ironically, whereas the jealous Olympian gods of Greece died with antiquity, Periclean Athens still thrives today.

Notes

Introduction

This introductory chapter was first written as an Effie Burkhalter/Yale University Fund Lecture for the 1991 Creative Mind Humanities Lecture Series on "Greek Thought in Contemporary Times," sponsored by Amarillo College, the Amarillo Art Center, the Texas Committee for the Humanities, and the Association of Yale Alumni of Amarillo. The original version is considerably longer and more personal in nature.

1. In this Age of Quantified Humanities such a question sounds unforgivably unobjective, almost mystical; but the truth is that the connection we feel with antiquity *is* to a significant degree emotional, and our response to the power of ancient holy places is visceral. So it was with the Greeks. So it is with elemental religious experience. Remarkably few scholars have written on this subject, presumably because it relies so heavily on personal impression as opposed to quantifiable data; on the other hand, A-B-C analyses of leaping hearts invariably trivialize them. By far the most detailed treatment in print of the relationship between landscape and Greek temple architecture is Vincent

Scully's *The Earth, the Temple, and the Gods* (New Haven and London, 1962; revised 1969, 1979), a work of remarkable insight, not the least for its recognition of the subject as fitting for a book. The view expressed in the present discussion differs from Scully not in the conviction that the relationship between landscape and temple is fundamental to an understanding of Greek architecture, but in the assumption that this relationship can be understood and analyzed in terms of a consistent set of specific physical features.

Mountains, sky, and sea, and their disquieting congregation at certain ancient spots, are a common and profound inspiration for studying antiquity, but the open contemplation of such subjective realms has traditionally been taboo among scholars. Nevertheless, few who spend time considering ancient architecture will deny the power of the landscape in Greek holy spots, or the crucial relationship between it and Greek temples.

2. Earlier in this century the great historian of ancient Greek architecture, W. B. Dinsmoor, served as consultant for the

construction in Nashville of a scaled-down replica of the Parthenon.

Landscape was not always the sole factor in the siting of early temples; their location was often more immediately determined by preexisting structures, in some cases the dwelling places of Dark Age chieftains responsible for the political and religious life of their towns. The Acropolis in Athens is a case in point: It was originally the site of a Mycenaean palace.

3. The original religious reflex may have been forgotten by the time successors to the first temple on a site were constructed. The siting of later temples, particularly on long-used sites, was often more directly a result of precedent – of architectural and religious tradition – than of the original inspiration of the landscape.

4. Scully, *Earth, Temple, Gods*, pp. 2–3.

5. The purpose of this Introduction is not to suggest that all Greek temple architecture, regardless of date, is a response first and foremost to the landscape, but to establish the landscape as a basic inspiration of early religious response and the earliest temples. In this way the architecture of the Acropolis is tied to something more than an intellectual tradition, and the reader is prepared on the most basic level for the interpretation of the tradition of mainland pedimental sculpture and, ultimately, architectural procession, which are presented in subsequent chapters.

Chapter 1. History in the Design of the Acropolis

1. Here the general interpretation of the topography of the Archaic Acropolis follows that of W. B. Dinsmoor, "The Hekatompedon on the Athenian Acropolis," *AJA* 51 (1947), 109–51. At the heart of his reconstruction is the conviction that a single, late-sixth-century temple stood on the foundations of the Temple of Athena Polias, just south of the later Erechtheion; he then reconstructs the substantial remains of an earlier temple – the Hekatompedon, for which no in situ evidence (i.e., still in its original place) has been found – on the site of the fifth-century Parthenon. On the other side of the issue is the traditional German interpretation, which restores the Hekatompedon and the Temple of Athena Polias as successive constructions on the same set of foundations. (The details of this debate are enumerated in Dinsmoor's article and in W. H. Plommer's rebuttal, "The Archaic Acropolis: Some Problems," *JHS* 80 [1960], 127–59.) In the face of inconclusive archaeological evidence, the debate becomes a matter of archaeological method: Is it more legitimate to assume the dismantling of a temple and a rebuilding on the same foundations, or to assume that the foundations of the original temple are now irretrievably entombed within those of one of its successors? The former strikes some as the more "economical" solution, and the recent suggestion that *three* successive temples occupied those same foundations is even more so (Immo Beyer, "Die Datierung der grossen Reliefgiebel des Athenatempels der Akropolis," *AA* [1977], 44–74). All other things being equal, however, a single temple on the Athena Polias foundations seems more likely: There are numerous examples of successive temples built on the

188

same site, but in most cases the unam-
biguous remains of earlier foundations
are preserved somewhere within the later
building; this is not the case in the Tem-
ple of Athena Polias. Similarly, in light of
the recent restoration of the contempo-
rary Temple of Aphaia on Aigina (Ernst-
Ludwig Schwandner, *Der altere Poros-
tempel der Aphaia auf Aegina* [Berlin,
1985]), the rejection of Dinsmoor's Heka-
tompedon on the basis of its combination
of large scale and nonperipteral form is
no longer convincing (Plommer, op. cit.,
144). All in all, Dinsmoor's reconstruc-
tion not only is consistent with what we
now know about Greek architecture of
the early sixth century, but also seems to
account for the remains on the Acropolis
in the simplest and most straightforward
fashion.

The problem will always remain that
more superstructures of buildings are
preserved on the Acropolis than founda-
tions with which they can be associated.
We cannot be sure how many temples
were constructed on the Acropolis be-
fore the Classical period or where they
stood. The oikemata superstructures are
similarly orphaned, and through a pro-
cess of elimination similar to that em-
ployed in locating the Hekatompedon,
Dinsmoor very reasonably assigns them
to the west side of the Acropolis, in the
area later cut away to form the terrace for
the Chalkotheke.

2. It has also been argued that the Tem-
ple of Athena Polias, the predecessor of
the Erechtheion, belongs to the very first
years of the new democracy (K. Stahler,
"Zur Rekonstrucktion un Datierung des
Gigantomachiegiebels von der Akropo-
lis," *Antike und Universalgeshchichte*, FS
H. E. Stier [Münster, 1972], 88–112), but

the standard view still assigns it to the
Peisistratids.

3. This apparently included the propy-
lon, which also appears to have been
repaired with various material salvaged
from the Persian destruction debris (W. B.
Dinsmoor, Jr., *The Propylaia to the
Athenian Akropolis, I, The Predecessors*
[Princeton, 1980], p. 54).

4. Aside, perhaps, from where it meets
the caryatid porch, there is little evidence
that the presently visible north face of the
foundation wall was obscured in Classi-
cal times. The unaltered, stepped nature
of that foundation, as well as the position
of the Classical screen wall that was set
on it, seem to preclude the possibility of
revetment.

5. Vitruvius, *The Ten Books on Archi-
tecture,* I.5 (trans. Morris Hickey Morgan,
1914). In the nineteenth century this pas-
sage was rejected as a legitimate source
for the interpretation of the Erechtheion
caryatids, a conclusion that has become a
part of the standard literature. Michael
Vickers, however ("Persepolis, Vitruvius
and the Erechtheum Caryatids: The ico-
nography of medism and servitude," *RA*
[1985], 4–5), reviews the flimsy basis on
which the passage was rejected and there-
by reestablishes its legitimacy as a source
to be considered in the interpretation of
the Periclean Acropolis.

6. Not only did its north foundation wall
remain visible, but the rear portion of
the cella building apparently stood and
was in use well into the fourth century
B.C. (W. B. Dinsmoor, "The Burning of
the Opisthodomos at Athens," *AJA* 36
[1932], 307–26).

7. It is generally thought that Mnesikles
intended to complete a wing of the Propy-
laia stretching south from its west porch,

at which time the Mycenaean wall would have been dismantled. However, as J. A. Bundgaard points out (*Parthenon and the Mycenaean City on the Heights* [Athens, 1974], p. 78), any extension of the Propylaia wall for that purpose would have first required the dismantling of all the obliquely cut blocks. The planned wing, therefore, must never have been intended to interfere with the junction of the Mycenaean wall and the Propylaia: "He [Mnesikles] assumed from the first that the Pelasgian [Mycenaean] wall would remain untouched as far into the future as he could visualize."

8. In addition to this rearticulation of a Mycenaean shrine in the masonry of the Classical bastion, it has been recently suggested by Erika Simon (National Gallery lecture, January 1993; forthcoming in the National Gallery's *Papers in the History of Art*) that the scene from the late-fifth-century Nike parapet (discussed in Chapter 5) that stood directly above the niches was also intended as a quasi-historical reference: that it referred to a sacrifice made

to Aigeus at the place of his suicide. (I was not present at this lecture and thank Bonna Wescoat for this reference.)

9. These remains are illustrated and described in Bundgaard, *Parthenon and Mycenaean City*, pp. 43–6.

It has been recently suggested (I. S. Mark, *The Sanctuary of Athena Nike in Athens: Architectural Stages and Chronology,* Archaeological Institute of America Monograph n.s. 2 and *Hesperia, Supplement* 26 [Princeton, 1993], p. 70) that a polygonal block was perhaps intended to fill this space and hide the Mycenaean rock. This, however, seems unlikely in light of the fact that there was no attempt to make this space conform to the otherwise perfectly coursed ashlar masonry of the bastion. Moreover, there is no evidence at all that such a block was ever set in place.

10. That is, after the Persian sack of the Acropolis in 480 B.C., as opposed to the Battle of Marathon in 490 B.C. "Pre-Persian" will similarly refer to the time before the sack.

Chapter 2. The Acropolis as Processional Architecture

1. See section "The Older Parthenon" and n. 1 in Chapter 1.

2. The small *naiskos,* the predecessor of the present marble Nike temple, may have been constructed in the mid-fifth century, rather than before the Persian sack (Mark, *Sanctuary of Athena Nike,* pp. 58–67). Indeed, it has been suggested that there were two Classical versions of nearly all the buildings we normally associate with the Periclean Acropolis (the Parthenon, the Propylaia, and the Nike temenos) and that Pericles was directly

responsible not for the ones now standing, but for their immediate predecessors (Bundgaard, *Parthenon and the Mycenaean City on the Heights* [Athens, 1974], p. 138). Here we subscribe to the view that the Classical buildings preserved on the Acropolis, including those completed after his death, are all elements of Pericles' general vision of the new Athenian Acropolis.

3. It has been suggested, however, that the inscription in question refers not to the temple presently standing, but to its

limestone predecessor (Bundgaard, *Parthenon and Mycenaean City*, p. 138; Mark, *Sanctuary of Athena Nike*, pp. 115–22; see n. 2). However, even in the extreme case that there were two nearly contemporary versions of three of the Periclean buildings (see n. 2), the fact that the present buildings on the Acropolis are all elements of a unified architectural conception remains unaltered.

4. If the Archaic altar was on the same site as the Classical one, it would have been to the east of the Temple of Athena Polias and, probably, to the northeast of the Hekatompedon.

5. The only nonprofile figures are Hera in the "Introduction Pediment" and a water carrier in the Troilos pediment. Their purpose, however, does not appear to be confrontational.

6. The west, back pediment is the better preserved of the two at Corfu. Enough of the east pediment remains for us to know that its central group was essentially identical to that on the west, and it has been universally assumed that it, too, had similar small narrative groups to either side. It is possible, however, that they did not exist in the east pediment, for fragments of those groups have not been identified (G. Rodenwaldt, *Korkyra,* vol. II, *Die Bildwerke des Artemistempels* [Berlin, 1939], p. 112).

7. To this point, there has been little controversy over the traditional assignment of pedimental groups to their respective ends of the Hekatompedon. As a result, no elaborate justification for their placement has been made (see n. 8). Here, however (for the reasons outlined in n. 8), the pedimental composition traditionally assigned to the east pediment of the temple has been reconstructed on the west; that normally assigned to the west is reconstructed on the east.

8. The only evidence for the now habitual assignment of this "Bluebeard" pediment (named for the blue beards of its triple-bodied monster) to the east end of the Hekatompedon seems to be Dinsmoor's assessment of the discrepancy in style between the sculpture of the temple's two pedimental groups ("Hekatompedon," p. 146): "It is simply an instance of the 'problem of generations': the more skillful sculptors were assigned to the pediment containing the human figures, presumably, therefore, the facade or east pediment, while to their less advanced or more conservative and backward contemporaries were entrusted the purely animal sculptures of the back or west pediment." In fact, the pedimental organization of the late-sixth-century Temple of Apollo at Delphi and the early Classical Temple of Zeus at Olympia, the central temples of the two most important sanctuaries in Greece, together with the distinctions between the *oikemata* pediments and the temple pediments on the Acropolis, argue much more strongly in favor of placing the Bluebeard pediment on the west end of the Hekatompedon. For a discussion of the "less advanced" style of east pediments, see n. 12 below. For the crucial relationship of the Delphi and Olympia pediments to those of the Archaic Acropolis, see "The Temple of Zeus . . ." in Chapter 4.

9. As will be seen, this distinction between front and rear pediments, which is more than simply a distinction between quiet and action-packed scenes, continues to be made even as late as the Parthenon.

Clearly, the interpretation of pedimental sculpture presented here is not com-

patible with a reconstruction that mixes a scene from one of the smaller Acropolis pediments with the figures from the east pediment of the Hekatompedon (I. Beyer, "Die Reliefgiebel des alten Athena-Tempels der Akropolis," *AA* 1974, 639–51); but that possibility has already been convincingly refuted on grounds of architectural and sculptural technique (B. S. Ridgway, *The Archaic Style in Greek Sculpture* [Princeton, 1977], pp. 203–4).

10. As with the Hekatompedon pediments, there is no archaeological evidence that places this pediment specifically at the east or at the west end of the temple. However, recent sentiment among several scholars (including the present author) places the Gigantomachy of Athena Polias at the west end of the temple. (See, e.g., A. Delivorias, *Attische Giebelskulpturen und Akrotere des fünften Jahrhunderts v. Chr.* [Tübingen, 1974], pp. 178–9, where he also reconstructs a four-horse chariot at the center of the composition; see also Ridgway, *Archaic Style,* p. 208.)

11. With the possible exception of four frontal horses hitched to a chariot (see n. 10).

12. Among others, M. S. Brouskari (*The Acropolis Museum: A Descriptive Catalogue* [Athens, 1974], p. 32) assigns this lion and bull group to the west pediment and the "more forward-looking composition of the Gigantomachia" to the east. See also n. 8 for Dinsmoor's comments on the relative quality of the pedimental sculptures from the Hekatompedon. Indeed, the use of human figures and narrative are forward-looking in that they gradually take over the traditionally emblematic realm of temple east pediments; similarly, more "forward-looking" techniques of sculpting accompany narrative scenes, where action and lifelike movement are requisite. It is wrong to conclude, however, that an emblematic pedimental composition is backward and belongs in a less prominent position on a temple because it does not employ the techniques of narrative sculpture. Emblematic representation has its own set of requirements, fulfilled by its own specifically appropriate techniques, not by those of narrative. For example, high, well-rounded relief and the illusion of the third dimension are desirable for the elucidation of complicated narrative action but not nearly so important for basically immobile symbols. (Compare, e.g., the little narrative figures in the Corfu west pediment with the Gorgon and leopard group.) Apparently the Archaic Greeks felt it was inappropriate for their symbols of divine power to mimic the physical world in detail; clear outlines, simple, unobstructed poses, and two-dimensional, emblematic compositions set them apart from the everyday and accomplished their purpose of unambiguous legibility and confrontation. Thus, the technical criteria used for judging the relative age or quality of Archaic sculpture in the round may often be irrelevant or misleading in the case of pedimental sculpture; a mobile, three-dimensional surface characterized by a multiplicity of sculptural planes, for instance, might well be inimical to the purposes of an Archaic east pediment. In fact, the emblematic east pediment compositions, which from the beginning fit their pedimental space and accomplished their purpose flawlessly, might just as easily be seen as advanced and the narrative compositions of west pediments as backward, having required a century of awkward experimentation to accomplish the adapta-

tion from the narrative tradition of painting to the architectural context of the gable.

13. It is risky to conclude that this strong sense of architectural direction and religious procession was a significant aspect of Doric architecture everywhere in the Archaic Greek world. Perhaps the tradition is more Athenian than universally Greek. With the exception of the Corfu temple, all of the temples mentioned thus far are either Athenian or have clear Athenian connections. The most tenuous connection is with Olympia, but the Zeus temple is an international sanctuary, and certain architectural correspondences between it and the Parthenon suggest close contact.

It is difficult to know whether or not the pediments of the late Archaic Temple of Aphaia at Aigina (both depicting battles and neither appearing particularly emblematic) belong in this line of evolution. It depends in part upon the nature of the original, late-sixth-century composition of the east pediment and in part upon whether or not the quiet, frontal Athena of its early-fifth-century replacement is interpreted as an intentional contrast to the striding central goddess of the preserved west pediment. The fragments of other early pedimental groups found on the same site do seem to come from battle scenes, but they are extremely fragmentary, and the nature of their central groups is uncertain – perhaps they were to one degree or another emblematic.

On the other hand, the hieratic direction implicit in the pediments from the central temples of the great international sanctuaries at Delphi and, in the Early Classical period, Olympia (see "The Temple of Zeus ..." in Chapter 4) shows that it was not completely confined to Athens. Moreover, although there is no evidence for contrasting themes in the pedimental sculpture of Archaic Sicilian temples, the closed back walls of their cella buildings and the screened intercolumniations of some of their peristyles do channel the pilgrim to the front of the temple. Finally, the great terra-cotta Gorgon faces that are often hung in the center of the pediment bespeak a conception of divinity similar to that expressed in the east pediments of Athenian temples.

14. The emperor Hadrian's apparent quotation of this in the facade of his Pantheon (second century A.C.) transforms the Propylaia's doubled pediment into a symbol of purely spiritual transition. Indeed, the transition it symbolized is not unlike that from the secular world outside the Propylaia to the great open-air temenos of Athena within: The columnar facade of the Pantheon does not lead to an open-air sanctuary, but it does lead to an interior space whose dome is intended to represent the vault of the heavens. In the Pantheon the sense of transition created by the double pediment is reinforced through its combination with another symbol of passage, the triumphal arch, whose attic stands between it and the cylinder of the cella.

15. This relationship with Egypt is discussed below in n. 17.

16. The Doric and Ionic styles are also employed in Sicily and South Italy, and Ionic has a long history in the island architecture of the Aegean; but for the purposes of this discussion, Ionic and Doric will refer to the architecture that developed in those regions of Greece that gave their names to the orders: Ionia and the Doric mainland.

17. In spite of the processional nature of Egyptian religious architecture, the Egyptian role in the origin of the Greek colonnade is often denied. Indeed, there are no exact parallels in Egyptian architecture for the *peristyle* (continuous exterior colonnade) of the Greek temple. However, interior courtyards surrounded by continuous colonnades, as well as multirowed columnar porches with graduated spacings, had been long common in Egyptian architecture by the late seventh and early sixth centuries B.C., the time of the first monumental peristyles in Greek temple architecture. This was also the time of the first Greek *stoa*s, shallow rectangular buildings open on one side in a colonnade. It is impossible to determine which came first in Greece, the peristyle or the stoa, and a common source is generally assumed for both. In other words, at the very beginning two distinctly different forms of colonnade appeared in Greece simultaneously, as different from one another as they are from the peristyle courts and hypostyle halls of Egypt. In addition, as has just been discussed in some detail, the character of Doric and Ionic peristyles were similarly distinct from one another. All these differences are remarkable as testimony to the quickness and originality of the Greek artistic mind in manipulating and adapting architectural forms to varying religious and aesthetic requirements; yet their basic kinship with contemporary Egyptian architecture should not be dismissed as insignificant. If an Egyptian origin of monumental Greek peristyles is denied for lack of an exact parallel, then so must a common source for Greek stoas and peristyles, and even for the two types of temple peristyles in Greece, Ionic and Doric.

That the Greeks themselves felt a deep connection between the origins of their Ionic temples and Egyptian architecture is possibly suggested by the epithet "Labyrinth," which was used to describe both the first dipteral temple of Ionia and a contemporary Egyptian temple (W. B. Dinsmoor, *The Architecture of Ancient Greece* [New York, 1975], p. 124).

18. The five doorways of the Propylaia crosswall coincide with the five intercolumniations and are also graduated in width from sides to center.

It is also possible to describe the graduated spacings of the Propylaia facade in purely Doric terms – that is, to attribute the narrow intercolumniations on each end to corner contraction (a peculiarly Doric feature resulting at least in part from the attempt to preserve the axial relationship between triglyphs and columns while positioning a triglyph at each end of the frieze), and the wide central intercolumniation to the purely practical concern of providing extra elbow room for the Panathenaic procession; the intermediate intercolumniations then become the only "normal" ones in the facade. Certainly, the Propylaia facade is Doric and must be contracted at the corners, and the central intercolumniation is suitable for a large procession; but to assume that Mnesikles was thinking in purely Doric terms when designing this facade is to ignore the appearance of the building, its symbolism, and its otherwise Ionic character.

19. The appearance of similarity is increased when we consider that in at least two of the colossal Ionic dipteroi there seems to have been a little temple or sacred enclosure within the open-air cella itself.

20. W. B. Dinsmoor suggested that this twice-normal corner contraction was intended to mitigate the proportional difference between the Parthenon's facade and a canonical, six-columned Doric facade (*Architecture of Ancient Greece*, p. 161).

21. Dinsmoor also suggests the possibility that this phenomenon and the excessive corner contraction result from an attempt to create an exaggerated perspective and, therefore, to create the illusion of a building of even greater width and length (*Architecture of Ancient Greece*, p. 165).

22. For standard expressions of this historical interpretation, see E. B. Harrison, "The South Frieze of the Nike Temple and the Marathon Painting in the Painted Stoa," *AJA* 76 (1972), 353–78; E. G. Pemberton, "The East and West Friezes of the Temple of Athena Nike," *AJA* 76 (1972), 303–10; B. S. Ridgway, *Fifth Century Styles in Greek Sculpture* (Princeton, 1981), pp. 89–91.

23. It is also significant that the battle scenes of the frieze are rendered according to traditional narrative convention, whereas the gods assembled on the east side engage in no recognizable action and hardly interact: They stand isolated in single file, serving more as emblems than as active participants in a story. For the emblematic use of human figures, see "The Temple of Zeus . . ." in Chapter 4.

24. See "The Parthenon Frieze" in Chapter 4.

25. It is perhaps worth noting that the architectural sculptures on the Acropolis that the procession of Athenians experi-

enced most closely, those the Sacred Way passed between on the way to the east end of the Acropolis, appear to have been the most specifically historical: the Nike battles, the caryatids, the Trojan War metopes, and one of the mortal sides of the Parthenon Ionic frieze.

26. These individual figures, like those of the gods of the Nike temple east frieze, are less obstructed by overlapping and action than anywhere else in the frieze (see n. 23); yet they interact easily and conversationally, and in many ways comprise the least formal grouping in the frieze.

27. Scully (*Earth, Temple, Gods*, pp. 174–85) also finds procession to be a key element in the architecture of the Acropolis. For him, however, it is less a procession from mundane to holy than a procession of views both on the Acropolis and of features of the surrounding landscape manipulated by the configuration of the buildings and monuments and the route of the Sacred Way; among other things, these views compel eastward procession. In Scully's understanding, the object of the eastward movement is ultimately the distant horns of Mt. Hymettos on the eastern horizon rather than the altar of Athena or the front of her temples. Certainly views of the hill itself and to the surrounding landscape are essential to the character of the Acropolis; but, unable to contribute anything new to the specifics of its analysis, I confine myself to the more general consideration of the character and relationship of the four major buildings on the Acropolis.

Chapter 3. Religious Tradition and Broken Canon

1. It is uncertain how closely Mnesikles' Propylaia resembled its immediate prede-

cessor, a large propylon constructed on the same spot, probably immediately fol-

lowing the Battle of Marathon in 490 and repaired after the Persian sack of the Acropolis in 480. The most significant similarity between the two seems to have been scale, though the propylon was not hexastyle: It is usually reconstructed with *tetrastyle* (four-column) facades; see n. 10.

2. With the exception of the discussion of dark stone, the general description of the Propylaia presented in the first two-thirds of this section represents standard views of the building.

3. The wide central spacing also resulted in structural problems in the entablature that Mnesikles ingeniously solved through the cantilevering of the two central frieze blocks. Lest the weight of the frieze plus the added tensile stresses created by the abnormally wide span crack the epistyle, Mnesikles altered the canonical relationship of frieze and column: Rather than supporting one end above a column, he *centered* a frieze block above each column, thus cantilevering its weight in the intercolumniation and effectively removing any added stress on the epistyle in the center of the span.

4. The proportions of Classical columns are usually expressed in multiples of their lower diameter, that is, the proportion of the diameter at the base of the column to its total height. In general, Classical Doric columns are five to six lower diameters high; Ionic columns are eight to ten. Thus, canonical proportions allow the Ionic columns of the Propylaia interior to reach higher than the Doric columns of the facade, but still maintain a smaller diameter. Thus, in a pure orthographic projection (i.e., a purely right-angle view), the Ionic columns would be invisible behind the Doric facade.

5. Eventually the temple of Athena Nike,

not yet built when the Propylaia was begun but certainly expected by Mnesikles, further masked the irregular nature of the south wing's west end.

6. An enumeration and interpretation of "Dark Stone in Greek Architecture" by L. T. Shoe appears in *Hesperia, Supplement* 8 [Princeton, 1949], pp. 341–52. With the exception of this initial observation, the interpretations presented in the present discussion differ considerably from hers.

In addition to the optical effect of the bottom step of the two wings, a specific allusion to ground level was implicit in the use of dark stone (see n. 8).

7. It is possible that, as suggested by Shoe ("Dark Stone," p. 346), the use of stone of contrasting color at orthostate level was ultimately suggested to Mnesikles by the age-old contrast between socle and superstructure in mudbrick and rubble walls. The specific symbolic and aesthetic uses to which Mnesikles then put it, as described in the text that follows, were all his own.

8. In the fifth century, dark stone was most often used in the lowest parts of buildings, that is, those in contact with the ground: whether the lowest step of the krepidoma (Older Parthenon; Hephaisteion, Athens; Stoa of Zeus in the Athenian agora; Temple of Nemesis at Rhamnous); the whole krepidoma (Stoa of the Athenians, Delphi; West Stoa in the Asklepieion, Athens); or the lower part of statue bases (Athena Promachos on the Athenian Acropolis). Here and elsewhere (as in the Propylaia west facade) one of its functions may have been visual leveling, but the primary purpose of the dark stone seems to have been one of transition, and the transition it effects is a significant one:

that between earth and architecture, between the natural and the man-made. The dark stone is carefully carved, like the masonry above, but its contrasting color and dull surface set it apart from the body of the building and convey, instead, a sense of continuity between it and the surrounding earth. (Thus, Dinsmoor, *Architecture of Ancient Greece,* p. 180, criticizes the use of dark stone for the bottom step in the Hephaisteion: "... [it] so combines with the surrounding ground as to give the impression that the temple has an inadequate base of only two steps.")

The subject of colored stone and its various uses is treated in more detail in the present author's forthcoming *A Story of Monumental Architecture in Greece* (Cambridge University Press).

9. The suggestion (Shoe, "Dark Stone," p. 347) that the contrasting color of the top step was aimed only at people leaving the Acropolis, its sole purpose to catch their eye and prevent them from falling down the stairway, is unlikely to be correct. If Mnesikles had intended neither for the dark step to be seen from the west, nor for it to change significantly the character of his stairway as it was approached from the west, it would have been invisible from that direction. It was visible from east and west because it was intended to be seen from both directions. The dark stone step visually articulated physical and spiritual transition for those both coming and going, but as is appropriate in a building whose primary function was to lead people onto the Acropolis rather than off of it, the step was more visible and its effect more pronounced from the west.

10. Again, it is uncertain how much of Mnesikles' building was inspired by the propylon that preceded it. The remains of the propylon are scrappy, and its reconstructions vary greatly. What can be said for sure is that its facades did not give the same impression of a temple as the Propylaia: They were not hexastyle prostyle, but in-antis arrangements like the treasuries and other gateways. Nor has anyone reconstructed the facades with graduated spacings. In addition, a recent publication on the propylon calls into question the commonly held view that, as in the Propylaia, a ramp replaced the stairs in the central intercolumniation; it convincingly argues from the physical remains that such a ramp could not possibly have continued as far as the interior stairs in the propylon (Dinsmoor, *Propylaia, I,* p. 50). Given this, the reconstruction of a ramp leading into the propylon makes little sense. Finally, a wide central spacing is certainly possible in the propylon and is regularly reconstructed, but there is no direct physical evidence for this. Similarly, double pediments are reconstructed on the propylon more on the basis of the later Propylaia than on archaeological evidence. In other words, there is little convincing evidence that the salient characteristics of Mnesikles' Propylaia were borrowed from its predecessor.

11. Olympia was an international sanctuary, not a city, and was not destroyed by the Persians. Moreover, the Temple of Zeus was a completely new undertaking, not a rebuilding. As such it seems to have been immune to the restrictions of the Oath of Plataia.

12. Long before Mnesikles and Iktinos, indeed from the middle of the sixth century B.C., Sicilian and South Italian architects freely employed Ionic elements in their Doric temples. Not only did they

make copious use of carved Ionic moldings, but from the beginning they built their cellas with a closed back wall and their colonnades with a dipteral front; graduated column spacings across the front of the temple and prostyle porches were not unknown; and at least once in the Archaic period Ionic columns were used behind a South Italian Doric temple facade. These elements also added a sense of direction, of procession, to their temples (see n. 13 below, where this is briefly discussed). Many of those aspects of the Parthenon that represent significant innovations in mainland Doric architecture find general parallels in earlier Sicilian and South Italian temples. Their contexts and origins are, of course, different, as are the specifics of form and meaning, and direct influence is difficult to pinpoint; but the Archaic temples of Sicily and South Italy do provide precedent for the mixing of the orders, precedent with which Athenian architects were certainly familiar.

13. That the orders had been combined earlier in Sicily and South Italy does not diminish the accomplishments of Pericles' architects.

14. As discussed in the section on "The Acropolis as Processional Architecture," in Chapter 2.

15. A standard interpretation of the Greek concept of *symmetria,* as presented by J. J. Pollitt in *Art and Experience in Classical Greece* (Cambridge, 1972), pp. 106–7.

16. Such ratios also exist in the details of the building.

17. Rhys Carpenter, *The Aesthetic Basis of Greek Art* (Bloomington, 1959), pp. 124–5; idem, *Greek Sculpture* (Chicago and London, 1960), p. 101.

18. "The so-called 'refinements' of Periclean architecture, the slight deviations from perfect regularity and symmetry, are not optical corrections for untrue illusions, but are added in order to give life to the rigid mathematical correctness of the standard norm; they are departures from the 'many numbers,' out of which arises perfection. . . . [T]he builders of the Parthenon . . . had applied to architecture the same secret of beauty which governs natural forms – the tempering of geometric accuracy by minute deviations in the interest of irregularity" (Carpenter, *Aesthetic Basis,* p. 124). Pollitt (*Art and Experience,* pp. 76–8) also finds this interpretation attractive and in keeping with the intellectual climate of the time.

19. "Paratactic" refers to the type of representation typical of Archaic times in which no attempt at creating natural transitions from one part of the body to the next was made: In painting and relief the major parts of the body – the head, the torso, the legs – were juxtaposed at right angles, that is, alternately represented in profile and frontal view.

20. The following brief discussion of the impressionistic elements in the Parthenon sculptures derives in large part from the detailed treatment of the same subject presented by Pollitt in *Art and Experience,* pp. 79–95.

21. Hipped roofs slope in to the ridge beam on the ends of the building as well as on the sides; pedimental roofs slope only on the sides.

22. This subject is treated in R. F. Rhodes, *The Beginnings of Monumental Architecture in the Corinthia,* Ph.D. diss., University of North Carolina, 1984. It is also discussed in detail in idem, *A Story of Monumental Architecture in Greece*

(forthcoming from Cambridge University Press), and in his forthcoming monograph on the seventh-century Temple of Apollo in Corinth.

23. A Doric or Ionic frieze may well have been carried on the pronaos columns of the Temple of Artemis at Corfu, and there is reason to believe that the decorated metopes from several Archaic temples at Selinos in Sicily also belong inside the peristyle.

24. That the cella was widened in preparation for Pheidias' huge cult image is a standard view; the implications as articulated here and in subsequent chapters are not.

Chapter 4. The Integrated Parthenon

1. It is fairly universally identified as a representation of the Panathenaic procession, and the debate usually centers on whether the procession depicted is contemporary with the Parthenon, the Battle of Marathon, the reorganization of the Panathenaic games, or the legendary history of Athens. All are plausible and in keeping with the overall spirit of the Parthenon and the Periclean Acropolis, but the specific identification of the procession with the Panathenaia is still not certain. The lack of mythological indicators does point to a more historical theme, and the significance of the Panathenaic procession for the Acropolis would make such a representation eminently suitable for the Parthenon; but the scene at the center of the east side (see Fig. 49) does not clinch the identification. It does seem to represent a presentation to the gods, but its specific association with the culminating ritual of the Panathenaic procession, the presentation of the birthday *peplos* (dress) to Athena, is tenuous. In fact, the peplos was more closely associated with the Temple of Athena Polias and then with the Erechtheion than with the Parthenon, for the ancient wooden statue on which it was hung was probably housed in them (M. Robertson, *A His-*

tory of Greek Art, 2 vols. [London, 1975], p. 308). If the procession is indeed that of the Panathenaia, the peplos ritual is a very attractive suggestion for the culminating scene of the frieze; but, conversely, the specifics of that scene are too ambiguous to prove the identification of the procession as a whole.

2. That is, through the representation of a legendary or mythological event that might be readily associated with the recent victory of the Athenians.

3. Olympia's immunity to the oath is briefly discussed in Chapter 3, n. 11.

4. It is also possible that a similar chariot stood in the center of the west pediment.

5. See Chapter 2, nn. 8, 12.

6. A similar struggle is perhaps indicated in the contest between Athena and Poseidon for control of Athens and in the very ancient myth that has Athena raised by Poseidon and cast away by him only after she accidentally kills his daughter, Pallas, her double. The memory of her original connection with the darker side of nature would then be preserved in the epithet Pallas Athena.

7. These dramatic possibilities were also well understood by the Black Figure vase painter Exekias in the late sixth century. As a moment of rest before or after some

decisive action, but containing the clear implication of that action, the Polygnotan moment is not unrelated to the physical characteristic of *rhythmos,* explored in detail by contemporary sculptors of the Early Classical period. (For an illuminating discussion of *rhythmos,* see Pollitt, *Art and Experience*, pp. 56–60.)

8. The sense is not unlike that inspired by the contemplation of photos of smiling soldiers who, the viewer realizes, died in battle only days later.

9. The pronaos and opisthodomos friezes of Olympia and the Hephaisteion depict humans, but those are mythological heroes: Herakles and Theseus, respectively.

10. "The throne on the relief [of the Madrid puteal, perhaps the best evidence for the central group of the Parthenon east pediment] is an uneasy compromise between profile and three-quarter, surely the consequence of adapting to low relief a three-quartered enthroned figure in the center of the pediment . . ." (Robertson, *History of Greek Art*, p. 302).

11. This is discussed at the end of Chapter 3.

Chapter 5. Creating Canon

1. For a summary of some of the major elements that indicate a unified design for the Periclean Acropolis, see the end of the opening section of Chapter 2.

2. A. F. Stewart, "History, Myth, and Allegory in the Program of the Temple of Athena Nike, Athens," in H. L. Kessler and M. S. Simpson, eds., *Pictorial Narrative in Antiquity and the Middle Ages*, *Studies in the History of Art* 16 (Washington, D.C., 1985), pp. 53–73, also sees the Nike temple as an emblem of the city.

3. See "The Parthenon (and the Other Temples" in Chapter 2.

4. The inscription that records the commissioning of the Nike temple to Kallikrates is a subject of considerable controversy, as are the dates of the Nike temple, its limestone predecessor, and the limestone facing of the bastion (see Chapter 2, nn. 2, 3). Opinion is divided as to whether the inscription refers to construction of a temple that was delayed for twenty years – in which case it represents the present Nike temple – or to a predecessor on the same site. Most recently, I. S. Mark (*Sanctuary of Athena Nike,* p. 137) has concluded that the present Nike temple was first commissioned in the mid–420s in the context of perceived victory in the first phase of the Peloponnesian War. Even if this is correct, and if, as Mark has also concluded, the present Nike temple replaced a more immediately post-Persian naiskos to Victory, it is still consistent with the spirit and inspiration of the Periclean building program. It may be one step removed from the original phase of planning and construction, and an additional cause for celebration may have intervened, but a Victory temple on the bastion was part of Pericles' original plan, and its replacement – or any other nearly contemporary Nike monument erected in the context of Pericles' rebuilt Acropolis – could not have been disassociated from victory over the Persians.

5. It appears that an unsculpted limestone parapet stood on the bastion before it was remodeled for the Nike temple. For a brief summary of the architectural history of the bastion, see J. Travlos, *Pictorial Dictionary of Ancient Athens* (New York and Washington, 1971), pp. 148–9.

6. Pollitt, *Art and Experience,* p. 125.

7. Pausanias, a traveler of the second century A.D., calls the temple the Temple of Wingless Victory, but the Nikes of the parapet are definitely winged.

8. An almost exact precedent for the Nike temple is found in a little Ionic temple (5.85 × 13.69 m) on the banks of the Ilissos river in Athens. In fact, it is possible that the Ilissos temple was built according to specifications originally intended for the Nike temple (Dinsmoor, *Architecture of Ancient Greece,* p. 185; see also Chapter 2, n. 3, as well as n. 4 of the present chapter, where the inscription is discussed). Still a very useful source for the architectural analysis of the Nike temple is I. Shear's "Kallikrates," *Hesperia* 32 (1963), 375–404.

9. Dinsmoor, *Architecture of Ancient Greece,* p. 139.

10. This "Attic" base – so named for Attica, the geographical region of which Athens was the central city – ultimately derives from bases like those in the Stoa of the Athenians at Delphi, built around the beginning of the fifth century B.C. The stoa bases also consist of a concave molding between two half-rounds, but that molding is a cyma recta as opposed to a scotia. Sometime between the construction of the Stoa of the Athenians and that of the Propylaia, the cyma recta hollows out into a simple scotia.

11. The end columns also lean inward toward the center of the facade.

12. Similar concessions to scale can perhaps be seen in the unusually wide proportions given to several small Doric temples of the late Archaic period (e.g., the Temple of Aphaia at Aigina) and in the reduction of the standard number of flutes (from twenty to twenty-four or more, to sixteen) in the Stoa of the Athenians at Delphi. In the former case, it was perhaps feared that the elongated proportions common in larger temples would result in a temple width that appeared almost miniature. In the latter, the carving of a larger number of flutes would have significantly reduced both the apparent and actual substance of already thin and widely spaced columns (but see Vitruvius, IV. IV.2, who suggests that by increasing the number of flutes the apparent thickness of a column is *increased*).

13. Another almost exclusively Doric refinement, entasis, appears in the Ionic columns of the Propylaia and is later repeated in the columns of the north porch of the Erechtheion.

14. See the chart in Shear, "Kallikrates," p. 424, for a detailed enumeration of these correspondences.

15. Such screen walls appear in Sicilian Doric temples of the late Archaic period, but no direct connection between them and the Erechtheion is likely to be established.

16. Caryatids already existed in late-Archaic treasuries at Delphi and are generally assumed to have East Greek (i.e., Ionic) origins.

17. My thanks to Bonna Wescoat for this turn of phrase.

18. This is the war with which Herodotus, the contemporary historian of the Persian Wars, begins his long explanation of the conflict between East and West.

19. The choice of divinities instead of humans for the frieze of the Erechtheion may not seem as appropriate as a reflection of the Panathenaic procession; but unlike the Parthenon, the Erechtheion is an Ionic building, and processions on Ionic buildings are traditionally single-file, nonnarrative compositions. Perhaps the nonnarrative, emblematic representation of humans seemed sacrilegious even to fifth-century Athenians.

20. As in Polykleitos' sculpture. For the chiastic balance of his sculpture, see "Freestanding Sculpture" in Chapter 7.

Chapter 6. Architectural Legacy and Reflections

1. The most recent and detailed discussions and illustrations of the Apollo temple are found in F. A. Cooper, *The Temple of Apollo Bassitas,* vol. I, *The Architecture* (in press), and B. C. Madigan, *The Temple of Apollo Bassitas,* vol. II, *The Sculpture* (Princeton 1992).

2. Scully, *Earth, Temple, Gods*, pp. 139–41.

3. Certain elements of the exterior were executed in marble, most noticeably the roof tiles and the roof *acroteria* (sculptural decoration on the peak and angles of the gable) and the guttae of the geison. Apparently the limestone was not stuccoed, and the contrasting appearance of the stones was key to the design of the building (Cooper, *Apollo Bassitas*). One could argue that through that contrast the similarity in nature between the temple limestone and the living rock was actually underscored, and the connection between temple and landscape further emphasized.

4. Scully, *Earth, Temple, Gods*, pp. 124–5.

5. These are described by Cooper in *Apollo Bassitas*.

6. In both the Archaic and Classical temples, that doorway apparently reflects a common concern in Greek temple architecture that the cult image be illuminated by the first rays of the sun on the god's festival day (F. A. Cooper, "The Temple of Apollo at Bassae: New Observations on its Plan and Orientation," *AJA* 72 [1968], 103–11).

7. Everyone notes the old-fashioned features of the Bassai temple. Scully also uses the term "archaism" in his discussion of some of them (*Earth, Temple, Gods,* pp. 125–6).

8. Pollitt, *Art and Experience,* p. 63.

9. Although Pausanias (8.41.9) identifies Iktinos as the architect at Bassai, his attribution has been disputed in recent years. Most recently, however, Cooper (*Apollo Bassitas*) argues for accepting Pausanias' testimony as truth.

10. The lack of curvature in the temple may not be due to archaism: Perhaps it was deemed inappropriate in such a small building. It has also been suggested (Scully, *Earth, Temple, Gods,* p. 124) that the intended primary view of the temple was from the hill above its north front, a position from which the effect of curvature might be to reduce even further the apparent scale of the building.

11. "The scale is set on the exterior and then becomes greater inside. The effect is one of surprise and indeed of spatial release where one had expected the usual spatial dwindling" (Scully, *Earth, Temple, Gods,* p. 125).

12. Stylistic details of the Corinthian capital suggest to F. A. Cooper (*Apollo Bassitas*) an intentional double connection with the columns of the Archaic temple and the tradition of freestanding votive columns.

13. Long ago Vincent Scully suggested that the column at Bassai represented the god (*Earth, Temple, Gods*, p. 127):

"We know that Callimachos, a fifth-century worker in bronze, made treelike metallic forms and was reputed to have invented the Corinthian capital. The latter is thus related both to metalwork techniques and to the evocation of trees. We recall that the Athenians had dedicated a bronze palm tree outside Apollo's temple at Delphi shortly after 460 B.C. and that Nicias donated, in 417 B.C., another bronze tree to the sanctuary of Apollo at Delos. We have already discussed the importance of that tree as a symbol of Apollo's birth. It had been, in Crete, a symbol of the goddess, and Leto had grasped it for support while bearing her divine child. The palm tree in bronze, therefore, was a symbol not only of Apollo but also of those chthonic powers of the goddess that he had usurped. The Corinthian column in stone is a treelike form derived from bronze originals. It is my belief that it is used for the first time at Bassae precisely in order that it should stand as a symbol of the god and, most appropriately at this site, of those earth powers which Apollo had brought under his sway."

Here are J. J. Pollitt's thoughts on the same subject (*Art and Experience*, p. 130):

"[W]as it supposed to call to mind forms which were ancient and half-forgotten like the floral capitals which were common in the ancient Orient and had sporadic use in Archaic Greece? Or did its formalized floral form, following the same line of thought, call to mind some of the primitive, agrarian, or at least un-Olympian, institutions of Greek religion, like the laurel associated with Apollo at Delphi, the oak sacred to Zeus at Dodona, and the olive tree of Athena on the Acropolis in Athens? In this connection it is interesting to note that Kallimachos devised, in the words of Pausanias, 'a bronze palm tree,' perhaps something like a Corinthian column, in the chamber of the Erechtheion where the most ancient image of Athena Polias was kept . . . perhaps it was . . . in some way symbolic, like the olive tree, of Athena's ancient aspect as a nature goddess."

14. The porch metopes were also sculpted, apparently depicting Arkas (the eponymous hero of Arkadia) and local nymphs at the front, and, at the back, the abduction of the Messenian Leukippidai by the Spartan Dioskouroi. Both are themes of local significance. In fact, on the basis of the Temple of Zeus at Olympia, the Hephaisteion, the Parthenon, and the Temple of Apollo at Bassai, it might be possible to conclude that, in general, the themes of porch friezes are more specifically local than those of temple peristyles or pediments. The subjects of the first three are, respectively, Herakles, the founder of the Olympian games; Theseus, the hero of Athens; and the Athenians themselves.

15. The same thing is also true of the fourth-century Temple of Apollo at Delphi.

16. Dinsmoor, *Architecture of Ancient Greece*, p. 219.

17. This subject is treated in detail in J. J. Pollitt, *Art in the Hellenistic Age* (Cambridge and New York, 1986).

18. For this interpretation of the Pantheon's facade, see Chapter 2, n. 14.

19. This interpretation of the Athena temple will require some modification if, as some archaeologists now suggest, it was in fact constructed in the fourth century B.C.

Excellent discussions of Athenian allusion in Pergamene art can be found in Pollitt, *Art in the Hellenistic Age,* chap. 4, "The Sculpture of Pergamon," and John Onians, *Art and Thought in the Hellenistic Age: The Greek World View, 350–50 B.C.* (London 1979), pp. 79–88.

20. Onians, *Art and Thought,* pp. 153–5.

21. This distinction in themes is also noted in Chapter 6, n. 14.

22. Pollit, *Art of the Hellenistic Age,* pp. 233–5.

Chapter 7. God and Man

1. Context and causes of many of these are discussed by Pollitt in Chapter 5 of *Art and Experience,* "The World of the Individual."

2. The subjects of the decorated metopes seem to have been similarly local in significance, representing various aspects of the legends surrounding Tegea.

3. According to an accompanying inscription, he represents Agias of Pharsalos in Thessaly, the son of Aknonios.

Glossary

abacus (pl. **abaci**). The uppermost element of a column capital, low and rectangular in elevation, usually square in plan.

acropolis. The "high city"; citadel.

Acropolis. Specifically, the acropolis in Athens.

acroterion. A decorative figure or design set on the peak or angles of the pediment.

adyton. An innermost recess of the cella, often separated from it by a wall or colonnade.

agora. A public square; marketplace.

amphiprostyle. With a prostyle porch on front and back.

antae. The slightly thickened ends of lateral walls, usually at the entrance to a Doric cella building, between which one or more columns are often set (cf. **in antis**).

anthemion. A decorative band of alternating lotus flowers and palmettes.

apophyge. The concavity that terminates an Ionic column shaft at its upper and lower end or that forms the transition between shaft and echinus in Doric.

architrave (epistyle). The lowest element of the entablature, resting directly on the column capitals and tying the columns together.

ashlar masonry. Horizontally coursed dry masonry of neatly squared, regularly sized stones.

axial spacing. The distance from one column axis to the next.

bolster. The lateral surface of an Ionic capital (as opposed to a face with volutes).

capital. The uppermost element of a column, which includes both echinus and abacus.

caryatid (sometimes **karyatid**). A column made in the shape of a woman.

cavetto. A concave molding whose section is usually one-quarter of a circle.

cella (naos). The main room of a temple, where the cult image is usually housed.

cella building. The solid-walled temple building, often set within a peristyle, of which the cella is the principal room.

chryselephantine. Constructed of gold and ivory, which are anchored to a wooden core.

classical. Pertaining generally to Greek and Roman civilization.

Classical. Belonging specifically to the period 479–323 B.C.

colonnade. A series of columns supporting an entablature; a portico.

Corinthian capital. A bell-shaped capital decorated with carved acanthus leaves and tendrils, invented in the later fifth or early fourth century B.C. and used in the context of the Ionic order.

corner contraction. Each corner intercolumniation was characteristically shorter than the otherwise regular spacing of columns in a Doric colonnade; thus, the corner spacings are regularly referred to as "contracted." (See Chapter 2, n. 18.)

cornice (geison). The uppermost element of the entablature, forming the projecting eaves of the building and protecting the wall below from rainwater.

cyclopean masonry. The masonry of huge stones often employed for fortification walls in the Mycenaean period in Greece.

cyma recta. A molding of double curvature; the concave portion of its curve has the greater projection in profile.

cyma reversa. A molding of double curvature; the convex portion of its curve has the greater projection in profile.

dentil. Simple rectangular elements that form a decorative band or frieze immediately below the cornice in Ionic architecture.

dipteros (pl. **dipteroi**). A temple with a double peristyle, that is, one whose cella building is surrounded by a pair of colonnades. The adjective, **dipteral,** can also refer to a temple front with a double colonnade.

distyle. Fronted by two columns.

Doric. The style of monumental architecture developed in the Doric regions of Greece and particularly characteristic of the Greek mainland.

drum. One of the cylindrical sections from which stone column shafts are regularly constructed in Greece.

echinus. The lower, convex element of the column capital that supports the abacus in the Doric order and the volute cushion in Ionic.

engaged column. A half- (or more than half-)column attached at its back to a wall.

entablature. The superstructure carried by the columns or, sometimes, at the top of the wall, and usually comprising epistyle (architrave), frieze, and geison (cornice).

entasis. The subtle outward curvature often introduced as a refinement to the tapering shafts of Doric columns. The resulting profile is a taut, suspended catenary.

epikranitis. The molding that adorns the crown of a wall.

epistyle. Greek for "architrave."

fascia. A low decorative band of vertical profile; one of the three horizontal divisions of an Ionic epistyle.

flutes. The concave, vertical channels that decorate the shafts of both Doric and Ionic columns.

frieze. The middle element of the entablature; or a horizontal sculpted band.

gable. The upper, triangular portion of the end wall of a ridged-roof building.

geison (pl. geisa). Greek for "cornice." The horizontal geison seats the lower end of the rafters and forms the eaves of the roof on the flanks of a building, as well as the base of the pediment on the ends; the raking geison forms the sloping eaves on the pedimental ends of a building.

guilloche. An ornamental cable pattern.

guttae. The peglike elements that project from the underside of mutules and regulae in the Doric order.

hekatompedon. "Hundred-footer," a common length and designation of early Greek temples.

Hekatompedon. Specifically, the hekatompedon on the Athenian Acropolis.

hexastyle. Fronted by six columns.

hipped roof. A roof whose end or ends, as well as its sides, slope up to the ridge (as opposed to having pediments).

hypostyle hall. An Egyptian building type characterized by multiple rows of columns.

in antis. With columns set between antae.

intercolumniation. The distance between columns in a colonnade.

inward inclination. The slight canting of exterior columns and/or walls toward the interior of a building.

Ionic. The style of monumental architecture developed in the eastern Aegean and Asia Minor and particularly characteristic of Ionia.

megaron. The large rectangular hall found at the heart of a Mycenaean palace, and the general form of a temple cella building.

metope. The panels between triglyphs in the Doric frieze.

mutule. A rectangular panel carved on the projecting soffit of the Doric geison.

Mycenaean. Belonging to the period or culture immediately preceding the Dark Age on the Greek mainland, from ca. 1550–1100 B.C.

naiskos. A small temple.

naos. The cella.

oikema (pl. oikemata). One of a number of small buildings on the Archaic Acropolis in Athens that probably served as treasuries.

opisthodomos. The back room or porch of many Doric cella buildings, open to the rear colonnade (if one exists), but closed to the cella.

orthostate. A course of tall blocks forming the base of a wall and resembling a dado.

ovolo. A quarter-round molding whose profile resembles that of an egg.

parapet. A low, protective wall placed at the edge of a platform.

pediment. Gable; the triangular space at the end of a gabled roof, articulated by horizontal and raking geisa and by a solid tympanum wall.

peripteral. Surrounded by a peristyle.

peristyle. A continuous, roofed colonnade that surrounds a building or a space.

pier. A freestanding rectangular pillar used as a vertical support, like a column.

propylaia. An elaborate temenos entranceway with more than one doorway.

Propylaia. Specifically, the Periclean entranceway of the Acropolis.

propylon. A simple temenos entranceway with a single door.

pronaos. The front room or porch of most Greek cella buildings, open to the cella behind and, if one exists, to the colonnade in front.

prostyle (as opposed to **in antis**). With columns set in front of wall ends instead of between them.

regulae. Rectangular elements immediately below the taenia of the Doric epistyle, each corresponding in position to a triglyph above.

reversa (see **cyma reversa**).

scotia. A concave molding whose section is usually an approximate semicircle.

shaft. The column between base (in Ionic) or stylobate (in Doric) and capital.

soffit. The exposed lower surface of an element of the superstructure, such as a geison or epistyle.

stoa. A building open on one long side in a colonnade.

stylobate. The course of blocks on which a column or a row of columns rests.

taenia. The low rectangular band that crowns the Doric epistyle.

temenos. A sacred precinct.

tetrastyle. Fronted by four columns.

tholos. A circular building.

torus. A convex molding whose section is approximately semicircular.

triglyph. A vertically channeled rectangular element that alternates with metopes in the Doric frieze.

tristyle. Fronted by three columns.

tympanum. The triangular wall that closes the pediment at the back.

volute. The spiral elements of the Ionic capital.

volute cushion. The horizontal continuation of the spiral volutes of the Ionic capital, on which rests the abacus.

Some Suggestions for Further Reading

Ashmole, B. *Architect and Sculptor in Classical Greece* (London: Phaidon, 1972).

Berger, E. (hrsg.) *Parthenon-Kongreß Basel 1982* (Mainz: Philipp von Zabern, 1984), 2 vols.

Berve, H., Gruben, G., and Hirmer, M. *Greek Temples, Theaters and Shrines* (London: Thames and Hudson, 1963).

Boardman, J. *Greek Sculpture: The Classical Period* (London: Thames and Hudson, 1985).

— *The Parthenon and Its Sculptures* (Austin: University of Texas Press, 1985).

Brommer, F. *The Sculptures of the Parthenon* (London: Thames and Hudson, 1979).

Bruno, V. J., ed. *The Parthenon* (New York: W. W. Norton, 1974).

Carpenter, R. *Greek Sculpture: A Critical Review* (Chicago: University of Chicago Press, 1960).

Coulton, J. J. *Greek Architects at Work* (Ithaca, N.Y.: Cornell University Press, 1977).

Dinsmoor, W. B. *The Architecture of Ancient Greece*, 3d ed. rev. (New York: W. W. Norton, 1975).

Doxiades, C. *Architectural Space in Ancient Greece* (Cambridge, Mass.: MIT Press, 1972).

Gruben, G. *Die Tempel der Griechen* (Darmstadt: Wissenschaftliche Buchgesellschaft, 1986).

Hopper, R. J. *The Acropolis* (London: Weidenfeld and Nicolson, 1971).

Lawrence, A. W. *Greek Architecture*, 4th ed. rev. (Harmondsworth: Penguin Books, 1983).

Lullies, R., and Hirmer, M., *Greek Sculpture*, 2d ed. rev. (London: Thames and Hudson, 1960).

Martin, R. *Manuel d'architecture grecque* I, *Matériaux et techniques* (Paris: A. & J. Picard, 1965).

Muss, U., and Schubert, C. *Die Akropolis von Athen* (Graz, Austria: Akademische Druck- u. Verlagsanstalt, 1988).

Palagia, O. *The Pediments of the Parthenon* (Leiden and New York: E. J. Brill, 1993).

Pollitt, J. J. *Art and Experience in Classical Greece* (Cambridge: Cambridge University Press, 1972).

Richter, G. M. A. *Sculpture and Sculptors of the Greeks*, 4th ed. rev. (New Haven: Yale University Press, 1970).

— *Three Critical Periods in Greek Sculpture* (Oxford: Clarendon Press, 1951).

Ridgway, B. S. *The Archaic Style in Greek Sculpture*, 2d ed. (Chicago: Ares Publishers, 1993).

— *Fifth Century Styles in Greek Sculpture* (Princeton: Princeton University Press, 1981).

— *The Severe Style in Greek Sculpture* (Princeton: Princeton University Press, 1970).

Robertson, D. S. A. *Handbook of Greek and Roman Architecture*, 2d ed. (Cambridge: Cambridge University Press, 1969).

Robertson, M. *A History of Greek Art*, 2 vols. (London: Cambridge University Press, 1975).

Schneider, L., and Höcker, C. *Die Akropolis von Athen: Antikes Heiligtum und modernes Reiseziel* (Köln: DuMont Buchverlag, 1990).

Scranton, R. L. *Greek Architecture* (New York: George Braziller, 1962).

Scully, V. *The Earth, the Temple and the Gods* (New Haven and London: Yale University Press, 1962).

Shapiro, H. A. *Art and Cult under the Tyrants in Athens* (Mainz am Rhein: Philipp von Zabern, 1982).

Stevens, G. P. *The Periclean Entrance Court of the Acropolis of Athens* (Cambridge, Mass.: Harvard University Press, 1940).

Stewart, A., *Greek Sculpture, an Exploration* (New Haven and London: Yale University Press, 1990).

Tomlinson, R. A. *Greek Sanctuaries* (London: Paul Elek, 1976).

Travlos, J. *Pictorial Dictionary of Ancient Athens* (London: Thames and Hudson, 1971).

Woodford, S. *The Parthenon* (Cambridge: Cambridge University Press, 1981).

Index

Note: All architectural monuments not otherwise identified are in Athens. Italic page numbers refer to illustrations.